# BASEBALL IN
# PORTSMOUTH, VIRGINIA

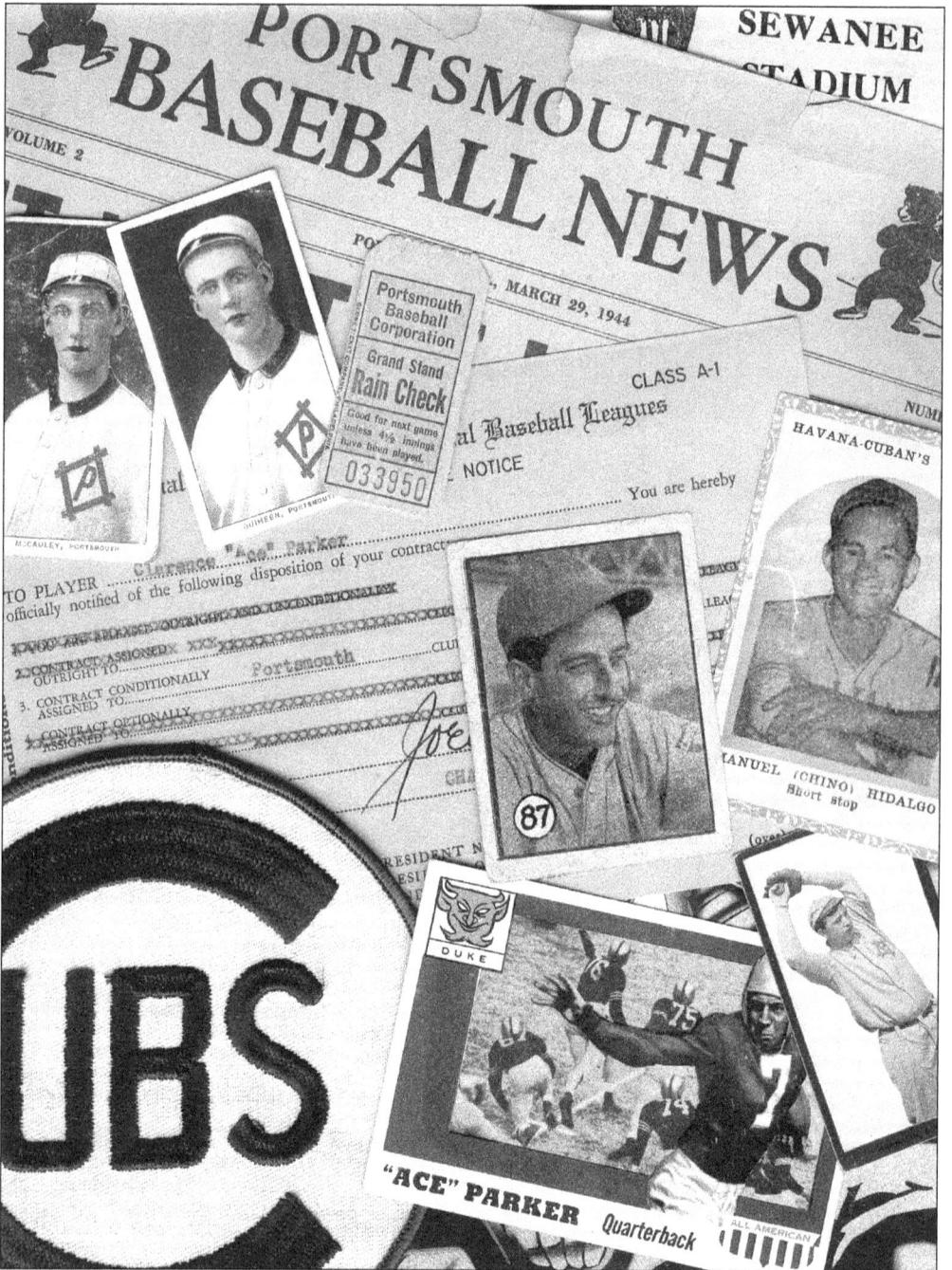

**PORTSMOUTH BASEBALL MEMORABILIA AND EPHEMERA.** Displayed above is a small sampling of items associated with the history of baseball in Portsmouth, Virginia. From worn and creased tobacco cards to tickets, newspapers, and programs, Portsmouth fans have collected and cherished mementos of the game over the years. (CSTG.)

# BASEBALL IN PORTSMOUTH, VIRGINIA

Clay Shampoe and Thomas R. Garrett

ARCADIA
PUBLISHING

Published by Arcadia Publishing
Charleston, South Carolina

Library of Congress Catalog Card Number: 2003112425

For all general information contact Arcadia Publishing at:
Telephone 843-853-2070
Fax 843-853-0044
E-mail sales@arcadiapublishing.com
For customer service and orders:
Toll-Free 1-888-313-2665

Visit us on the Internet at www.arcadiapublishing.com

## PHOTOGRAPHY LEGEND

PPL: From the archives of the Portsmouth Public Library.
NPL: From the archives of the Norfolk Public Library.
VP: From the archives of the *Virginian-Pilot*.
CSTG: From the personal collection of Clay Shampoe and Thomas R. Garrett.
All other photographs credited individually.

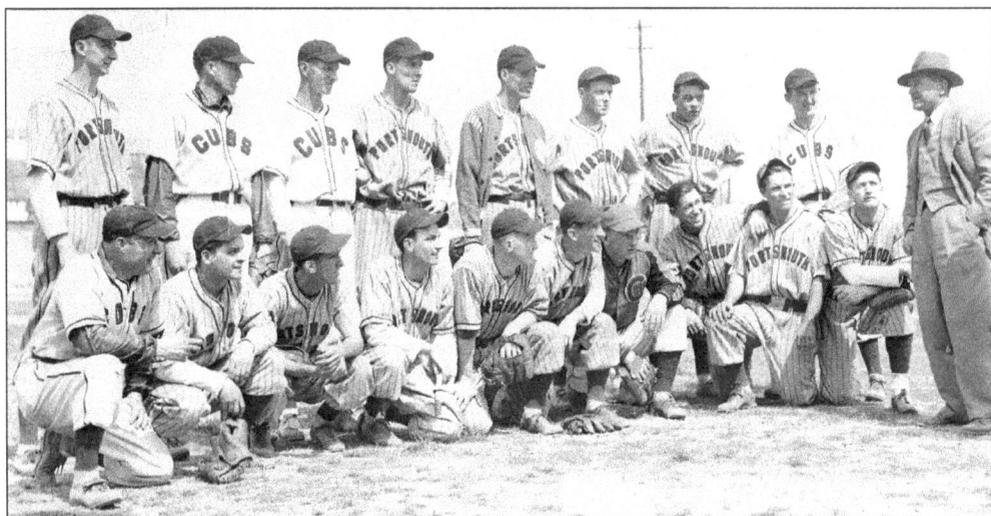

PORTSMOUTH CUBS, 1943. Manager Milt Stock and the team are pictured at Portsmouth Stadium. (CSTG.)

# CONTENTS

# ACKNOWLEDGMENTS

The authors acknowledge that this book was completed with generous assistance from many knowledgeable individuals, therefore special thanks are in order to the following contributors and consultants that went above and beyond in their support of this project: Sue Burton, Director of the Portsmouth Public Library; Chic Rebel, *Virginian-Pilot*; Peggy Haile-McPhillips, Norfolk City Historian; Susan Beck, Arcadia Editor; the research staff at the National Baseball Hall of Fame Library; the girls at Atlantis Photography; John Wesley Lawrence; Jeff Eastland; Thomas Burt; Joan B. Estienne; and our proofreader JoAnn Barnes.

Clay thanks his wife, Deborah, and his parents for their continuing support in his writing and research. Tom gives heartfelt thanks to his dad, wife, Carol, and son, Andrew, for their constant encouragement during this project. Thanks also to Jim Shampoe and Joel Rubin for their support and assistance during the authors' annual research trip to Cooperstown.

While researching this book, the authors were fortunate to meet a number of charismatic individuals who shared their memories regarding baseball in Portsmouth. One particular person made an indelible impact on the authors: Harry Land. No one was more gracious or supportive of our quest in the project. Back in 1940, as a 17-year old catcher, Harry signed a pro contract and within days found himself behind the plate with the Leaksville Luckies of the Bi-State League. From there, his career transversed through the minors with successful seasons in Zanesville, Los Angeles, Portsmouth, and New Bern. If not for a catastrophic beaning in 1948, as a member of the Portsmouth Cubs, his dream and ambition of playing in the major leagues would have been fulfilled.

For every photograph in this book there is a story and for every story there is a person that through his own life experiences has brought the tale to life. Without special individuals like our friend Harry Land, many of the memories, events, and stories surrounding the history of baseball in Portsmouth, Virginia, may have been left untold.

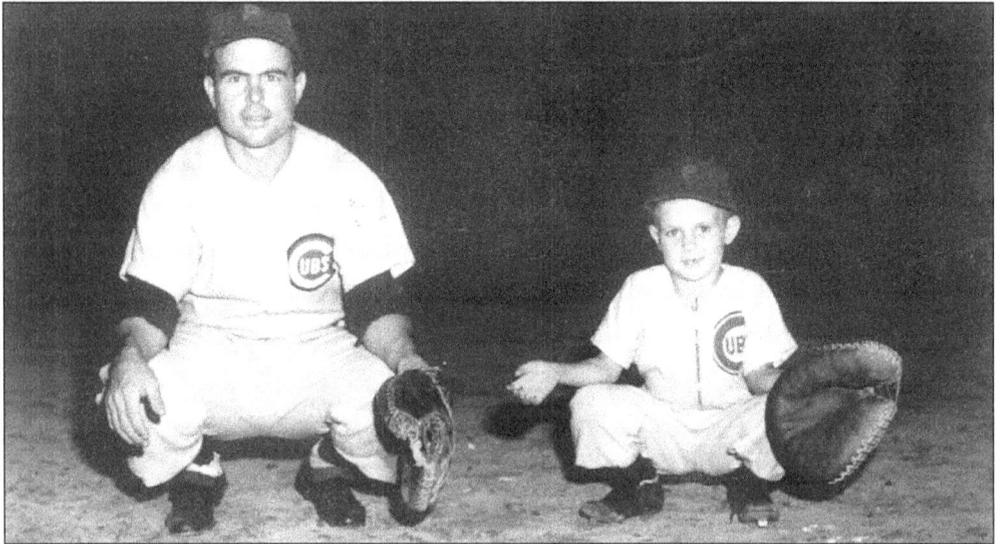

BIG CUB, LITTLE CUB. Portsmouth catcher Harry Land strikes a pose with his son Butch before a Piedmont League contest in 1946. (From the Family Archives of Harry Land.)

# INTRODUCTION

Today, it is nearly impossible to find the remnants of the old stadiums and ballparks that once showcased minor league baseball in America. Most of the splintered, knot-holed outfield walls encircling countless playing fields have long been torn down and carted away. Like lost mythical shrines and temples, the foundations of these once cherished diamonds are buried beneath new construction, their history forgotten.

For many small towns and cities across the country, professional baseball ended in the bottom of the ninth, on a called third strike as every fan stood rooting for a miracle comeback by the home team. As the ball settled into the worn, leathered pocket of the catcher's mitt and the crowds shuffled from the park, something more was lost than just the game itself. Minor league baseball, once such a thriving social and economic stimulus for the small town and its fans, was gone and would not be resurrected.

Such was how the game played out in the historic city of Portsmouth, Virginia. From the debut of the Truckers in 1895, until the final out was recorded in the fall of 1969 by the Tidewater Tides, the city proudly and enthusiastically supported professional baseball. Unfortunately, Portsmouth was not alone in its attempt to keep baseball alive. Countless other small towns and cities were once a part of the glory days of professional minor league baseball—some for only a season, while others lasted and prospered for decades. From 1946 through 1951, what is now considered the golden age of minor league baseball, more than 400 localities across America fielded a professional franchise. Charismatic teams such as the Norfolk Tars, Suffolk Goobers, Newport News Dodgers, Roanoke Red Sox, Petersburg Generals, and Emporia Nationals once existed and provided local fans with countless summers of exciting contests. As the 1950s headed into the middle innings, baseball enthusiasts discovered other diversions on which to spend their entertainment dollar, with a visit to the ballpark not as important as it once was. With fewer patrons clicking the turnstiles, many cities lost baseball. On a chilly, rain swept evening in early September of 1969, the final inning of minor league baseball in Portsmouth transpired and the game came to a historic end.

Despite more than 30 years since the crack of the bat resonated throughout the city, the stories of the players, games, and celebrations remain forever woven into Portsmouth's storied tapestry. Of all the towns that fielded professional minor league teams in the past century, few can boast of as many legendary players and managers that played such a key role in Portsmouth's baseball history. Individuals that are so well known and admired that they grace the walls of the National Baseball Hall of Fame in Cooperstown: Pie Traynor, Hack Wilson, Tony Lazzeri, Jimmie Foxx, and Walter "Buck" Leonard. Few fans of the modern game are likely to realize the wealth of talent that once ran, hit, and pitched as young minor league prospects with "Portsmouth" stitched onto their wool and flannel jerseys. From the early days of the Virginia League, to the historic Piedmont League years, to the birth of the Tidewater Tides, Portsmouth's baseball heritage is filled with mythical players and celebrated events.

Today, the wooden bleachers and outfield walls of Portsmouth's Sewanee Stadium and High Street Park are dust; the concrete edifice embracing the diamond of Frank D. Lawrence Stadium reduced to rubble. Despite the passing of these shrines and the historic events that took place within their hallowed walls, authors Clay Shampoe and Thomas R. Garrett hope to renew faded memories by inviting the reader to explore the pages of this book as they revive the history of baseball in Portsmouth, Virginia.

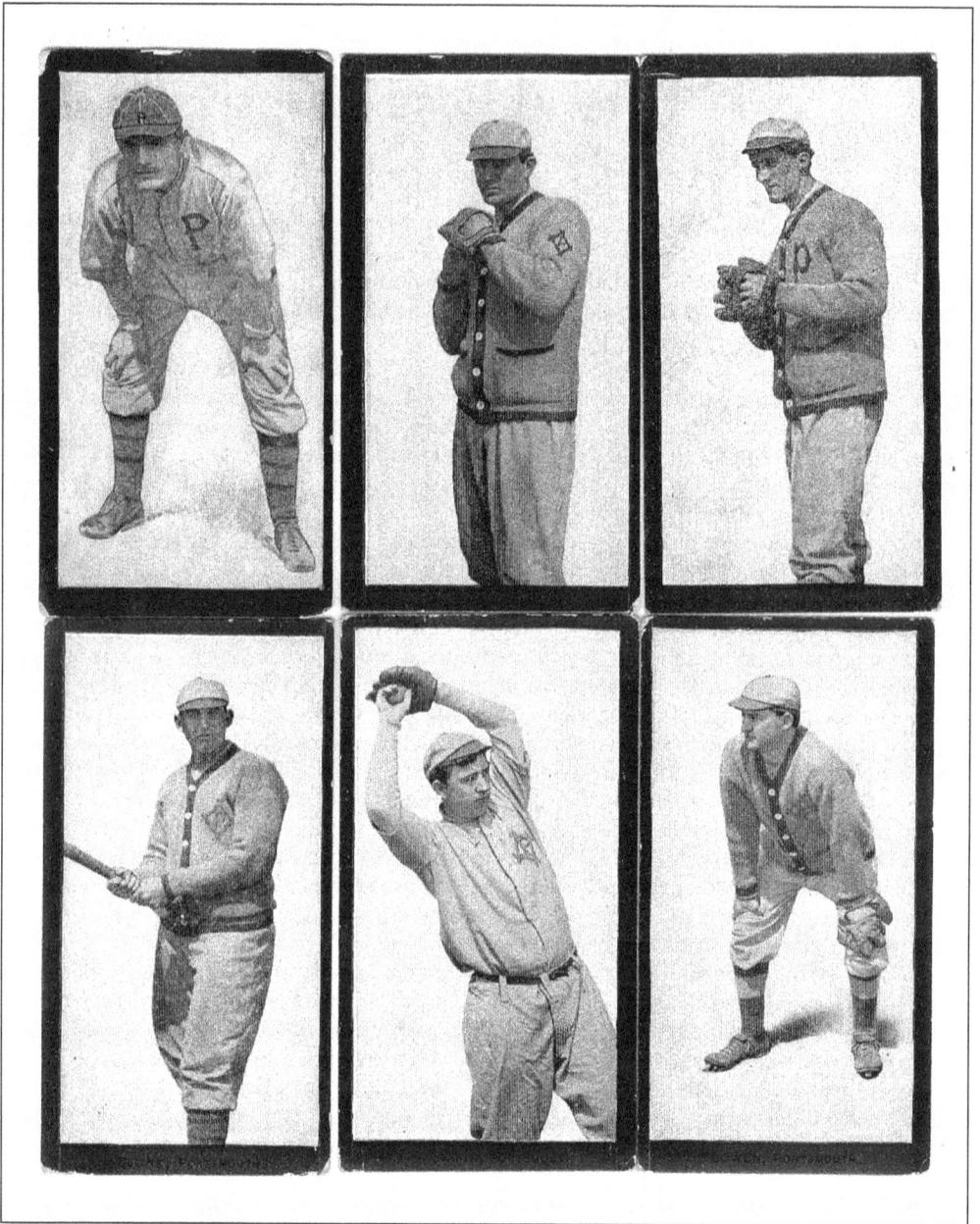

EARLY TOBACCO CARDS OF THE 1909 PORTSMOUTH TRUCKERS. As part of an incentive to sell tobacco products, manufacturers inserted small cards into their product showcasing celebrities of the era. The most popular insert proved to be athletes, especially the ballplayers of the day. The representative set shown above features team members of the 1909 Portsmouth Truckers of the Virginia League and was most likely produced early in 1910 for the public. The cards were printed with black and white depictions of the players surrounded by a bright red border. On the reverse was an advertisement for Old Mill cigarettes, a popular brand of the time. From left to right are the following: (bottom row) Clunk, outfielder; Hannifin, pitcher; and Bowen, utility man; (top row) Toner, third baseman; Earl Hamilton, pitcher; and Foxen, pitcher. (CSTG.)

# ONE

# Early Baseball in the City of Portsmouth

While its neighboring city, Norfolk, first fielded a professional team as early as 1885, Portsmouth's baseball history did not commence until 1895, when the historic seaport garnered a franchise in the old Virginia League. The six-city league encompassed the southern portion of the state with Richmond, Lynchburg, Petersburg, Roanoke, and Norfolk serving as competition for the newly organized Portsmouth team. The moniker of the new franchise, the Truckers, at first seemed somewhat unusual unless you were a resident of the city or the surrounding areas in the late 19th century. Upon leaving the bustling docks along the Elizabeth River, the countryside surrounding the city consisted of countless farms growing a plethora of fruits and vegetables hauled to market on horse-drawn flatbeds, with the locals known as "truckers," hence the name for the new baseball team.

In 1895, with Portsmouth fans exuberant over the prospects of a professional team in the city, the Virginia League season opened with fanfare and unbridled optimism. The season, which started with such high hopes, soon evolved into a nightmare as the team hired and then fired three managers over the course of the campaign. The final outcome proved to be dismal as the Truckers could manage only a 57-68 record and finished 22 games behind the first place Richmond Bluebirds. The one bright spot on the squad proved to be big Edward Tate who led the Virginia League with a .412 batting average while garnering 194 hits. To make matters worse for the Truckers, Tate abandoned Portsmouth mid-way through the season and become the player-manager of the Norfolk Crows.

The following year, the Richmond Bluebirds continued their dominance of the league and once again captured the pennant. The Portsmouth nine, renamed the Browns, improved their record to 65-64 but boasted few heroes to speak of on the team. Despite the mediocre record, the franchise survived the entire campaign while the cities of Roanoke and Lynchburg disbanded in late August. The depleted league's survival was short-lived, as the remaining owners were unable to ignite interest for the upcoming season. For the next three years, half-hearted attempts to revive the game in Portsmouth failed, with local fans growing more vocal in their desire for the city to again field a team.

As the first season of the new century dawned on the city of Portsmouth, the citizens were once again rewarded with professional baseball in the city limits. Fans returned in droves to League Park and its newly expanded grandstand to witness their Portsmouth Pirates, under the guiding hand of Pete Weckbecker, take on a new congregation of Virginia League challengers. While the season ended prematurely as teams disbanded in mid-June, the 1900 campaign was ruled by Norfolk's Christy Mathewson on the mound and Portsmouth's Jim Murray at the plate. Mathewson dominated the league with a 20-2 record and outfielder Murray led all hitters with 11 home runs and 98 RBIs. As the league officially folded in the dog days of summer, both the Norfolk and Portsmouth players continued to stage home and away contests for the remainder of the season to the delight of local fans. In 1901, the Portsmouth Browns became members of the new Virginia-North Carolina League, but in less than two months, Manager Win Clark and the team packed their trunks and headed south across the border,

finishing out the turbulent campaign as the Tarboro Tarters. Once the gates were locked at League Park, no professional team would take up residence in Portsmouth again until 1906.

As members of the Virginia League from 1906 until 1914, the Truckers struggled to stay in contention, but for the most part found themselves deep in the second division year after year. With Win Clark at the helm for the 1915 season, the crafty veteran motivated his team to a second place finish with a 68-58 record and the outlook for the team looked promising. The following season found Clark with the Hopewell Powder Puffs and the Portsmouth nine came under the direction of James Fox. Known throughout the area as the "Foxes," the team ran nip and tuck with the Newport News Shipbuilders during the course of the season, ending up in second place, three games behind the Virginia League champions. Throughout the entire league, few hitters dominated like Portsmouth's Manuel Cueto. The feisty Cuban won the Virginia League batting title with a .321 average and topped the circuit in hits (126) and purloined bases (41). As the popularity of baseball in Portsmouth continued to grow along with its success on the field, the specter of war in Europe derailed the game all across America. The following season the Virginia League lasted only into the third week before folding on May 15, 1917, as players and managers scrambled to find new cities in which to play.

As the 1920s emerged, the Portsmouth franchise entered upon a new road to success led by owner and local banker Frank D. Lawrence. A mainstay with the team from as far back as 1913, Lawrence was often referred to as Portsmouth's "Mr. Baseball." Possessing a keen eye for talent, he signed one of the most steady and reliable infielders in the history of game for his 1920 Portsmouth Truckers: Harold "Pie" Traynor. With Traynor's steady glove anchoring the infield and the potent bat of player-manager Jimmy Viox (.302) driving in plenty of runs, the Truckers dominated the second half of the 1920 season. From the mound there was no one better than W.M. McGloughlin as the young hurler dominated opponents with 155 strikeouts while posting an impressive 22-8 record. Despite losing Traynor to the Pittsburgh Pirates in the waning weeks of the regular season, the Truckers won an exciting playoff series from the Richmond Colts, earning the city its first championship in professional baseball. The following season, manager Jimmy Viox won the Virginia League batting title, as the Truckers took the pennant for the second consecutive year, but not without controversy. As the season came to an end, the North Carolina franchises were found to be padding their payroll with higher salaried players than allowed in the league. The high commissioner of baseball, Judge Kenesaw "Mountain" Landis, reviewed the concerns of the league and essentially removed the Wilson and Rocky Mount franchises from the standings completely, thus giving Portsmouth the first half season title. In a post-season playoff series with the Norfolk Tars, Portsmouth prevailed and lofted a second league championship pennant up the lanyards of Washington Street Park.

The 1923 season found the Truckers wallowing deep in the second division of the Virginia League; however, a new center fielder by the name of Lewis Wilson would soon make the fans forget the team's dismal record. With a stature that resembled a fire hydrant more than a baseball player, "Hack" wielded the most explosive bat in the entire league. The future Hall of Famer crushed opposing pitching as he posted a league leading .388 batting average and topped the circuit in RBIs (101), home runs (19) and triples (15). Propelling himself on tiny size 6 shoes, Hack Wilson was swift in the outfield and a flash on the basepaths. Winning the Virginia League's Triple Crown drew the attention of several major league clubs and owner Frank D. Lawrence eventually sold his slugger to John McGraw's New York Giants.

The Truckers finally put it all together in 1927, with Zinn Beck at the helm as Portsmouth captured their third pennant in franchise history. Portsmouth's longtime relationship with the Virginia League lasted until June 3 of the 1928 season as the league disbanded with the Truckers only one game behind the first place Norfolk Tars. Saddled with large debt, owner Frank D. Lawrence announced that his foray into professional baseball was over.

SECOND BASEMAN WIN CLARK, 1900. In the spring of 1900, Win Clark arrived in the city as a 25-year old ballplayer with six seasons of baseball under his belt with time spent in Staunton, San Antonio, Montreal, and Louisville. The young veteran quickly established himself as the starting second baseman for manager Pete Weckbecker's Portsmouth Pirates for the 1900 Virginia League campaign. The following season Portsmouth began the 1901 season in the Virginia-North Carolina League with Clark named as manager of the squad. Later in the campaign, the team was relocated to Tarboro, North Carolina, to become the Tartars. The venerable second sacker returned to the area in 1906 as player-manager with the Norfolk Tars and led the Virginia League in hitting with a .303 average. His final tenure in Portsmouth came in 1915, as he led the Truckers to a respectable 68-58 record and second place finish in the league. Following his days on the diamond and in the dugout, Win Clark served as president of the Bi-State League, became a respected umpire for Virginia League games, and held the position of secretary for the National Players Association well into his senior years. (CSTG.)

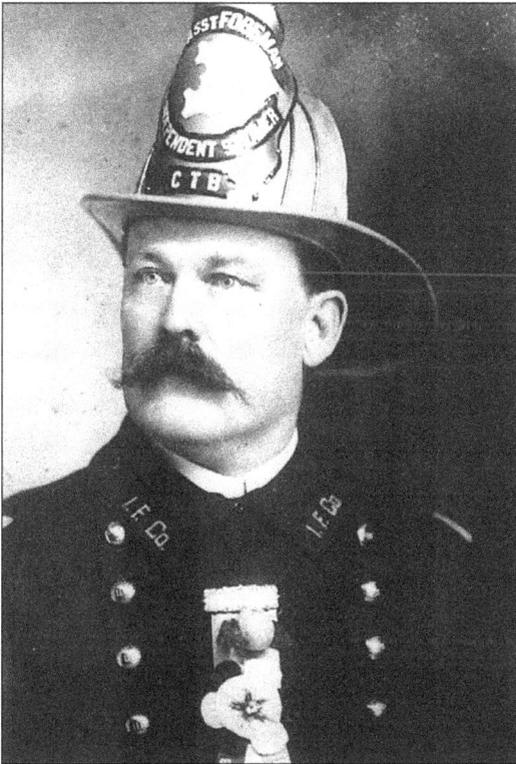

CHARLES T. BLAND. With ties to Portsmouth baseball from its infancy, Charles T. Bland was considered by many as the inspiration for the game in the city. Bland first served as part-owner of the Portsmouth Browns of the Virginia-North Carolina League in 1901 before the team relocated south at midseason. Repeated attempts to find a league to accept his Portsmouth team proved unsuccessful and, in 1906, Bland helped re-establish the old Virginia League with the Truckers as charter members. The charismatic Bland, shown in the uniform of an Assistant Foreman of Portsmouth's Independent Fire Company, sold his interests in the ball club when he was elected to the position of Commonwealth Attorney for the city in 1909. (From the family archives of Mrs. Charles Cross.)

11

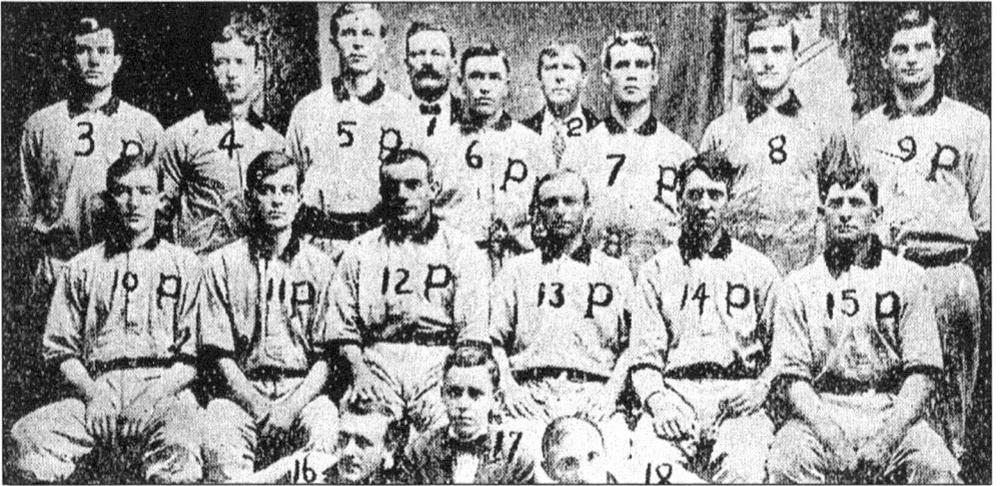

THE PORTSMOUTH TRUCKERS OF THE VIRGINIA LEAGUE, 1908. This team photograph, which appeared in the *Reach Official American League Guide* for 1909, features the Portsmouth Truckers sporting their distinctive uniforms. The team compiled a record of 57 wins against 71 losses, positioning them well behind the pennant winning Richmond Colts. The following are pictured from left to right: (front row) Schraeder, M. Bland (mascot), and Billett; (middle row) Smith, Wadleigh, Toner, Andy Lawrence (manager), Hilbert, and Guadinger; (back row) Hamilton, Hannifan, Brennan, Charles T. Bland (owner), Vail, Hoofnagle, Gushlen, Buckley, and Hallman. (CSTG.)

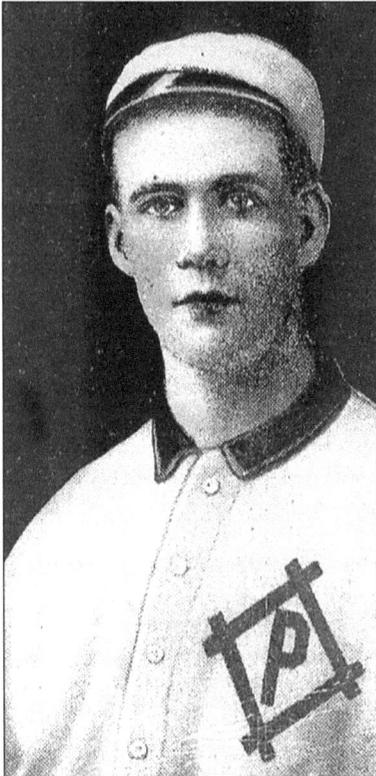

THOMAS GUIHEEN, 1908–1910. This early 20th century tobacco card shows the image of Thomas Guiheen, second baseman for the Portsmouth Truckers of the Virginia League. Guiheen was signed by owner Charles Bland during the 1908 season and appeared in 80 games while posting a respectable .259 batting average. The following season he replaced Maurice White as manager of the squad and continued to serve in his regular role as starting second sacker for the team. Despite the managerial change, the Truckers finished well back in the league's second division with a disappointing 49-72 record. Guiheen began his third season with Portsmouth in 1910, but was informed on July 5 that the team would pull up stakes from their Elizabeth River home and relocate to Petersburg to become the Trunkmakers. With much of the old Portsmouth team still on its roster, the Petersburg nine, including Thomas Guiheen, won the championship trophy for the 1911 Virginia League season. (CSTG.)

# Portsmouth Base Ball Club, Inc.

Portsmouth, Va.

April 25th 1919.

Mr. Powell.

Pitcher U.N.C. Base Ball Club.

Chapel Hill N.C.

Dear Sir-;

I understand that this is your last year at College and would like to know if you anticipate playing ball this Summer. If you do think I can make you as good offer as you can find. If you will consider playing in the Virginia League and playing with the Portsmouth Club let me know also what you will sign a contract for. I would like to get hold of a couple of Pitchers and as you have been recommended to me very highly would like to talk business with you in the event you play professional ball.

Yours very truly.

*H.P. Dawson*

Vice-President.

A PROPOSAL FOR A PROSPECT. In the spring of 1919, with his college education coming to an end, University of North Carolina pitcher Jack Powell received the above letter in the mail at his residence in Chapel Hill. The document, dated April 25, 1919, originated from the desk of club Vice President H.P. Dawson. The Portsmouth administrator extended an invitation to discuss salary and the prospect of the young pitcher to sign a contract with the Truckers for the upcoming Virginia League season. Despite the offer, the celebrated North Carolina pitcher, does not show up in any of the yearly league statistical guides following the season. It must be assumed that the young Jack Powell thought it best to pursue other career goals away from the diamond. (CSTG.)

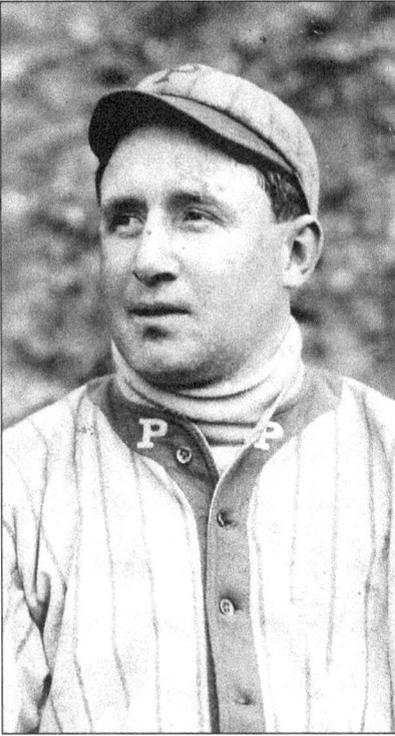

**JIMMY VIOX, 1920–1922.** James Henry Viox spent his entire short-lived major league career with the Pittsburgh Pirates of the National League. From 1912 through 1916, he was the starting second baseman for the Bucs and found himself playing on the Steel City infield alongside legendary third baseman Honus Wagner. Following his career with the Pirates, Viox bounced around the minors for a number of seasons until Frank D. Lawrence signed him as player-manager for the Truckers. Despite his slight build and short stature, Viox proved to be a powerful and inspirational skipper for his players both on and off the field. As left fielder for the Truckers, Viox captured the Virginia League batting title in 1921, averaging .370 from the plate while slugging 12 homeruns and stealing 33 bases. His managerial talents were just as impressive as he guided Portsmouth to postseason pennants in 1920 and 1921. (CSTG.)

**"PIE" TRAYNOR, 1920.** Harold Joseph "Pie" Traynor first stepped to the plate on Friday, May 14, 1920, as the starting shortstop for the Portsmouth Truckers, managing only one hit in four at bats. Despite the fact that Traynor would go on to an illustrious major league career and a lifetime .320 average, the 1920 season in Portsmouth was one of the few years in which his average dipped below .275. While searching for his swing, the 19-year old prospect proved to be a solid defensive shortstop, leading the Portsmouth nine to the second half season Virginia League title. Before postseason playoffs began, several major league teams showed interest in purchasing the young infielder and Portsmouth owner Frank D. Lawrence quickly sold the Trucker shortstop in the final days of the season. As one of the all-time great infielders and hitters of the game, Pie Traynor earned a well-deserved induction into baseball's Hall of Fame in 1948. (National Baseball Hall of Fame.)

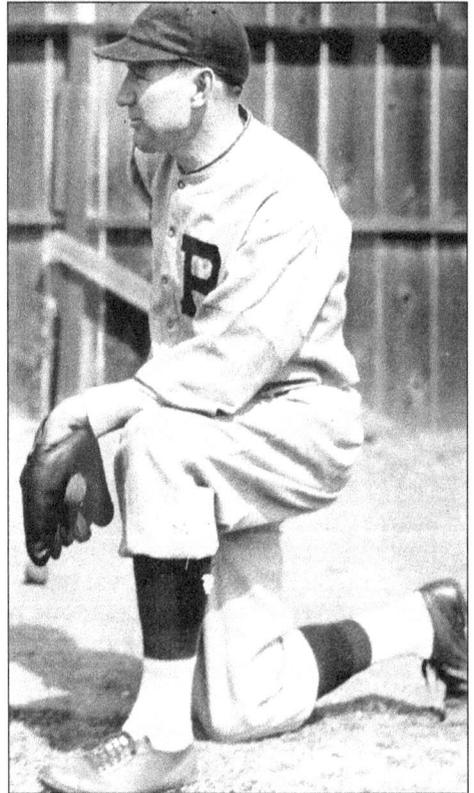

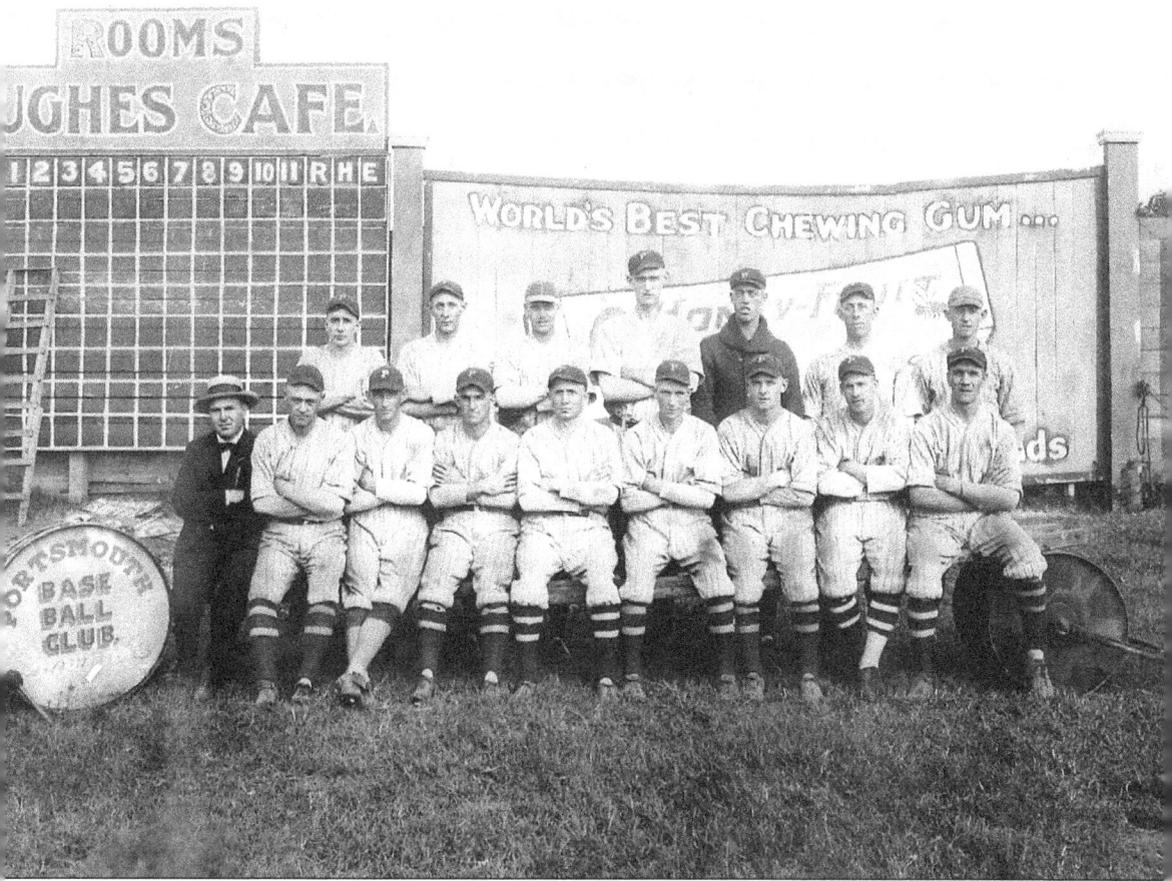

**THE PORTSMOUTH TRUCKERS, CHAMPS OF THE VIRGINIA LEAGUE, 1920.** On a bright fall day within the confines of the city ballpark, the Portsmouth baseball team poses for its annual photograph just before the start of the postseason playoff series against the Richmond Colts. The image shows the scoreboard with the names of the two teams displayed along with a variety of local business advertisements painted on the outfield walls. Interestingly, the bass drum used by the "Trucker Jazz Band," a small musical troupe that performed at the ballpark, is sitting alongside the players. While the team was skippered by former Pittsburgh Pirate infielder Jimmy Viox, the player that is most remembered for his time spent with the 1920 Truckers proved to be future Hall of Famer Harold "Pie" Traynor. One of the best infielders of all time, Traynor was discovered by fellow Trucker teammate Les Bangs when the two played together in a semi-pro league in the Boston area. By the time this photo was taken, "Pie" was in a Pittsburgh Pirate uniform, having been sold to the National League club at the end of the regular season. Behind the exceptional pitching of Sam Post, the Truckers wrestled the Virginia League trophy from the Colts in an exciting postseason series. In the photograph above the players and staff are identified from left to right: (front row) H.P. Dawson, co-owner; Harry Champlin, shortstop; Ed Winston, outfield; Howard Mallone, outfield; Jimmy Viox, manager; Ed Goosetree, third base; Allie Watt, second base; Les Bangs, outfield; and Frank Rooney, first base; (back row) Dixie Parker, catcher; Otto Greenea, catcher; Leo Mangum, pitcher; Bill McGlouglin, pitcher; Sam Post, pitcher; Jake Fromholtz, pitcher; and Rube Benton, pitcher. (PPL.)

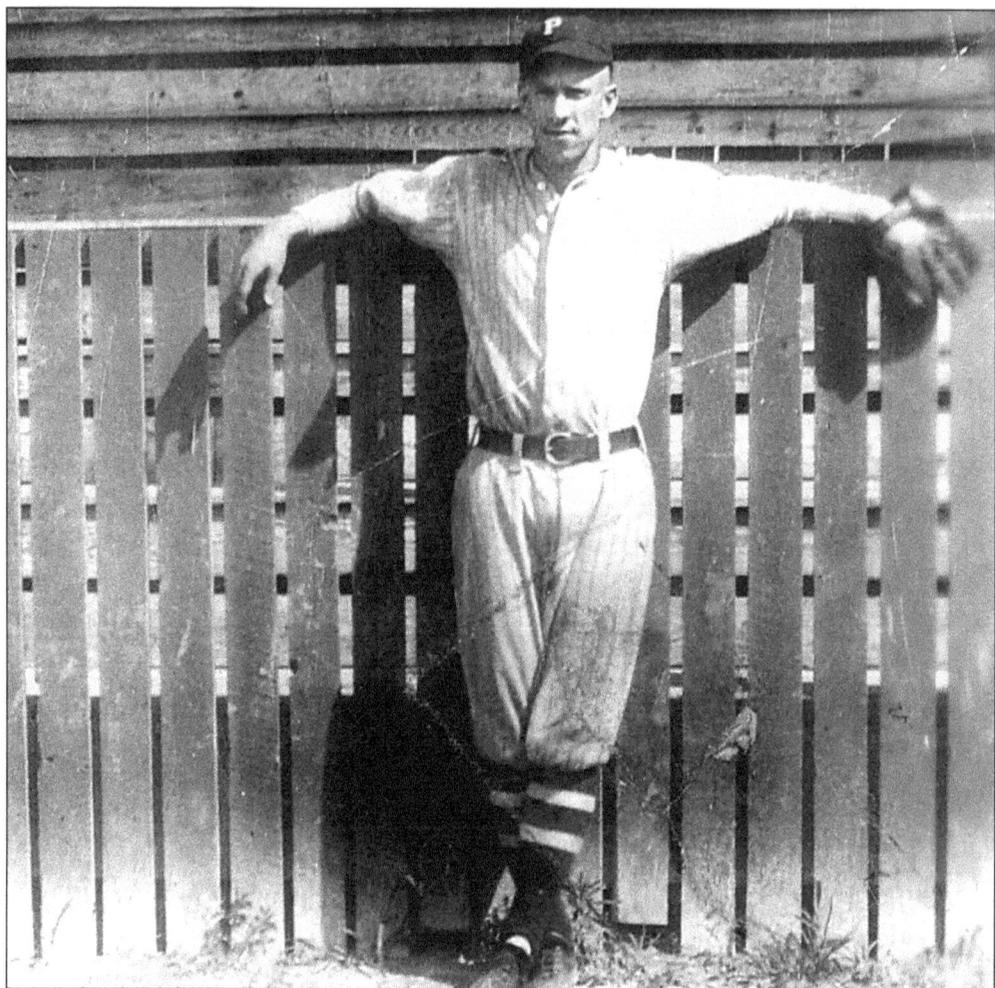

**LES BANGS OF THE PORTSMOUTH TRUCKERS, 1919–1926.** Pictured here in a casual pose in front of the High Street Park spectator fence is Les Bangs, Sr. As a youngster, Bangs first played organized ball in the Boston area with a number of semi-pro teams and by the age of 20 earned a chance for a tryout with the Red Sox. While not signed with the major league club, Boston sent him on to Providence in the Eastern League where he suited up with none other than Babe Ruth for part of the 1914 season. Bangs continued to play professionally with Hagerstown of the Blue Ridge League before he was shipped overseas with the 29th Army Division. Upon his return to his hometown near Boston, Bangs came up with a novel scheme to get himself on the roster of Portsmouth's Virginia League team. He sent a telegram to team owner Frank D. Lawrence with the words "Terms Accepted" on the wire, when actually the Truckers had initiated no correspondence or shown any interest in his services. He followed up the telegram with another stating "Send transportation money immediately" and to his surprise the funds arrived the following day. The 25-year-old outfielder was signed to a contract by the Truckers and settled into his Norfolk home for the next eight seasons. The fleet-footed Bangs led the league three times in stolen bases and wielded a dangerous bat and reliable glove. In 1923, he gave up his outfield position to Portsmouth rookie phenom Hack Wilson but soon established himself as the team's starting third baseman. Truckers owner Frank D. Lawrence admired Bangs' optimism and enthusiasm for the game, naming him manager of the team in 1925 and again in 1926. (From the family archives of Joan B. Estienne.)

16

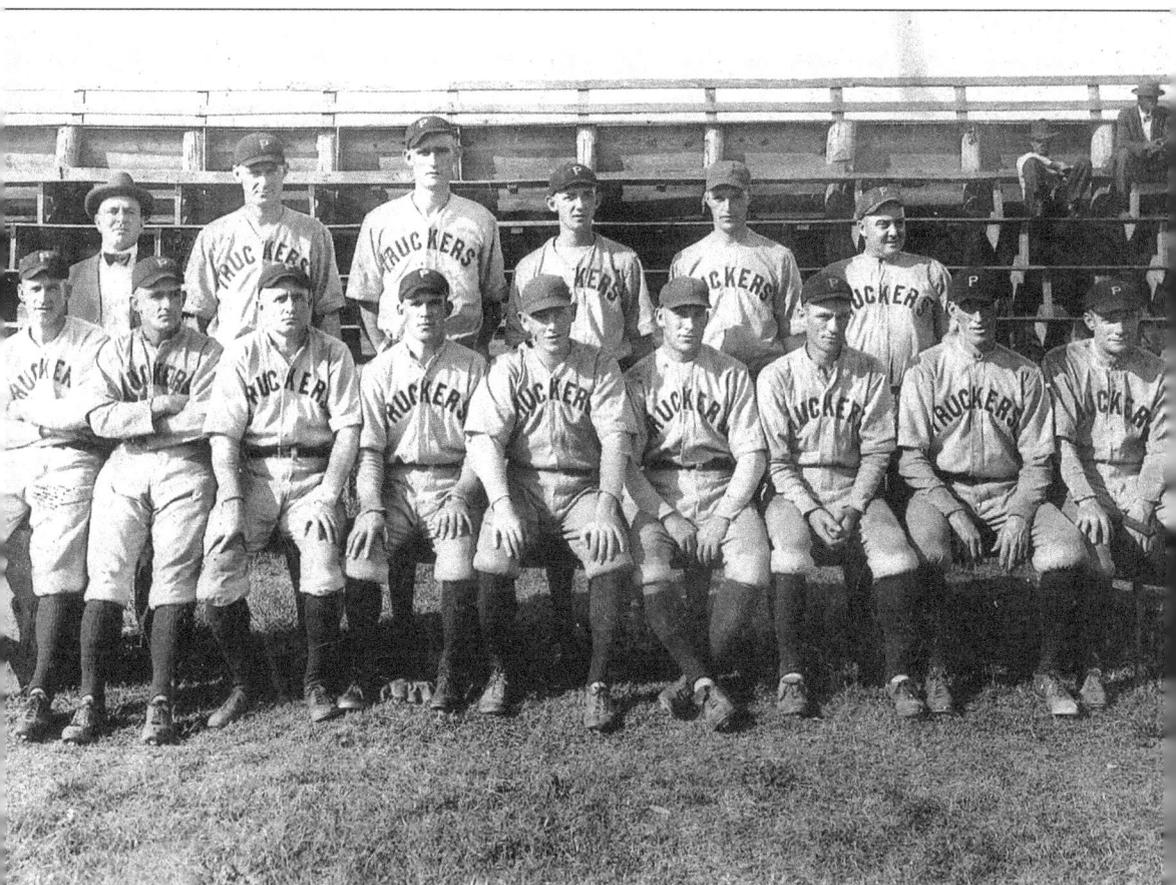

**THE PORTSMOUTH TRUCKERS, 1921.** The Portsmouth baseball club poses in front of the stands of the Washington Street ballpark as a few curious fans watch from the bleachers. The team was coming off a stunning victory in the 1920 postseason playoffs, topping the Richmond Colts for the league trophy. Player-manager Jimmy Viox found himself with several key players returning to the fold and was optimistic that the trophy would stay in the city. During the first half of the 1921 season, the Truckers kept pace with both the Wilson Bugs and the Rocky Mount Tar Heels only to drop to third place in the final days of the campaign. Before euphoria set in for the champion Tar Heels, baseball commissioner Kenesaw "Mountain" Landis was informed that both Wilson and Rocky Mount had exceeded the league's salary limit and he immediately eliminated the two violators from the race, thus handing the pennant to Portsmouth. The second half of the season was won by the Norfolk Tars with the Truckers a close second. In the postseason battle between the two champions of the split season, Portsmouth bested their cross- river rivals in four games of a five game series to capture their second Virginia League trophy in a row. Many of the players on the Portsmouth squad had banner years. Trucker manager Jimmy Viox led the league in hitting with a .370 average, while hurler William McGloughlin posted an impressive 25-8 record, and fellow pitcher Al Benton topped the circuit in strikeouts with 196. Pictured in the photo are (front row) Les "Shipwreck" Bangs, Mallone, Jimmy Viox, Minnie Manning, Kearns, Black, Ed Goosetree, Ray, and Gus Kellerman; (back row) club president H.P. Dawson, Ralph Ledbetter, William McGloughlin, Al Benton, McQuinn, and Jack Casey. (From the family archives of Joan B. Estienne.)

**HACK WILSON, VIRGINIA LEAGUE TRIPLE CROWN WINNER, 1923.** Lewis Robert "Hack" Wilson began his storied baseball career in 1921 as a catcher for the Martinsburg Mountaineers of the Class D Blue Ridge League. By his third professional season he found himself roaming the outfield in a Portsmouth Truckers uniform, as evidenced by this rare newspaper photograph taken during the 1923 season. The short, stocky Wilson, known as "Babe" to the Portsmouth fans, thoroughly dominated the league in almost all offensive categories and easily won the Triple Crown with a .388 batting average, 19 home runs, and 101 RBIs. At the end of season, with several major league offers on the table, Portsmouth owner Frank D. Lawrence offered Wilson's services to John McGraw's New York Giants for $25,000, but the National League club balked. McGraw stated he would never pay so much for a "bush league" player like Wilson. Lawrence, confident that his Triple Crown winner would make good in the majors, offered to take $5,000 cash and $1,000 for every point Wilson's batting average was over .300 as a New York Giant on July 1. Lawrence's eye for talent proved to be sharp as ever, when to everyone's surprise "Hack" was batting a nifty .371 when the month of July began. Needless to say, Lawrence never received the $71,000 as part of the "verbal" deal with McGraw. Wilson's major league career spanned from 1923 until 1934 as a member of several teams including the Giants, Cubs, and Dodgers. Known for his weakness with the bottle, his lifetime stats are still held in high esteem throughout baseball; especially the 190 RBIs he accumulated during the 1930 season with Chicago. Despite his enormous success on the diamond, Portsmouth's "Babe" died penniless and destitute at the age of 48. (PPL.)

**A Letter to Les, 1925.**
During the winter of 1925, Portsmouth Truckers owner Frank D. Lawrence had already announced to the media that his veteran outfielder, Les Bangs, would be managing the team for the upcoming season. In this correspondence to Bangs in January he discussed a number of pitching prospects that he was pursuing and hoping to sign for the season. The tone of the letter reflected Lawrence's unwavering optimism and outlook for the upcoming campaign. The letterhead originated from the American National Bank, which Lawrence founded, but continued to work at as cashier. He did not accept the position of bank president for another 20 years, finally taking formal control of the bank in 1943. (From the family archives of Joan B. Estienne.)

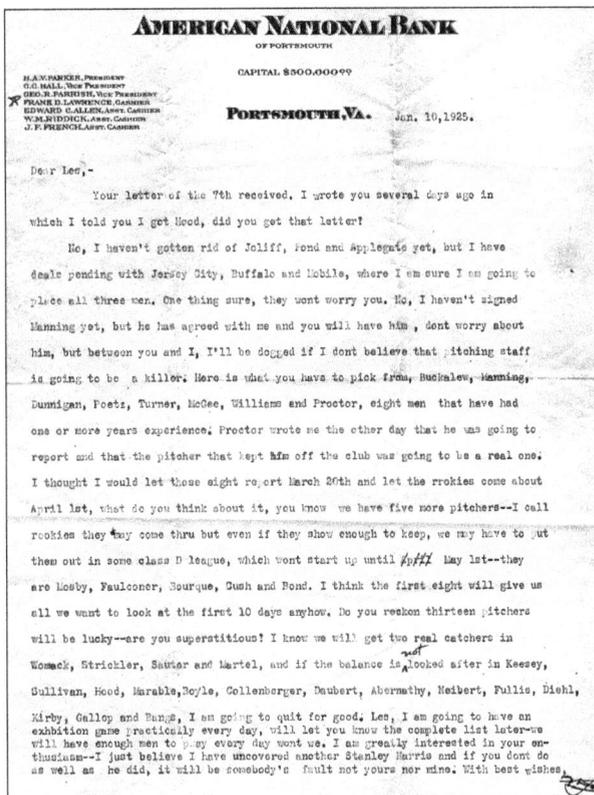

## AMERICAN NATIONAL BANK
### OF PORTSMOUTH

H.A.V. PARKER, President
G.C. HALL, Vice President
GEO. R. PARRISH, Vice President
FRANK D. LAWRENCE, Cashier
EDWARD C. ALLEN, Asst. Cashier
W.M. RIDDICK, Asst. Cashier
J. F. FRENCH, Asst. Cashier

CAPITAL $500,000.00

**PORTSMOUTH, VA.** Jan. 10, 1925.

Dear Les,-

Your letter of the 7th received. I wrote you several days ago in which I told you I got Hood, did you get that letter?

No, I haven't gotten rid of Joliff, Pond and Applegate yet, but I have deals pending with Jersey City, Buffalo and Mobile, where I am sure I am going to place all three men. One thing sure, they wont worry you. No, I haven't signed Manning yet, but he has agreed with me and you will have him, dont worry about him, but between you and I, I'll be dogged if I dont believe that pitching staff is going to be a killer. Here is what you have to pick from, Buckalew, Manning, Dunnigan, Foetz, Turner, McGee, Williams and Proctor, eight men that have had one or more years experience. Proctor wrote me the other day that he was going to report and that the pitcher that kept him off the club was going to be a real one. I thought I would let these eight report March 20th and let the rokies come about April 1st, what do you think about it, you know we have five more pitchers--I call rookies they may come thru but even if they show enough to keep, we may have to put them out in some class D league, which wont start up until May 1st--they are Mosby, Faulconer, Bourque, Gush and Bond. I think the first eight will give us all we want to look at the first 10 days anyhow. Do you reckon thirteen pitchers will be lucky--are you superstitious? I know we will get two real catchers in Womack, Strickler, Sautor and Martel, and if the balance is not looked after in Keesey, Sullivan, Hood, Marable, Boyle, Collenberger, Daubert, Abernathy, Meibert, Fullis, Diehl, Kirby, Gallop and Bangs, I am going to quit for good. Les, I am going to have an exhibition game practically every day, will let you know the complete list later--we will have enough men to play every day wont we. I am greatly interested in your enthusiasm--I just believe I have uncovered another Stanley Harris and if you dont do as well as he did, it will be somebody's fault not yours nor mine. With best wishes,

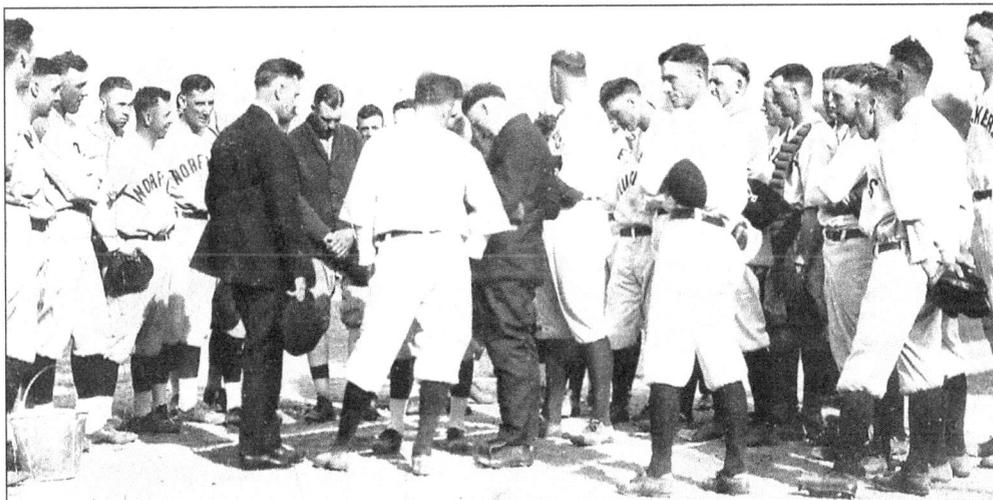

**A Baseball Blessing, 1925.** With players gathered around home plate, two Virginia League umpires offer a quick prayer before the opening day contest of the 1925 season. To the left are the ballplayers of the Norfolk Tars with their manager Dave Robertson wearing a sweater and bowing his head. On the opposite side of home plate, the Portsmouth Truckers gather as their newly appointed player-manager Les Bangs appears in the center of the photo with his back to the camera. Portsmouth ended the season with a 73-59 record, placing them in second place only 5 games behind the pennant winning Richmond Colts. (From the family archives of Joan B. Estienne.)

19

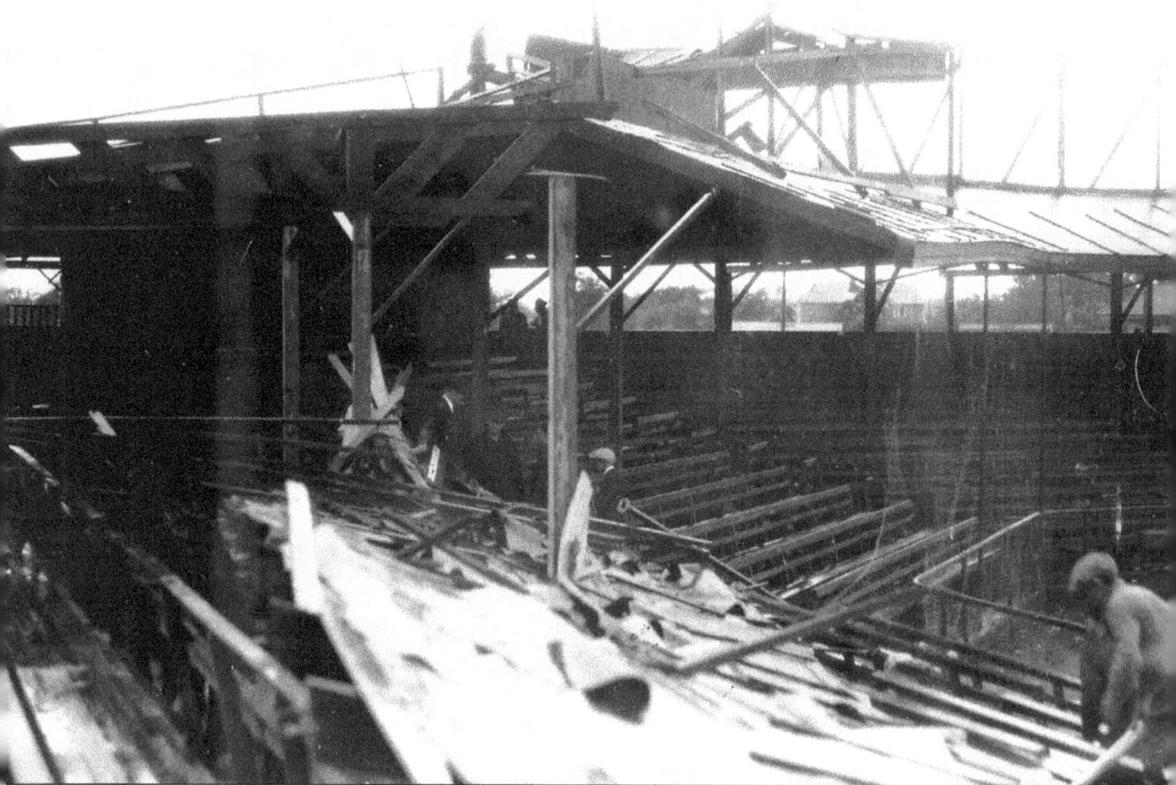

**A Day Not Soon to be Forgotten.** May 25, 1927, proved to be an eventful and horrifying day in the history of Portsmouth baseball. With the 1927 season in full swing, Commissioner Judge Kenesaw "Mountain" Landis accepted an invitation from Frank D. Lawrence to spend time in Portsmouth as a special guest of the Truckers. On the morning of the May 25, Landis paid a visit to the Navy Yard, played a round of golf, and attended a luncheon in his honor. At four o'clock in the afternoon he was scheduled to serve as guest of honor for a game between Portsmouth and the visiting Petersburg Broncos at High Street Park. Twenty minutes before the first pitch was to be thrown, Landis settled into his box seat alongside his host. Suddenly and without warning the wind escalated and a violent tornado slashed through the park as the commissioner and fans cowered in the aisles. The storm first tore apart the leftfield fence, showering large sections of the outfield wall onto the playing field among the players warming up on the diamond. As can be seen in this rare photo of the aftermath, much of the grandstand roof was torn from its trusses and crashed down on fans huddled near the commissioner. In only a matter of minutes the squall passed and an eerie quiet enveloped the park. Spectators, players, and police rushed to the aid of over 30 injured fans with one person discovered dead beneath fallen debris. Landis, in an article he penned for the Norfolk *Virginian-Pilot* the following day wrote, "Just a few feet away, I became a witness to the terrific destruction that endangered the lives and limbs of hundreds. I passed through the severest storm in my experience yesterday afternoon in the Portsmouth, Virginia League, baseball park." Later he was quoted as saying that whenever he found himself in windy, turbulent weather he thought of Portsmouth and his friend, Frank D. Lawrence. For Judge Landis, May 25, 1927, remained a day not soon to be forgotten. (CSTG.)

20

# PORTSMOUTH BASEBALL NOTES

Interesting facts about the game in Portsmouth's early baseball history

- During the final days of the 1900 season, Portsmouth Pirates manager Win Clark hired a number of local youngsters to hawk bags of peanuts at League Park. One of the boys that accepted the job later established himself as the most important and influential individual in the long and storied history of baseball in Portsmouth: Frank D. Lawrence.
- Upon entering the Virginia League in 1906, the management of the Portsmouth baseball team decided to award season tickets to the persons selecting the most acceptable name for its new team and ballpark. During the contest, over 150 names were suggested including the Patriots, Slipknots, Dingbats, Skippers, Redskins, and the Navy Beans. Despite the myriad of interesting names offered by the fans, the ball club resurrected the tag Truckers, which was accepted and formally stitched onto their jerseys. The name of the new field was labeled Portsmouth Athletic Park.
- Despite an optimistic outlook, the 1906 season began with the Portsmouth baseball team in turmoil with owner Charles Bland less than patient with the situation. After only four games, skipper E.C. Landgraf was fired and replaced by Tom Reynolds. The new manager lasted three weeks as his team only posted a dismal 4-14 record. Unsatisfied with the team's progress, Bland fired Reynolds and named Barley Kain as his replacement. The change made little difference for the Truckers as they finished the season in fifth place, just ahead of cellar-dwelling Roanoke in the standings.
- With the opening of the new ballpark in 1906, owner Charles Bland encountered an unexpected problem that would warrant police intervention. After the first game of the season, Bland discovered that holes had been cut into the outfield fences to allow penny-pinching fans to watch the game without paying admission. The culprits, known as "crack rooters," were apprehended after Bland hired two detectives to stake out the fence during the following game. Once nabbed, the fans were arrested, carted off to jail, and fined five dollars each for defacing property.
- Longtime Portsmouth Trucker Les Bangs was tagged with an interesting nickname: "Shipwreck." On his journey south from Baltimore to Hampton Roads to begin play with the Portsmouth Truckers for the 1919 season, Bangs was a passenger on board the steamer *Virginia* that caught fire and sank in the middle of the Chesapeake Bay. He and the other survivors saved themselves by jumping overboard and were rescued from the frigid water. Bangs arrived in Portsmouth with nothing more than the shirt and pants he wore when he escaped with his life. The harrowing story made news in the local papers and his appearance with the Truckers drew a number of curious fans to the ballpark. As Bangs strode to the plate for his first appearance of the season, a fan called from the bleachers of Washington Street Park, "Put some wood on it, Shipwreck." The name stuck and throughout his career he was forever referred to as Les "Shipwreck" Bangs.
- While with the Truckers in 1923, future Hall of Famer Lewis "Hack" Wilson was referred to as "Babe" by local fans in reference to George Herman "Babe" Ruth, the legendary New York Yankees slugger. Wilson earned the nickname "Hack" later in his playing career while with the New York Giants because of his resemblance to a famous wrestler of the day, George Hackenschmidt. Wilson's body type proved to be an enigma. Weighing 190 pounds and standing a short 5-feet 6-inches, he took on the characteristics of a fireplug. Hack appeared to have little or no neck topping his broad shoulders and muscular arms, however his most unique feature was his feet. Despite his fullback-like body dimensions, Wilson's feet were tiny. He wore a size six shoe.

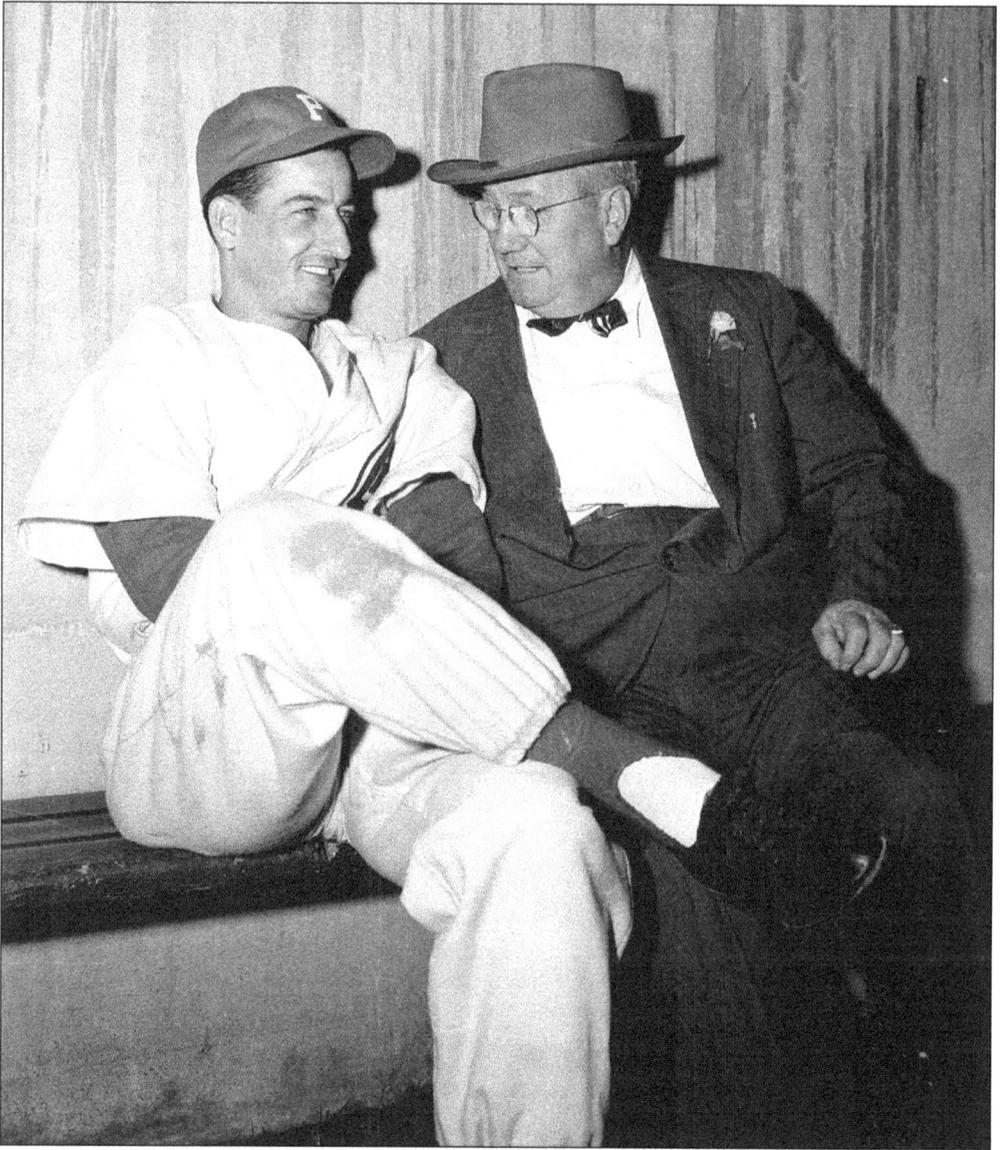

**DUGOUT DIALOGUE, 1951.** Following the Cubs' championship season in 1950, owner Frank D. Lawrence promoted one of his favorite players, Cuban Reggie Otero, to skipper the team for the new campaign. Lawrence had a real admiration for the Cubans he signed to play in Portsmouth. Otero, with contacts well-established in the professional baseball leagues in the Caribbean, funneled many top players to the Cubs over the years. The Portsmouth owner was always personally involved with his team and was often found mingling with the players in the dugout and locker room on a regular basis. He was famous for his inspiring pep talks and always exuded a paternal passion for the game and his players. Portsmouth fans will remember Frank D. Lawrence as a respected banker with a profound love of baseball, while his players will fondly recall his eternal optimism and fairness in their treatment. (PPL.)

# Two

# Frank D. Lawrence
# Portsmouth's "Mr. Baseball"

When the topic of Portsmouth baseball is discussed, there is one name, and one name only, that is synonymous with the history of the game in the city: Frank D. Lawrence. For nearly 50 years, this garrulous, colorful, and benevolent icon of the community played an active and pivotal role in the day-to-day operations of baseball in Portsmouth, Virginia.

Frank Dudley Lawrence's life story reads like a Horatio Alger novel. Born March 15, 1891, Lawrence was the son of a man who owned and operated a small grocery store in the Park View section of the city while raising his family on a modest income. Young Frank was soon observed to take on the ambitious characteristics of his father and by the age of nine secured a job as a hawker of peanuts at old League Park, home of the Portsmouth Pirates of the Virginia League. His eventual life-long love of baseball was surely ignited watching the likes of Portsmouth slugger Jim Murray sending towering shots over the wooden slats of the ballpark or a young Christy Mathewson toiling on the mound as the Norfolk Mary Janes challenged his beloved Pirates. Seven years later, the enterprising teen-ager took over the concession sales at the stadium, earning a profit of $300 by the end of the season, while continuing to work as a part-time sports reporter for the local paper, the Portsmouth-Star.

Upon graduation from Portsmouth High School in 1907, Lawrence began his financial career at the ground floor as a $5-a-week runner for Merchant and Farmer's Bank. The young Lawrence quickly worked his way through the ranks to clerk, bookkeeper, and a temporary position as the bank's teller. Upon settling into to his new job at the bank he approached the president for a raise and a permanent role with the institution, but was rebuffed. Instead of returning to his teller position, he submitted his resignation and canvassed the community, selling $250,000 in capital stock, thus organizing a new financial institution in Portsmouth, the American National Bank. As founder of the new bank, the 27-year-old Lawrence wisely refused to take the prestigious position of president, instead appointing a local civic leader to fill the role and continued to service the institution as a teller. He did not assume the position of president of his own bank for another 25 years. Upon his retirement in 1959, the bank had a net value of $25,000,000.

As a young man, Lawrence continued to play a minor administrative role with the Portsmouth baseball team as they struggled to remain solvent in the Virginia League. In 1913, with the team losing money and on the verge of folding, Lawrence organized a corporation by selling stock for $25 a share and took over operations of the club. At the time, baseball was a risky business venture and as the impact of World War I affected the economy across America, many leagues folded. With his frugal business approach, Lawrence kept baseball in Portsmouth alive and eventually brought the city its first championship in 1920.

Despite the fact that Frank D. Lawrence's on-field baseball experience was limited to the sandlots as a youth, he displayed an uncanny knack for spotting raw talent. From as early as 1920, when Law-

23

rence contracted the services of a novice infielder by the name of Harold "Pie" Traynor, to the final days of the Piedmont League and his discovery of pitcher Brooks Lawrence, he unearthed enough "diamonds in the rough" to fill a major league All-Star team. A few of the other notables that began their baseball careers in Portsmouth include Bill Nicholson, Eddie Stanky, Harry "The Cat" Breechen, and slugger Hack Wilson.

The Virginia League continued to stagger through the 1920s as Lawrence fielded a number of winning teams with excellent seasons in 1920, 1921, 1924, 1925, and 1927. The Portsmouth franchise had a reputation as tough competitors on the diamond with sound management in the front office. It was during this era that Frank D. Lawrence began his unrelenting campaign to challenge Portsmouth's Blue Law and overturn the interdiction to play baseball on Sunday. Exasperated and repulsed by his numerous requests for the lifting of the ban, Lawrence decided to build a new stadium, High Street Park, just outside the city limits in Norfolk County where the restrictions on Sunday baseball were not enforced. The plan proved successful; however, the league lasted only until the early days of the 1928 season before folding, leaving Lawrence with almost $26,000 of debt. Being a respected banker and one that stressed financial responsibility, he paid all liabilities out of his own pocket by procuring personal loans and mortgaging his home. Bitter and disillusioned with the game, he vowed that he would never return to baseball.

By 1934, the historic Piedmont League had moved into the area and set up shop across the Elizabeth River in Norfolk. The following season Lawrence convinced the league, over the objections of the Norfolk Tars and their parent club the New York Yankees, to grant him a franchise. The heated battle over New York's concern with allowing a rival team in such close proximity to Norfolk was well-documented in the local papers. As he often did, Lawrence seemed to fan the fires of discontent by announcing that he would continue to battle the still intact Blue Law restricting Sunday baseball in the city and begin to play night games under the arcs once his team was in place. The New York franchise finally acquiesced with night baseball but demanded 50% of Portsmouth's gate receipts when they played at Sewanee Stadium. Lawrence, nicknamed "The Battler" by local sports writer W.N. Cox for his "David vs. Goliath" feud with the mighty Yankee organization, smugly accepted the compromise and opened the gates of the ballpark to the baseball-starved fans of Portsmouth.

From its inaugural season in the Piedmont, until the final days of the league in 1955, Portsmouth fielded a competitive and first-class team. One of only a handful of truly independent owners in the minors, Frank D. Lawrence became known throughout the country for the manner in which he handled his baseball operation. For his accomplishments, he was named by The Sporting News as "Minor League Executive of the Year" for 1943.

In 1949, at the height of minor league baseball's golden era, the usually optimistic Lawrence prophesized that the system was headed for trouble. He predicted that as the popularity of major league baseball broadcasts on radio and TV grew, fans would ultimately choose to stay home rather than visit a minor league ballpark for entertainment. Many administrators at both the major league and minor league levels viewed him as a humorless cynic regarding the future of the game, especially during such a robust period of baseball. True to his word, in less than a decade the game at the grass roots level was truly in jeopardy. Lawrence sued major league baseball for infringement into his territory via broadcasts and the case advanced to the Supreme Court before it was dismissed. By the time the final ruling was read, Portsmouth and the rest of the Piedmont League was history.

In 1961, a new era of baseball arrived in Portsmouth with the Tidewater Tides and Lawrence provided his services to the franchise pro bono as an executive consultant. In a fitting tribute, the city renamed the ballpark "Frank D. Lawrence Stadium" in 1964. On January 15, 1966, Portsmouth's "Mr. Baseball" fell ill and passed away. The local papers were filled with tributes to the benevolent banker and civic leader who dedicated his life to preserving baseball in the city for almost 50 years. Well before his death, Lawrence personally selected a plot within Evergreen Memorial Park as the imminent site of his internment. Fittingly, the simple marker that bears his name sits directly upon the spot where home plate was once located at the old High Street baseball park.

A BENEVOLENT ACHIEVER. This vintage photo of Frank D. Lawrence shows the young banker at the age of 29. The image was featured in a souvenir book showcasing members of the Portsmouth Kiwanis, a group Lawrence organized in 1919. The ambitious civic-minded Lawrence dabbled in politics and staged an unsuccessful bid for the state senate in 1920 but later served with distinction on the Portsmouth City Council for more than decade. Known as a shrewd banker and community leader, Lawrence was more than willing to give his time, money, and effort to help others in need. He spearheaded a personal campaign to rid King's Daughters Hospital of debt as well as conducted a virtual one-man drive to gather over $1 million for the city's Community Chest from 1942 to 1949. (From the family archives of John Wesley Lawrence.)

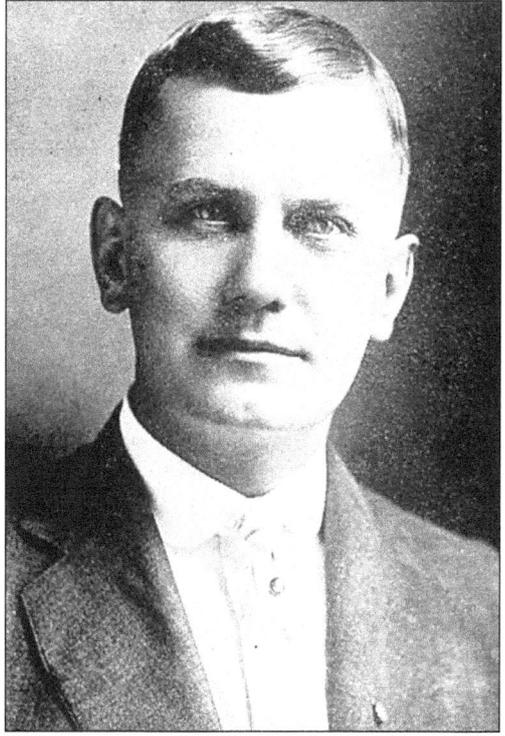

TESTIMONIAL DINNER

IN HONOR OF

FRANK D. LAWRENCE

PORTSMOUTH, VA.

WEDNESDAY EVENING, MARCH 27, 1935

7:00 O'CLOCK

PORTSMOUTH COUNTRY CLUB

*(Sing to tune of "What's the Matter With Father")*

We are going to have baseball,
Rah! Rah! Rah!
Frank is giving us baseball,
Sis! Boom! Bah!
We're as happy as can be,
The reason's as simple as A-B-C,
Lawrence is giving us baseball,
Rah! Rah! Rah!

FRANK D. LAWRENCE TRIBUTE. On the evening of Wednesday, March 27, 1935, the city of Portsmouth held a special tribute dinner for local banker and baseball icon, Frank D. Lawrence. The elaborate affair, staged at the Portsmouth Country Club, was attended by 250 well-wishers including Dan Hill, President of the Piedmont League. Many in the local community felt that Lawrence would never return to baseball after the personal losses he suffered when the Virginia League folded on June 3, 1928. Despite having to personally cover the team's debts and payroll, which he did by mortgaging his home, Lawrence renewed his interest on the diamond and obtained a franchise in the historic Piedmont League for the 1935 season. For seven long years Portsmouth had been without baseball and the lyrics printed on the cover of this program show how the city appreciated their local banker for trying his hand again in the business of the national pastime. (CSTG.)

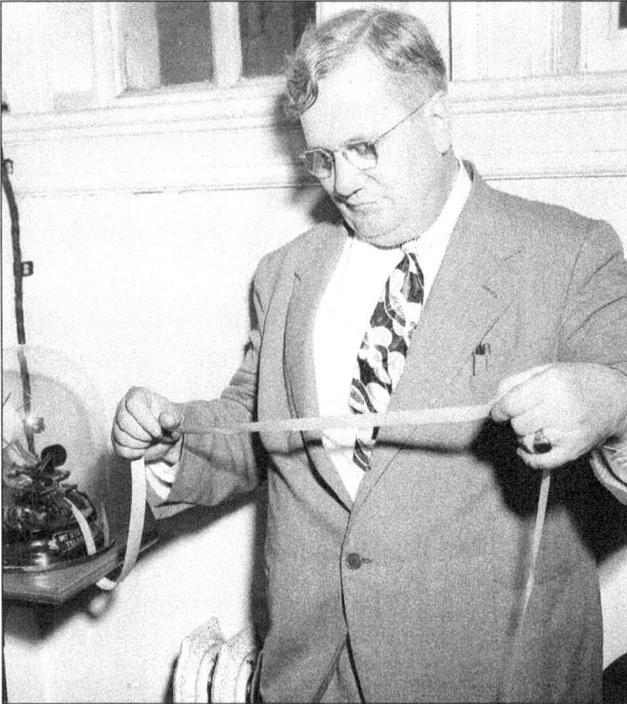

**TALE OF THE TAPE, 1943.** One of the daily habits of Frank D. Lawrence as President of the American National Bank was checking the ticker tape regarding financial news and events. To no one's surprise, many of his closest friends knew that Lawrence tended to use the tape more often in checking the progress of his beloved Cubs while on the road. Here he is probably making sure that manager Milt Stock and his Cubs were continuing their winning ways while on their way to the 1943 Piedmont League pennant. (PPL.)

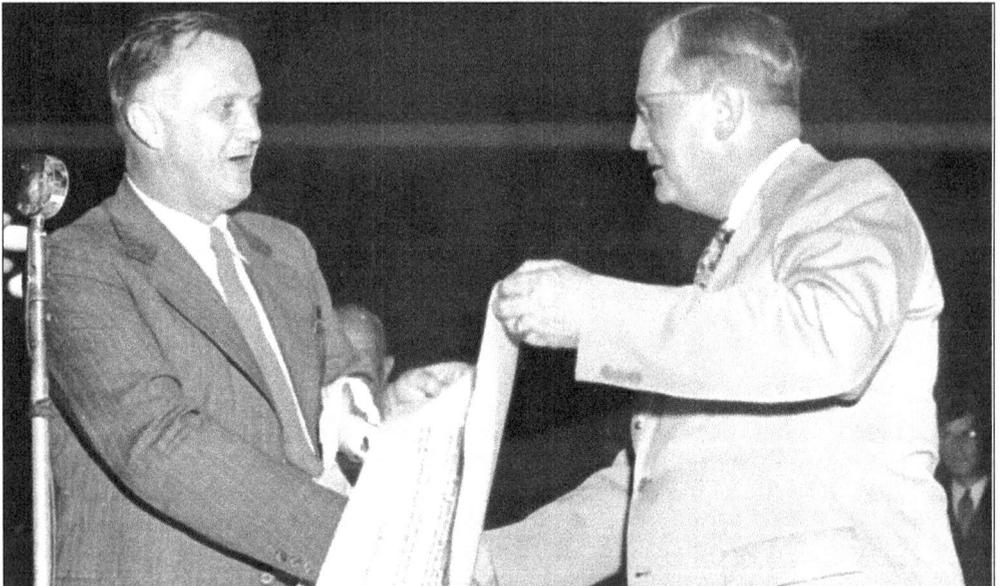

**FRANK D. LAWRENCE, MINOR LEAGUE EXECUTIVE OF THE YEAR, 1943.** Over 7,000 fans filled Portsmouth Stadium on Thursday, June 15, 1944, to pay tribute to Frank D. Lawrence in a night filled with festivities as he was honored as the "Minor League Executive of the Year" by *The Sporting News*. Shown above in the presentation of the scroll to Lawrence is Virginia governor Colgate Darden (left). The citation reads: "To Frank D. Lawrence, president of the Portsmouth Cubs, cited by *The Sporting News* as the No. 1 minor league executive in the United States, in winning Portsmouth its first flag in 17 years and for service rendered to his community." (NPL.)

# BASEBALL

**ALBERT B. CHANDLER**
COMMISSIONER

**WALTER W. MULBRY**
SECRETARY-TREASURER

**HEROLD D. RUEL**
ECIAL ASSISTANT TO THE COMMISSIONER

12 June 1947

CAREW TOWER
CINCINNATI

Mr. Abe Goldblatt
Norfolk Virginian Pilot
Norfolk, Virginia

My dear Abe:

      In reply to your telegram of 11 June, let me
say that I am coming to Portsmouth to pay tribute to
Frank Lawrence on the occasion of his 40th anniversary
in Baseball and Banking. I wish sincerely that all of
the clubs in the Piedmont League would join me on this
occasion by sending representatives or messages to ex-
press appreciation of Frank Lawrence's fine service to
Baseball.

      With good wishes, I am

           Cordially yours,

           Albert B. Chandler

CELEBRATING 40 YEARS OF SERVICE. Monday, June 16, 1947, was a day of celebration throughout the city of Portsmouth as dignitaries, fans, and friends honored Frank D. Lawrence for his 40th year in banking and baseball. Major League baseball commissioner Happy Chandler confirmed his attendance with a letter (shown above) mailed to local sports writer Abe Goldblatt and served as keynote speaker for a luncheon at the Hotel Portsmouth. The brochure pictured to the left was distributed to all attendees and highlighted the life and accomplishments of Portsmouth's beloved baseball guru and banker. The all-day celebration culminated with a Piedmont League game at the stadium featuring the hometown Cubs and the visiting Richmond Colts. On the night of the game the benevolent owner threw open the gates at Portsmouth Stadium and admitted all fans free of charge. As expected, every available seat in the ballpark was taken as over 12,000 fans flocked to the contest. (CSTG.)

*40th Anniversary*
**BANKING and BASEBALL**
*1907-1947*

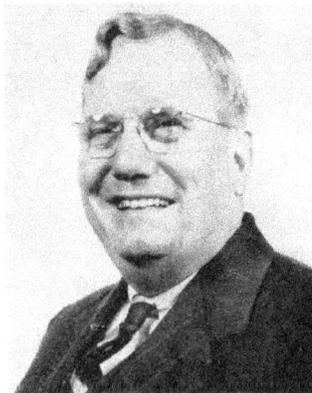

FRANK D. LAWRENCE
JUNE 16, 1947
HOTEL PORTSMOUTH—PORTSMOUTH STADIUM
PORTSMOUTH, VA.

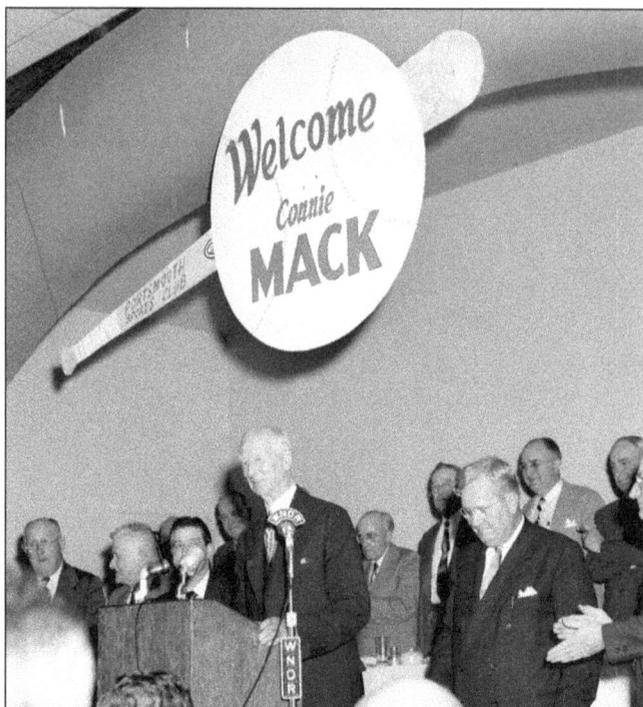

A WARM WELCOME FOR MACK. One of the many events planned by Cubs owner Frank D. Lawrence to honor the visit of Connie Mack and his Athletics to the city was a luncheon sponsored by the Portsmouth Sports Club. Shown at the podium is Mack as he acknowledges a standing ovation from the crowd at the Suburban Country Club. The event, held on May 16, 1949, drew 600 men, women, and children to see the legendary manager as he gave his opinion on the upcoming baseball season and the chances for his team in the American League. To the right of Mack, with head bowed, is host Frank D. Lawrence. (PPL.)

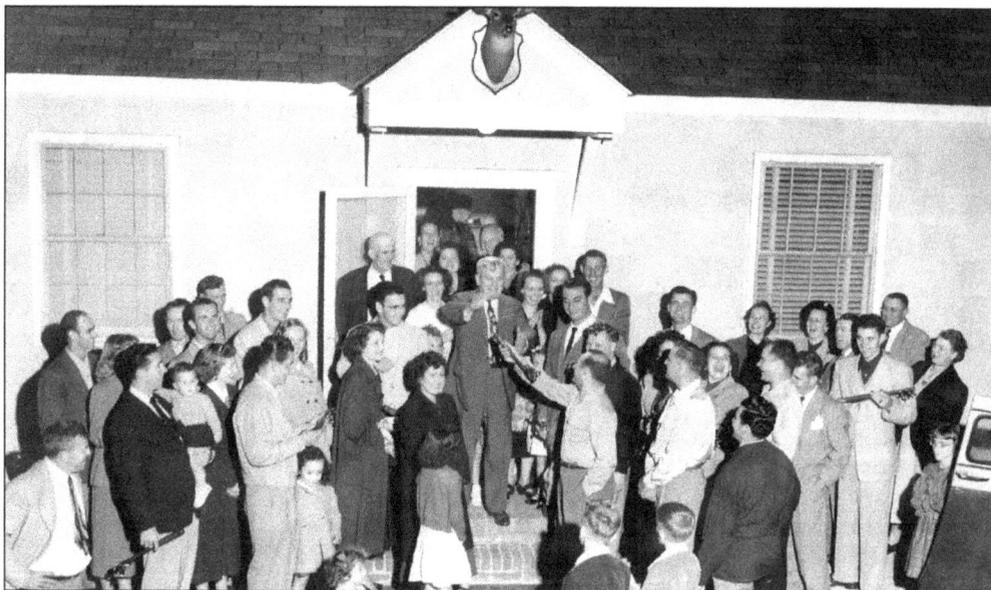

CELEBRATING THE CHAMPIONSHIP WITH THE BOSS, 1950. Shortly after capturing the 1950 Piedmont League championship by a slim margin over the Roanoke Red Sox, Cubs owner Frank D. Lawrence threw a special celebration dinner party for his baseball "family." Held at the local Elks Lodge, the owner catered the entire event and invited all the players and their families to a sit down dinner. Shown outside on a chilly fall evening is Lawrence (center) handing out specially inscribed miniature bats to all the players. At the foot of the stairs is manager Skeeter Scalzi toasting his boss and presenting a well-deserved bat in his honor. (From the family archives of Harry Land.)

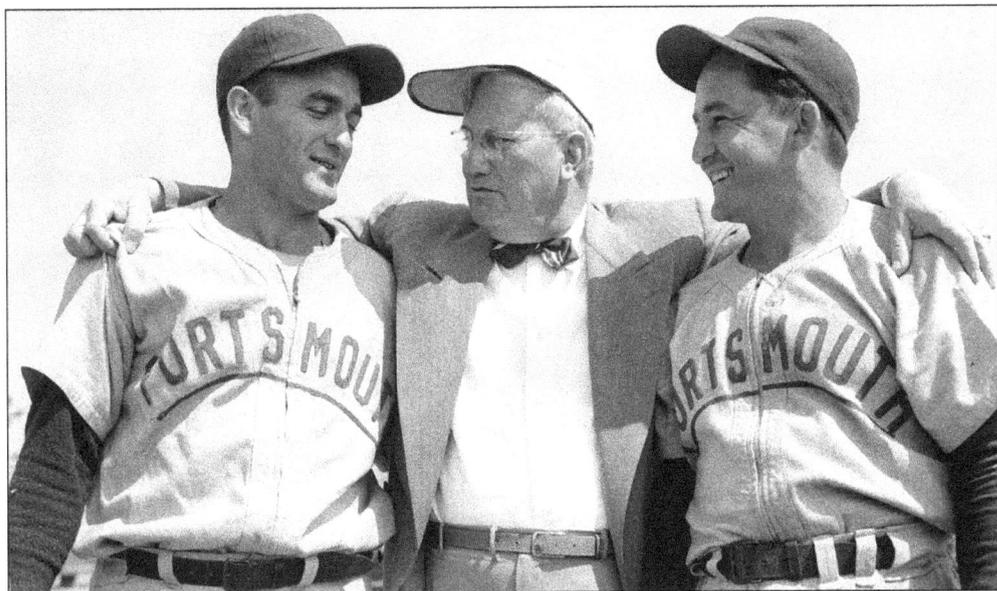

**FRANK D. LAWRENCE AND THE CUBAN CONNECTION, 1951.** Cubs' owner Frank D. Lawrence throws his arms around two of his Cuban players during spring training in Hollywood, Florida. Lawrence, a sound businessman and banker, had an uncanny eye for newfound talent and often signed and brought Cuban players to Portsmouth. Having player-manager Reggie Otero's Cuban connection didn't hurt the scouting and recruiting of new talent for the team. On the owner's right is catcher Ike Seaone and to his left is second baseman Frank "Cisco" Gallarado. Both Cubans earned starting positions for the Cubs in 1951. (PPL.)

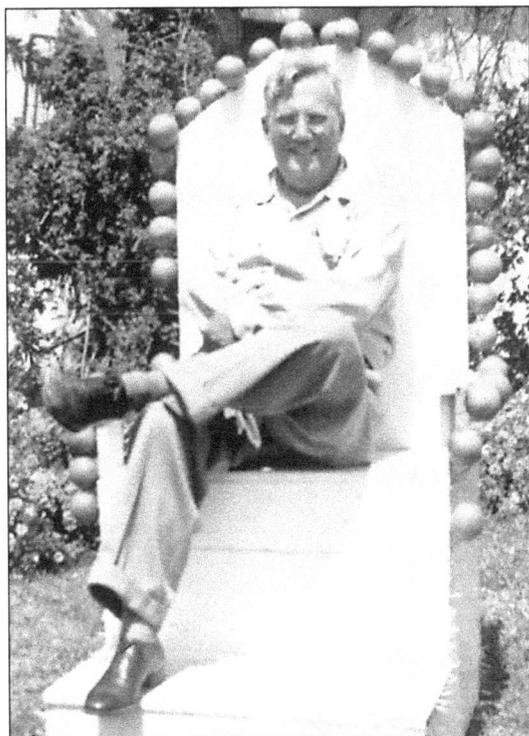

**GRAPEFRUIT LEAGUE KING, 1951.** Always the innovator, Frank D. Lawrence was the first minor league executive to pack up his entire team and send them thousands of miles south to train in the Florida sun alongside American and National League squads. This candid photo shows Lawrence in Hollywood, Florida, during the spring of 1951 gracing a throne bordered with ripening fruit, thus earning his well-deserved title of "Grapefruit League King of the Minors." (From the family archives of Harry Land.)

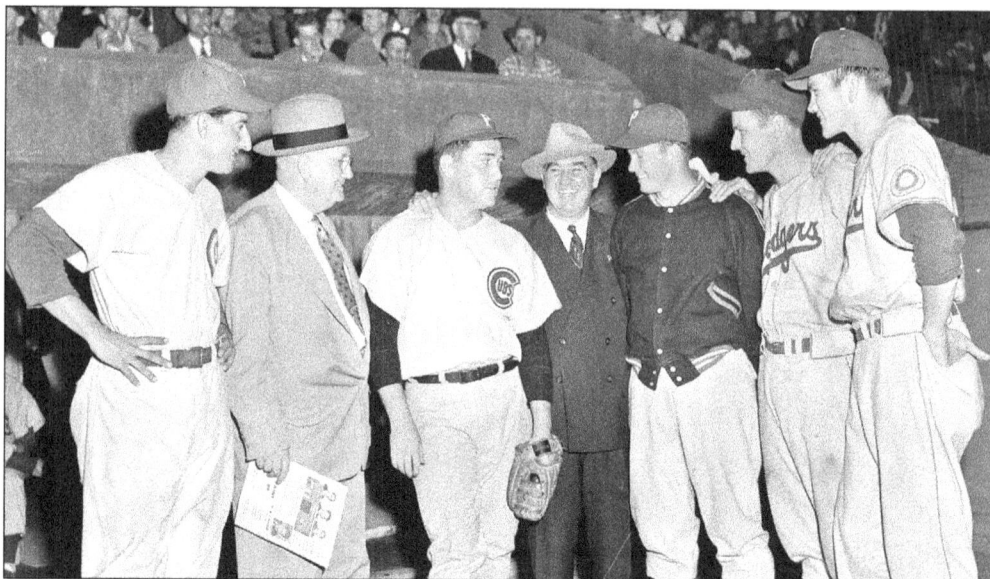

HAPPY CHANDLER RETURNS TO PORTSMOUTH, 1952. Cubs' owner Frank D. Lawrence had a special fondness for "Happy" Chandler (center) and invited the effervescent Kentuckian to visit the city a number of times. On May 17, 1952, the former Commissioner of Baseball and ex-governor of the Bluegrass State poses with Lawrence (second from left) while throwing his arms around fellow Kentucky natives Joe Weddington (to his right) and Bill Chambers (to his left) of the Cubs. Portsmouth manager Reggie Otero watches (far left) along with Newport News Dodgers manager Ray Hathaway (second from right) and Baby Bum pitcher Tom Bigham (far right). Chandler was in the area to speak to the sailors aboard the aircraft carrier Midway while celebrating Armed Forces Day. (PPL.)

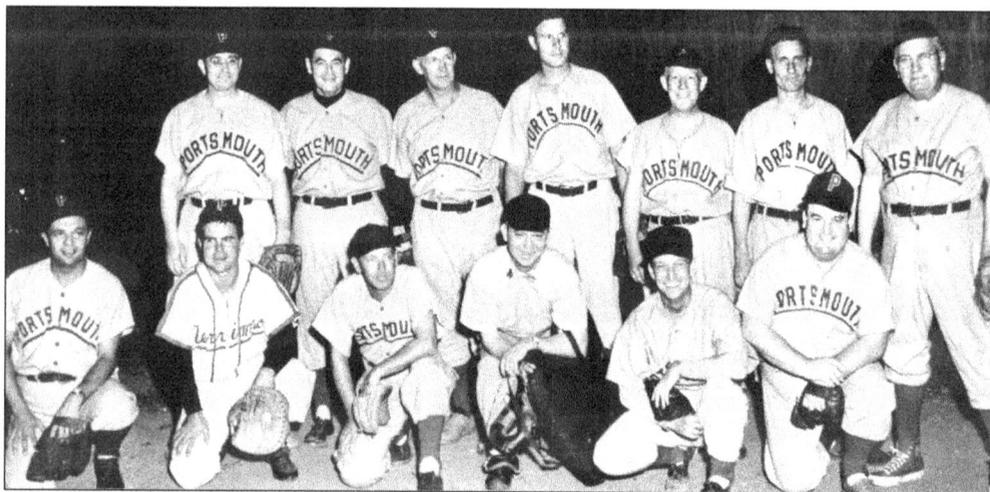

LOCAL BUSINESSMEN SUIT UP, 1953. Portsmouth Merrimacs owner Frank D. Lawrence (standing far right) arranged a pre-game contest at the ballpark that showcased some of the business and civic leaders that supported his efforts to keep baseball alive in the city. Here the group poses for the camera in the uniforms of the old Portsmouth Cubs. Merrimac catcher Harry Land (front row, second from left) served behind the plate for the game since none of the old timers volunteered to slip on the mask and padding for the contest. (From the family archives of Harry Land.)

30

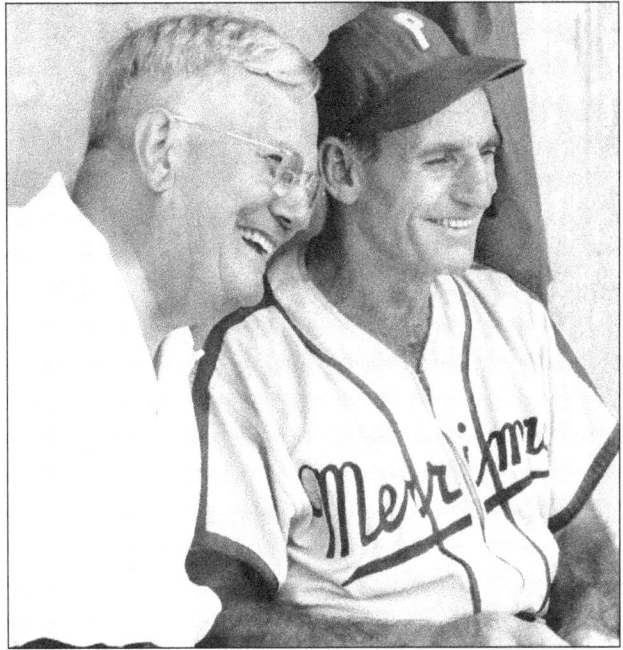

DUGOUT SMILES, 1954. Frank D. Lawrence and newly hired manager Pepper Martin enjoy a light moment together in the Portsmouth dugout before a scheduled Piedmont League contest at the stadium. Over the years Lawrence attracted many former big league legends to come play and manage for his team including Jimmie Foxx, Milt Stock, and Tony Lazzeri. The marquee effect of having a well-known player at the helm of his club always seemed to help fill seats at the ballpark. (From the collection of Ducky Davis and Bobby McKinney.)

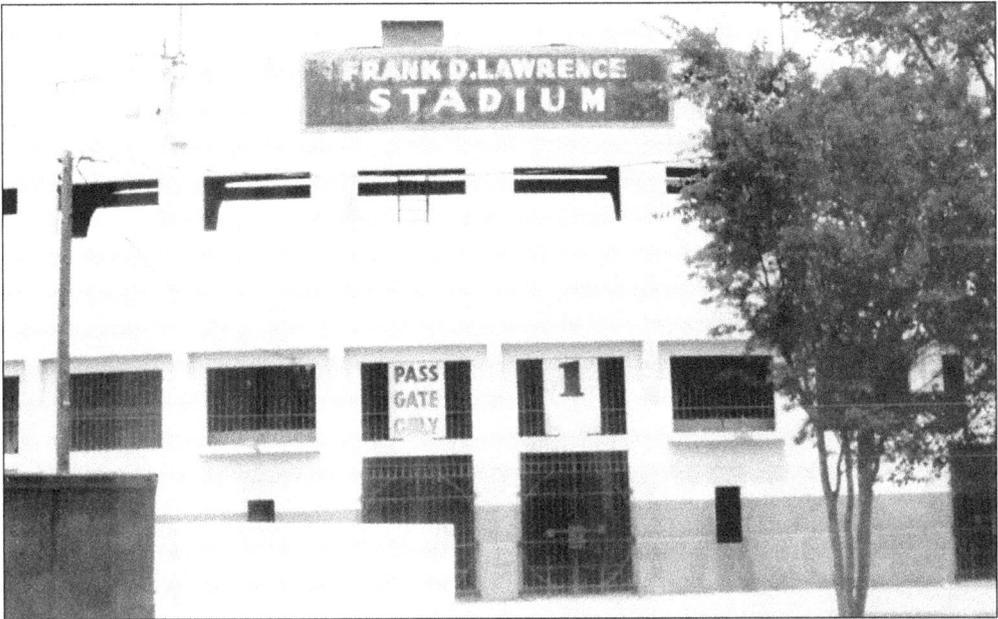

FRANK D. LAWRENCE STADIUM. Completed in 1941, Portsmouth Stadium proved to be a state-of-the-art facility that provided fans with an unobstructed view of the playing field from the covered grandstands behind home plate. In honor of Portsmouth's baseball patriarch, the ballpark was re-dedicated as Frank D. Lawrence Stadium on Sunday, May 17, 1964. The occasion was marked by a weekend filled with pageantry and celebration, including a banquet attended by many former Portsmouth players such as Eddie Stanky, Jimmie Foxx, Larry Weldon, Les Bangs, Skeeter Scalzi, Harry Land, and Ace Parker. This photo shows the exterior of the facility with the press box just behind the stadium's sign. (From the collection of George Tinker.)

31

EXTRA  PORTSMOUTH  EXTRA
BASEBALL NEWS

VOL. 1—NUMBER 2   PORTSMOUTH, VA.—AUGUST 31, 1943   PRICE—FREE

# CUBS WIN THE PENNANT

★★★ ★★★ ★★★ ★★★ ★★★ ★★★ ★★★ ★★★ ★★★ ★★★

## SHAUGHNESSY PLAY-OFFS BEGIN SEPT. 8

**First Championship For Portsmouth Since 1927**

**RICHMOND HERE SEPTEMBER 1-2-3**

**NORFOLK HERE SEPTEMBER 5-6 (A.M.)**

**Roanoke First Opponent In September Classic**

First Two Games Here, Next Three at Roanoke; Finals Here, Then Either Norfolk Or Richmond—Fans Hope Norfolk.

---

**1943 Team Has Made History—Several will be in Higher Company in 1944—Stock Has Made Enviable Record As Manager.**

By ABE GOLDBLATT
(Virginian-Pilot Sports Writer)

For the first time in 17 years a baseball championship comes to Portsmouth.

Climaxing the greatest mopping up campaign since Johnny Neun's Tars walked away with the race in 1936, our conquering Cubs have put the Piedmont League pennant on ice.

Portsmouth won its last flag in 1927, when the old Truckers, under Zinn Beck, claimed the Virginia League crown. Previous pennants were captured in 1920 and 1921, with Jimmy Viox in the driver's seat.

Winning the Piedmont League flag is a great victory for Owner Frank D. Lawrence, who has reached his goal after a thrilling, uphill fight of nine years against the rich Major League farm system.

Lawrence placed Portsmouth in the Piedmont League in 1935. The Cubs of 1943 bring Portsmouth its first Piedmont title.

Last year the Cubs, led by Manager Tony Lazzeri, came close, losing a spectacular photo finish to Greensboro on the very last day by a couple of percentage points.

This season it wasn't even a race. With the cagy Manager Milton Stock at the helm, the sensational Cubs have had the enemy reeling on the ropes almost from the very start.

Most of the critics conceded Portsmouth the championship as early as July 4, when the Cubs led their nearest opponents, the Richmond Colts, by eight full lengths.

In winning the pennant, the Cubs produced many stars.

First, for National glory, we'd like to nominate Frank Lawrence as the outstanding Minor League owner in the country, and Milton Stock as the No. 1 manager.

Irvin Stein, the righthander with the uncanny control, made pitching history. Already he has bettered Lefty Brecheen's record, the 1937 Cubs of 21 records and 21 defeats.

Centerfielder Wilmer Skeen has walked away with the majority of the league's batting honors. Weighing only 147 pounds, this speedy outfielder

**A REAL WINNER**

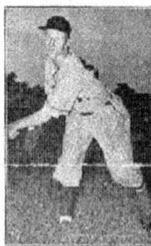

IRVIN STEIN
(Right hand pitcher)

First season with Portsmouth—purchased last Winter from Charleston South Atlantic League. Having his best season—should win 25 games—certain to be in faster company in 1944. Married and has four children.

packs a mean wallop in his bat and has paced the Cubs offensive.

Tony Ordenana, a rookie from Havana, became the sensation of the league with his brilliant play at shortstop. He is regarded by Portsmouth fans as the smoothest infielder since Pie Traynor's days with the old Truckers.

The Cubs have at least five candidates for all-Piedmont honors. They are Manager Stock, Wilmer Skeen, Irvin Stein, Tony Ordenana and Catcher Bill Steinecke.

Several of this season's Portsmouth players are heading for higher company, with two at least expected to perform in the majors in 1944.

Winning the Piedmont pennant adds another successful season to Stock's brilliant managerial record. He hasn't finished out of the first division since 1932.

Welcome home, champions! It has been a great season, but it isn't over yet. Let's make it a clean sweep and win the Shaughnessy playoffs.

Photos furnished through the courtesy of the

*Virginian-Pilot*

Portsmouth Baseball's friend.

**HERE'S HOPING YOU WIN $1,000 WAR BOND**

— RULES —

1—Winner must be present tonight at the game between Portsmouth and Richmond.

2—The first number will be drawn and announced at the conclusion of the 5th inning. If the number is not presented by the close of the 7th inning another number will be drawn and announced. If that number is not presented by the close of the game another number will be drawn and announced and the holder will be declared the winner and receive the $1,000 War Bond.

3—In the event that the same number called is possessed by more than one person, which is possible thru printer's error, that drawing will be invalidated and another number drawn.

**AMONG THE BEST**

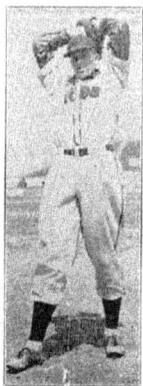

RALPH (Red) WILLIAMS
(Right hand pitcher)

Has been with the Cubs since 1939—purchased from Hutchinson, Kansas. Finishing his best season with Portsmouth—will unquestionably be in a higher league next season unless he is drafted into the Army. Married and has one child (after Pearl Harbor).

**LEAGUE'S BEST HITTER**

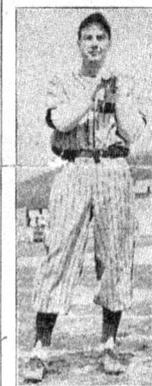

WILMER SKEEN
(Center fielder)

Playing his first season in Portsmouth—purchased last Winter from Charleston South Atlantic League Club. Enjoying his best season—leading the league in nearly every department—will be playing next year with either Chicago Cubs or Los Angeles. Married and has one child (before Pearl Harbor).

Some pretty wise baseball men have said that pitching is 75 percent of baseball.

Milt Stock has been piling up a lot of testimony in support of that contention.

Stock has been blessed with a veteran pitching staff that has been outstanding all year. Only once during the month of July was it necessary for Stock to relieve one of his starting pitchers. Working in regular turn without interruptions for relief duty, has kept Stock's staff in fine shape and it's paying dividends.

Milton Stock holds a world's record in baseball. Did you know that Stock made 16 hits in four consecutive games while playing with Brooklyn in 1925?

FLASH—FLASH

This article was written as we went to press. However, as all fans know our baseball is so uncertain, The Cubs may have to play Lynchburg instead of Roanoke. Regardless, the Shaughnessy play-offs will begin at the Stadium, Wednesday, September 8 at 6:30 P. M.

The Shaughnessy play-off will begin Wednesday, September 8th at 6:30 P. M. at Portsmouth Stadium, with Heinie Manush's Roanoke Red Sox, occupants of fourth place in the pennant race, as the opponents of Milton Stock's pennant winning Cubs. Norfolk opens as third place winners, with Richmond (second place) at Richmond. These four clubs will play until two clubs have won best four out of seven, and then the grand finals will be played by the two winners of the first series.

The question has been asked, many times, "Why is it called Shaughnessy play-off?"

We will endeavor to answer. The plan of the first four clubs playing a post-season series was advanced by Frank Shaughnessy, President of the International League and everywhere it has been played, it has been called the "Shaughnessy play-off" after the man who "invented" it.

There has been a lot of argument for and against the plan. However it seems to meet with favor among most baseball fans and has been played by the Piedmont League since 1936. Shaughnessy is thinking the plan out argued that fan interest would be maintained in most cities of the league if the fans thought their "home club" would have a chance even to finish in fourth place if the pennant couldn't be won. We think Shaughnessy was right and that the present plan is a good one to keep up fan interest throughout the season. It has proved to be true in the Piedmont.

Portsmouth finished in third place in 1937 under Rabbit Yoter, defeated Asheville, the pennant winner in the semi-finals, and

(Continued on page 4)

---

PORTSMOUTH BASEBALL NEWS, 1943. With the headlines shouting that the Cubs secured the Piedmont League pennant, the excitement and optimism of the upcoming postseason playoffs was evident in the stories of this late-August issue of the *Portsmouth Baseball News*. Local sports writers Abe Goldblatt and Bill Cox contributed articles about the Cubs' pennant-winning season with front page photos featuring hurlers Irv Stein and Red Williams, along with the team's most dominating slugger, Wilmer Skeen. The four-page rag, given away at the ballpark, is just another example of owner Frank D. Lawrence's commitment to creating a first-class franchise by providing fans with news about the team in a variety of ways. (CSTG.)

# THREE

# From Truckers to Cubs
# Early Piedmont League Years
# 1935–1945

More than six years passed before baseball fans in Portsmouth again heard the distinctive crack of the bat within the walls of the ballpark. With the sudden collapse of the Virginia League on June 3, 1928, the Portsmouth Truckers' players turned in their wool uniforms and were forced to pursue other means of employment. Owner Frank D. Lawrence found the financial state of the team deeply in the red and was forced to mortgage his home and procure personal loans to cover player salaries and other baseball related debts. Portsmouth's "Mr. Baseball" made it clear to family, friends, and the city that his days of overseeing a professional baseball team were through. Without Lawrence, the future of the national pastime in the riverfront community appeared dim.

Across the Elizabeth River, Norfolk ended its two-year drought of baseball as the Piedmont League Durham Bulls relocated and took up residence at Bain Field in 1934. Backed by the powerful New York Yankees organization, the Class B Norfolk Tars enjoyed a successful inaugural season, capturing the league pennant while filling the ballpark with thousands of baseball-starved fans. Portsmouth civic leaders and the media began to voice discontent regarding the lack of baseball in their city and began a crusade to bring the game to their side of the Elizabeth River. Despite Lawrence's seemingly adamant stand to never become involved with baseball again, the pressure from the fans began to erode his will. The success of the Tars and his love of the game surely seduced him into another affair with professional baseball. While baseball ruled Lawrence's heart, he was the consummate businessman always aware of the bottom line. Thus, the ultimate lifting of the "Blue Law," which restricted the play of baseball on Sundays, and the addition of night baseball proved to be contributing factors in the eventual financial success of the franchise.

During the early months of 1935, following weeks of tense negotiations and bickering between league officials and owners, Portsmouth was accepted into the Piedmont League. Frank D. Lawrence, the city's most admired banker, informed the citizens of the city that the Portsmouth Truckers would join Norfolk, Richmond, Asheville, Wilmington, and Charlotte as a bonafide member of the historic league and that he would serve as sole owner and president. The joyous news was soon plastered on the front pages of the local papers and proved to be the talk of the town. Lawrence made arrangements with the Atlanta Crackers, an independent team in the Southern Association, to supply players for his new team and formally named "Pip" Koehler to manage the squad in their inaugural year.

The 1935 season began with fans and players in a euphoric, optimistic mood; however, reality quickly set in and the Truckers languished in the second division of the league, finishing their first year in the Piedmont with a 67-72 record. The following season, Lawrence negotiated an informal agreement

with Chicago of the National League and out of respect changed the name of his team to the Portsmouth Cubs, a moniker that would remain in place until the 1953 season. Manager Koehler was retained in 1936, but the powerful Norfolk Tars massacred most of their opponents and the Cubs again failed to post a winning record.

Finally, after two disappointing seasons, the Cubs developed and fielded a winning team in 1937, earning a spot in the postseason Piedmont League Shaughnessey playoffs. Despite solid pitching from Harry "The Cat" Breechen, superb defensive work by Eddie "The Brat" Stanky, and effective hitting by Bill "Swish" Nicholson, the Cubs were eliminated in the championship round by their cross-river rivals, the Norfolk Tars.

In 1939, owner Frank D. Lawrence surprised the baseball world by loading up his entire team in April and sending them to Florida for spring training to prepare for the upcoming season alongside the likes of the New York Yankees and other major league clubs. Despite the unique method of preparing for the season, the Cubs finished the year with a losing record at 66-71 and repeated their futility in 1940 with an even more dismal mark of 59-78. Over the winter of 1940, things began to change for the Cubs. Owner Lawrence convinced the city to take on a massive community work project in building a new, state-of-the-art home for his Cubs. On Easter Sunday, April 13, 1941, amid protests by the local ministry for staging the affair on the Sabbath, the city opened Portsmouth Stadium. Lawrence invited a number of past Portsmouth players including Pie Traynor, Eddie Stanky, Ace Parker, Jimmy Viox, Les Bangs, and Hack Wilson to attend the dedication of the stadium and partake in a contest with the Cubs. In 1941, within the confines of the new diamond, the Cubs posted a winning record and finished 75-65, just behind the pennant winning Durham Bulls.

In the off season the city found itself focusing on the war effort as the local shipyard geared up and prepared for imminent naval actions overseas. Frank D. Lawrence, always looking for a big name player to bring on board, hired former New York Yankee legend Tony Lazzeri to suit up and manage the Cubs for the 1942 season. Despite the depletion of players due to the war, the Cubs put up quite a fight and chased the Greensboro Red Sox for the pennant until the last day of the regular season, losing the Piedmont League title by mere percentage points. The Sox continued their dominance over the Cubs in the postseason playoffs and captured the Shaughnessey trophy in six games.

After eight seasons of disappointments and near misses, the Cubs finally put it all together in 1943. With new manager and former major leaguer Milt Stock at the helm, Portsmouth began the season with a bang by winning 21 of their first 25 games to make the race for the pennant a runaway. Stock, the Cubs' new skipper, exuded an unusual persona in that he never ventured out of the dugout to argue calls and dressed in a dapper suit and tie for each contest. With Wilmer Skeen capturing the league's MVP award for his dominance with the bat and Irv Stein posting an impressive 24-6 record on the mound, it was little wonder why the Cubs finally broke their pennant-winning drought.

With expectations high in 1944, the Cubs were picked to repeat as league champs. To everyone's surprise they were blindsided by the Lynchburg Cardinals and ended the year in second place with a 72-67 record. Manager Bill Steinecke was sold to the New York Yankees in the final weeks of the season and owner Frank D. Lawrence convinced the Chicago Cubs to loan slugger Jimmie Foxx to him for the remainder of the year. "The Beast" arrived in Portsmouth with much fanfare, but failed to motivate the Cubs as Portsmouth lost out to the Cardinals in the finals of the postseason playoffs. The following season the Cubs reverted to their losing ways and posted a record of only 67-69 in the regular season, but quickly made fodder of first Norfolk and then Richmond in the finals to capture the Shaughnessey Trophy under skipper Ival Goodman.

From 1935 through 1945, Portsmouth enjoyed a re-birth of the national pastime in this baseball-starved city as the keen eye of owner Frank D. Lawrence continued to discover many legendary players including Jimmie Foxx, Eddie Stanky, Bill Nicholson, Tony Lazzeri, and Ace Parker and enticed them to sign with Portsmouth. The exploits of these men, as well as their teammates, set a precedent for things to come in Portsmouth's baseball future.

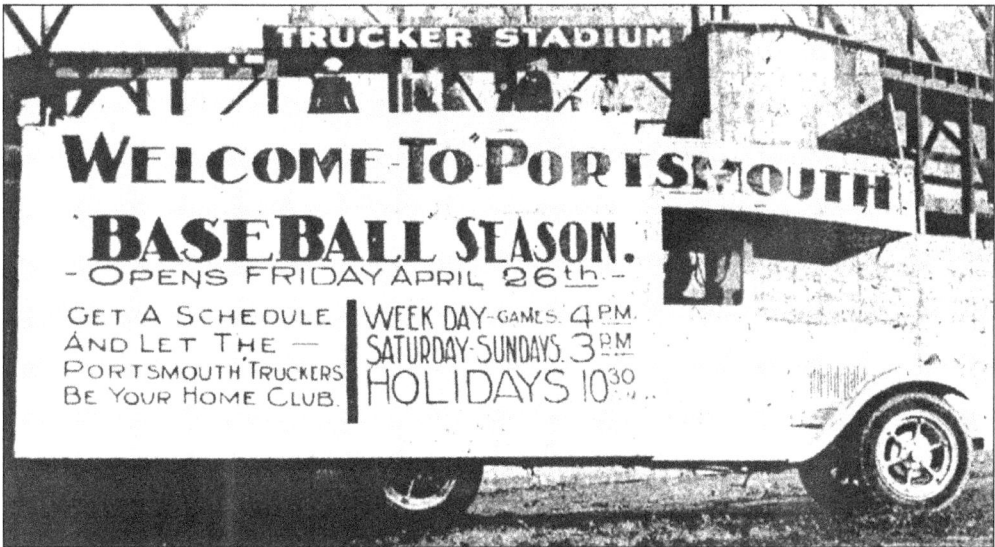

CARRYING PORTSMOUTH TRUCKER BASEBALL TO THE FANS. With the excitement of the upcoming inaugural season heavy in the air during April of 1935, owner Frank D. Lawrence created a unique marketing strategy to let the public in outlying areas know about his team. A huge broad-sided truck, positioned in front of the ballpark in the photograph above, was sent on a 600-mile tour throughout southeastern Virginia and eastern North Carolina distributing 100,000 printed schedules urging baseball fans to make Portsmouth their hometown team. (*Portsmouth-Star*/ PPL.)

OPENING GAME BROADSIDE. This advertisement, appearing in the April 26, 1935, edition of the *Portsmouth-Star*, encouraged local fans to attend the inaugural home game of the Truckers in the Piedmont League. The game, held at the old Washington Street ballpark, often referred to as Sewanee Stadium or Trucker Stadium, was filled with 3,500 supporters on opening day. Following a festive parade originating at the ferry terminal, city mayor Vernon A. Brooks threw out the first ceremonial pitch of the 1935 home season. The Truckers, led by skipper "Pip" Koehler, lost a close battle to the defending league champion Norfolk Tars 5 to 4, despite a spirited comeback that fell just short in the bottom of the ninth. (*Portsmouth-Star*/ PPL.)

PLAY BALL

★ ★ ★ ★

Let's All Attend the Opening Game in Portsmouth at the New "Trucker Stadium"

Portsmouth

—vs.—

Norfolk

Friday, April 26th

WE ARE PROVIDING AMPLE TRANSPORTATION FACILITIES

RIDE THE BUSES AND STREET CARS

NO PARKING WORRIES !!!

VIRGINIA ELECTRIC AND POWER COMPANY

Take Buses or Cars Marked

● Cradock, stops on the East Side of Park.

●Piedmont Heights Car, one block from the West Side of Park.

● Prentis Park Bus, stops on the South Side of Park.

They Pass Very Close To the Trucker Stadium.

● Resolve Further to attend all Piedmont League Games in Portsmouth.

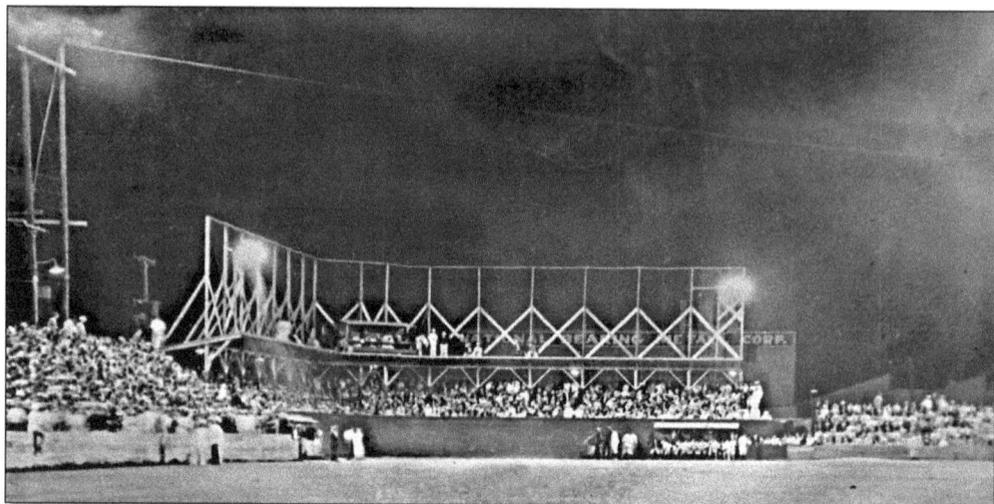

**PORTSMOUTH'S FIRST GAME UNDER THE LIGHTS, 1935.** Despite the fact that the first game of baseball under illumination reportedly took place in 1880, the idea of watching the national pastime on cool summer evenings was still somewhat of a novelty. Newspaper accounts report that minor league baseball used lights as early as 1922, while the first official major league game under the arcs came much later on May 24, 1935 at Cincinnati's Crosley Field. Above is a rare photograph of the inaugural game using a fixed system of illumination in Portsmouth. The game was held on the evening of August 25, 1935, with the visiting Norfolk Tars serving as fodder for the hometown Truckers as the Portsmouth nine thoroughly dominated the contest 17 to 1. (PPL.)

**"HOT POTATO" MERVILLE, 1935.** A favorite of owner Frank D. Lawrence, Larry Merville served as the Portsmouth starting center fielder for four solid seasons. Pictured here in a classic swing with his weapon of choice, the husky outfielder was a master of getting on base. At the plate, his batting average hovered around the .300 mark during each of his four seasons with Portsmouth and his powerful swing resulted in a generous number of home runs to the delight of Sewanee Stadium fans. Despite a muscular physique and menacing cut, his talent in waiting for the right pitch was legendary and he consistently averaged over 100 walks a year, often leading the league in this statistic. The source of his nickname, "Hot Potato," remains a mystery. (NPL.)

# PORTSMOUTH "CUBS"--- Piedmont League

## Let's Get Behind Them and Win the Pennant

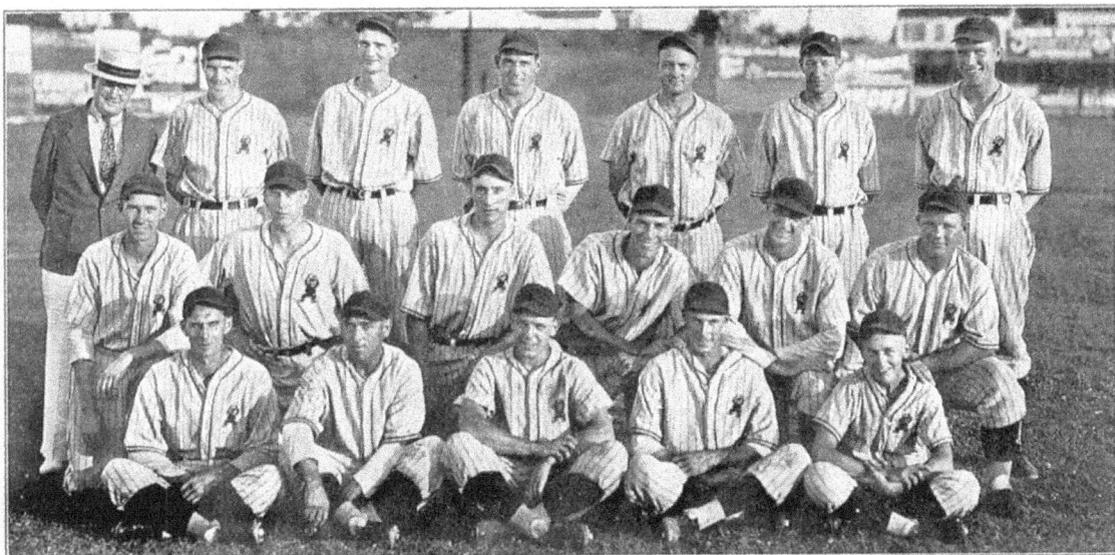

PORTSMOUTH CUBS TEAM PHOTO. Pictured on the grass of Sewanee Stadium are the 1937 Portsmouth Cubs of the Piedmont League. Beginning in 1936, Frank D. Lawrence and his franchise established a direct working agreement with the Chicago Cubs of the National League. The relationship was evident in this photo with the Portsmouth players wearing the old Chicago Cubs uniforms with the "C" removed around the club logo of the bear in mid-wind up. The team was well-stocked with a number of future big name major leaguers including Eddie Stanky, Harry Breechen, Harold Wagner, and Bill Nicholson. The Cubs boasted a solid combination of great pitching, as evidenced by Harry "The Cat" Breechen's impressive 21-6 record, and hitting with Bill Nicholson leading the way with a .310 average and 20 home runs over the season. Other big lumber on the team was held by Larry Merville with 22 homers and a solid .290 average. The Cubs finished in third place with a 75-62 record, but bested the first-place Asheville Tourists in the first round of the Shaughnessy Playoffs before succumbing to their neighboring rivals the Norfolk Tars in a three-game sweep. Looking dapper in his straw skimmer is owner Frank D. Lawrence on the far left of the top row. The following are pictured from left to right: (front row) Hal Schultz, shortstop; Elmer "Rabbit" Yoder, manager and third baseman; Eddie "The Brat" Stanky, second basemen; Harry "The Cat" Breechen, pitcher; Allyn, Lawrence's son, batboy, and mascot for the team; (middle row) Harold Wagner, catcher; Carl Byrd, pitcher; Bill Herring, pitcher; John Friedli, first baseman; "Pip" Koehler, right fielder; and Dick Luckey, catcher; (back row) Frank D. Lawrence, owner; Jimmy Calleran, utility man; Earl Allen, pitcher; Bill "Swish" Nicholson, center fielder; Larry "Hot Potato" Merville, left fielder; Warren "Red" Bridgens, pitcher; and Willard Donovan, hurler. (CSTG.)

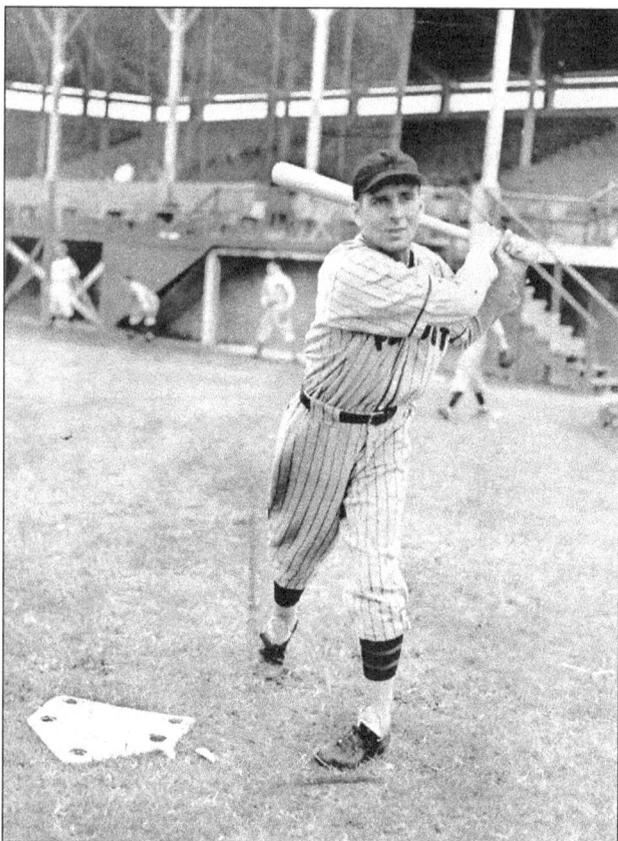

**HAL SCHULTZ, 1937–1938.** Harold "Hal" Schultz served as an integral part of Portsmouth's dynamic double play combination in conjunction with a young second baseman by the name of Eddie Stanky. The duo proved to be weak hitters at the plate, but reliable on the diamond in turning more than 120 double plays during the 1937 season. Schultz, shown in a batting pose for the photographer, hit only .250 in 1937 and fared even worse in 1938 with a .232 average. The grandstands of Sewanee Stadium are in the background. (From the collection of Ducky Davis and Bobby McKinney.)

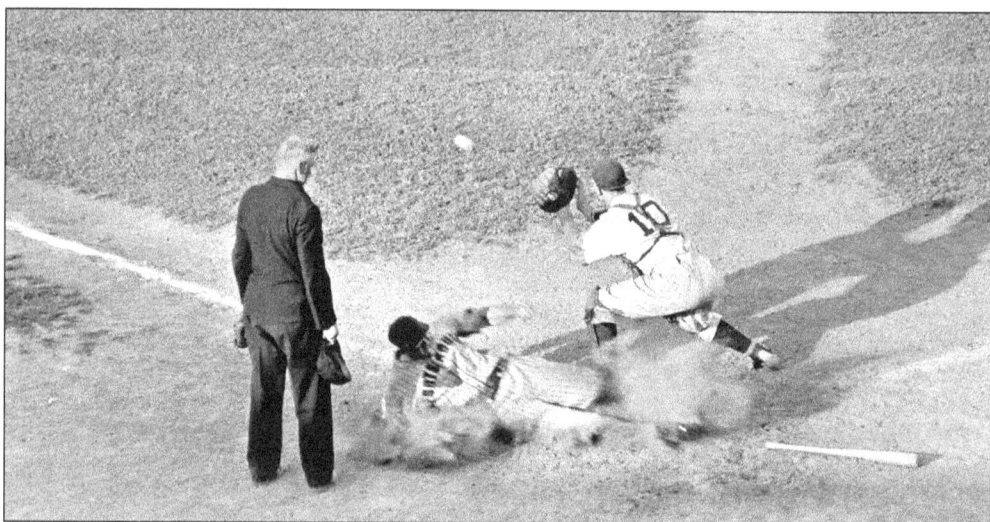

**BILL "SWISH" NICHOLSON SAFE AT HOME, 1937.** Pictured above is Bill Nicholson of Portsmouth sliding across home plate at Norfolk's Bain Field in the third inning during the inaugural postseason playoff game between the Cubs and the Tars. Nicholson, nicknamed "Swish" because of his prodigious swing at the plate, dominated the National League with his power during the peak years of World War II. As a member of the Chicago Cubs, Nicholson led the circuit in home runs and RBIs during both the 1943 and 1944 seasons. (NPL.)

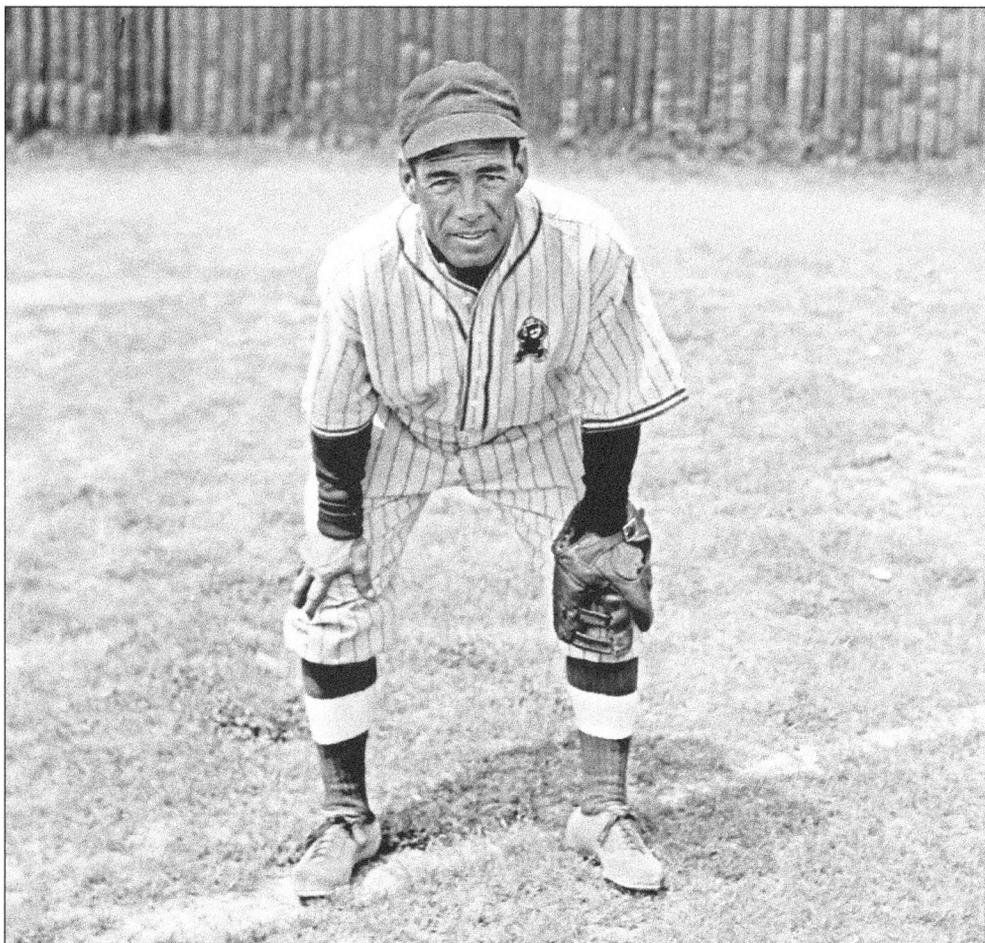

**AN AGELESS WONDER RETURNS TO PORTSMOUTH 22 YEARS LATER.** Manuel Cueto contributed to Portsmouth's success during the 1916 Virginia League season as the Truckers battled for the pennant through the last week of the campaign. Cueto, a former major leaguer with the St. Louis Terriers of the Federal League in 1914, captured the 1916 Virginia League batting title with a .321 average and led the circuit in stolen bases (41) and hits (126). Following the 1916 season, Portsmouth owner Frank D. Lawrence sold Cueto to the Cincinnati Reds for whom he played a part-time role for three years until his retirement from the major leagues in 1919. In a surprise move, Lawrence contacted the 47-year old Cueto in San Salvador during the spring of 1938 and asked if he would like to try out for the Cubs. Cueto agreed and arrived in Portsmouth amid frenetic hype generated by Lawrence and the local press. Thousands of fans flocked to Sewanee Stadium to see the ageless wonder and former Portsmouth hero return to the diamond. Many in Portsmouth questioned the wisdom of Lawrence to bring back the Cuban, but Cueto quickly quieted any critics by blasting an exhibition game home run against Philadelphia Athletics pitcher Edgar Smith in his first appearance as a Portsmouth Cub. Interestingly, the "Count," as he was known to Portsmouth fans, relieved catcher Dick Luckey behind the plate in the sixth inning of the game, a position he had not assumed in over 10 years. Cueto appeared in only 16 games during the first two months of the regular season and despite his age managed to hit a respectable .265 at the plate before he returned home. He died in Cuba only four years later. (NPL.)

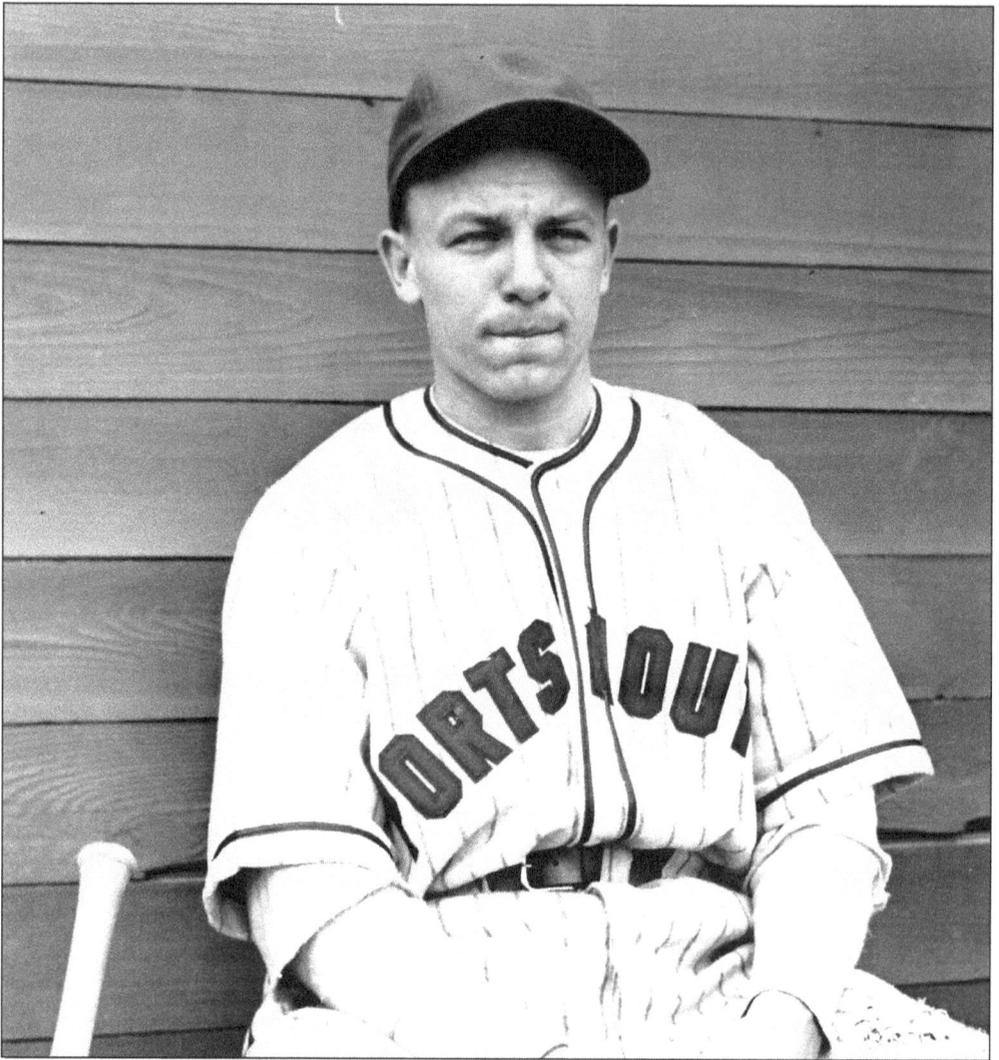

**EDDIE STANKY, PORTSMOUTH'S FIERY SECOND SACKER, 1937–1939.** Wearing the flannel of the Portsmouth Cubs and his trademark scowl, a young Eddie Stanky reluctantly poses for the photographer against the wooden slats of Sewanee Stadium. Known for his durability and hot temper, Stanky, nicknamed "The Brat," was a fierce competitor and was always willing to mix it up with opposing players or umpires at the drop of a hat. His ongoing rivalry with Norfolk Tars infielder Gerry Priddy was legendary during the 1938 season as few games between the two teams finished without some type of on-field confrontation. Stanky served as the starting second baseman for the Cubs from 1937 until 1938. In 1939, he played in only a handful of games before Portsmouth sold "The Brat" to Syracuse of the International League and later played for teams in Macon and Milwaukee. While with the Macon Peaches, Stanky married the daughter of his manager, Milt Stock, who later served as skipper for the Portsmouth Cubs in 1943. Following his retirement from the game as a player in the early 1950s, Stanky served as manager for a number of major league teams until 1977. He closed out his storied career as a respected baseball coach at the University of South Alabama. (CSTG.)

"COWBOY" MCHENRY, 1938–
1940. Art "Cowboy" McHenry
served as the starting right fielder
for the Portsmouth Cubs in 1938
and again in 1939, producing
impressive offensive numbers
both seasons. His 1938 stats (.319
average, 17 home runs, 79 RBI)
were just as notable the following
year (.304 average, 25 homeruns,
106 RBI). By 1940, Cubs owner
Frank D. Lawrence made an
unusual switch with the managers
of the two clubs he owned
and initially sent McHenry
to skipper Tarboro midseason
and then brought him back to
Portsmouth before the campaign
was completed. McHenry's stats
for the 1940 season reflect the
upheaval during the year in
which he managed the team as
he batted an anemic .218, well
below his usual average. (CSTG.)

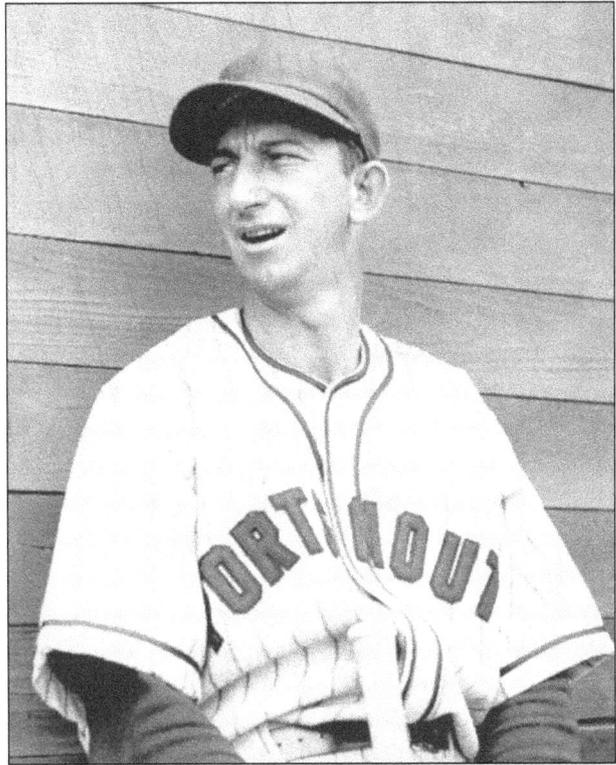

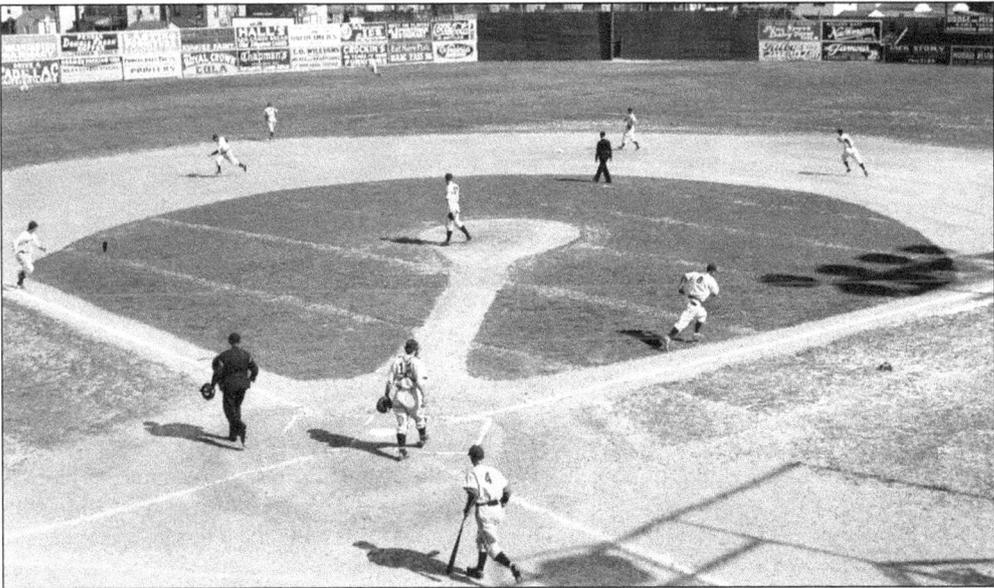

A PORTSMOUTH CUBS RALLY AT SEWANEE STADIUM, 1939. This photo, obviously taken from the press box situated over the grandstands behind home plate, gives the viewer an opportunity to see legendary Sewanee Stadium from a spectator's vantage point. The Cub batter, hitting with the bases loaded, has just sent a ball over the outfield fence of the ballpark for a crucial rally in a Piedmont League contest from the 1939 season. The old ballpark was used only through the 1940 season when it was replaced by Portsmouth Stadium. (PPL.)

41

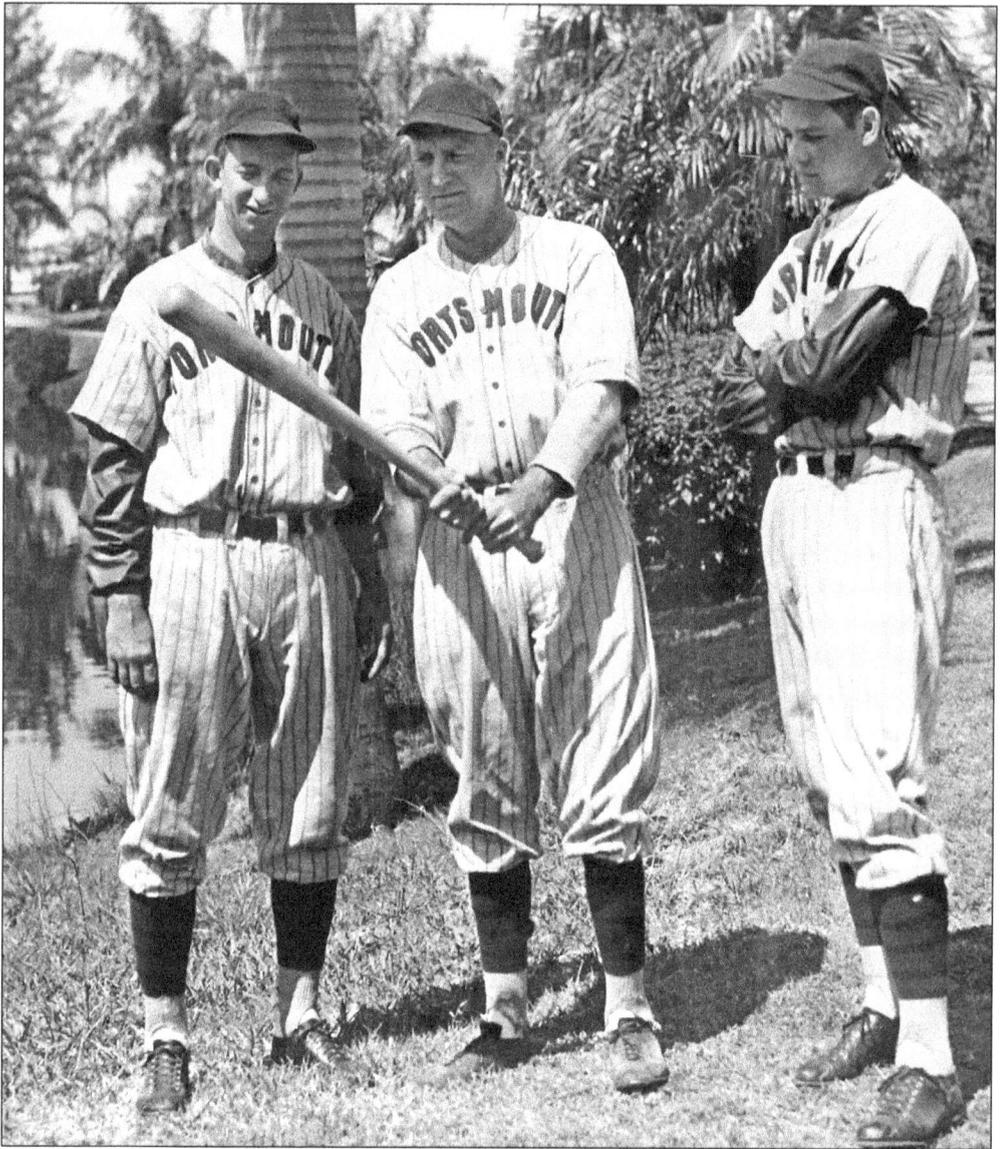

THE FLORIDA SUN SHINES ON THE CUBS. In February of 1939, Portsmouth Cubs owner Frank D. Lawrence shocked the baseball world by announcing that his Class B Piedmont League team would spend three weeks in West Palm Beach, Florida, for spring training in preparation for the upcoming season. Taking a minor league team thousands of miles from home to Florida in the shadows of the major leaguers had never been done. Lawrence, always one to show his fans, players, and other baseball executives his devotion for his team, paid for all expenses and took West Palm Beach by storm, winning over residents and retailers with non-stop speaking engagements and incentives to see his players in action. Pictured here with water and palm trees in the background is (from left to right) right fielder Art "Cowboy" McHenry, Cub manager James Keesey, and left fielder Ed Yount. The Florida sunshine must have been to Yount's liking as he had a banner year in 1939 and led the Piedmont League with a .350 batting average. (CSTG.)

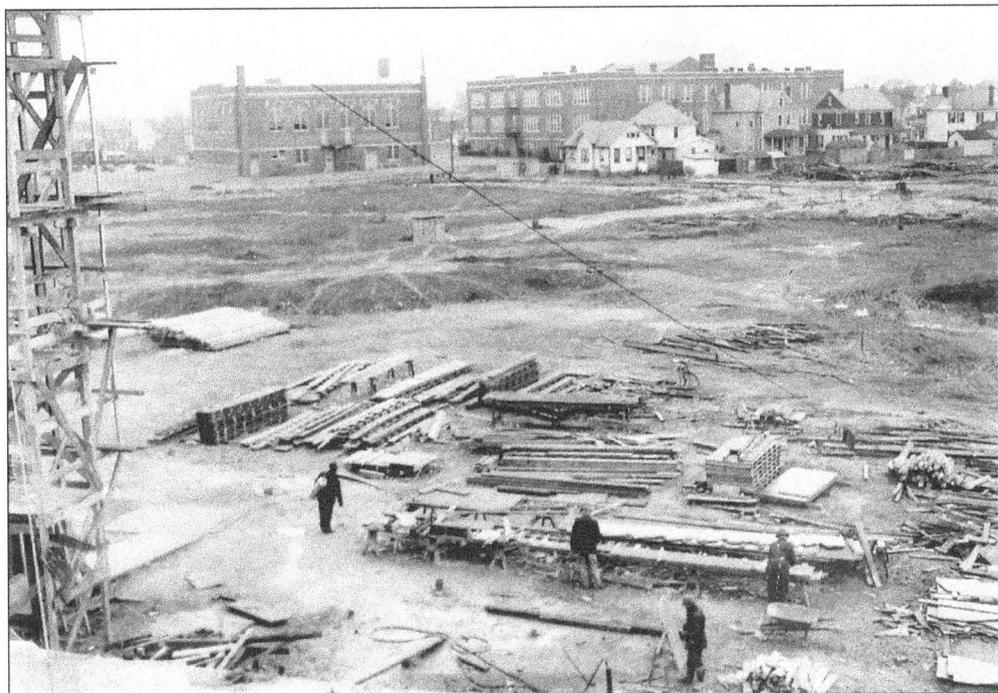

A NEW STADIUM RISES OVER SCOTT'S CREEK, 1941. For years the Truckers and Cubs toiled in a number of ballparks throughout the city including League Park, High Street Park, and most recently Sewanee Stadium. With some politicking by owner Frank D. Lawrence, the city was convinced to begin a public works project for a new stadium in Portsmouth. The site selected was on High Street across from the Scott's Creek inlet, which bordered the Shea Terrace section of the city. The area was undeveloped and the location was filled in with hundreds of discarded, old cars before the pilings were drilled. The picture above shows the early stages of construction, while the photo below depicts the nearly completed project with scaffolding still surrounding the freestanding overhang above the grandstands behind home plate. The stadium cost the city $250,000 and was dedicated on Easter Sunday, April 13, 1941. Despite objections from the local ministry for playing the game on Easter, the dedication went off without a hitch as the fans welcomed the Cubs to their new home. (PPL.)

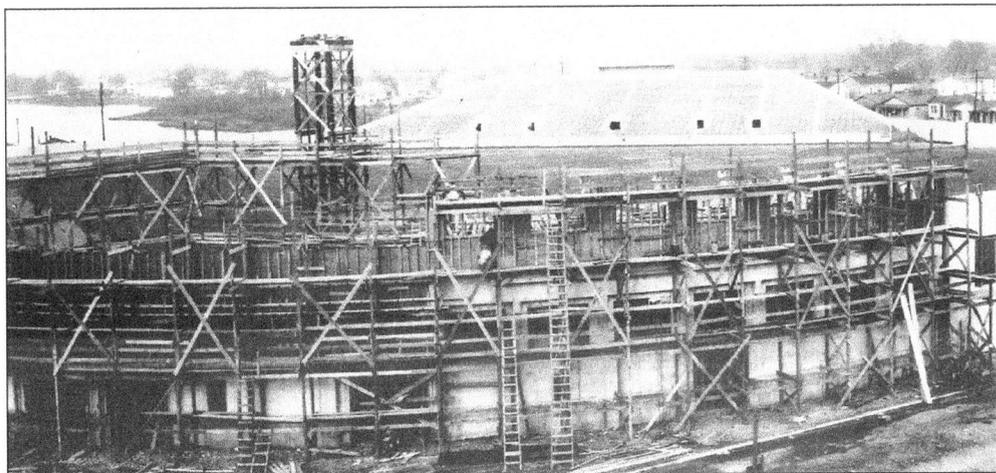

**DON CURRY, 1939–1941.** With Eddie Stanky departing Portsmouth at the beginning of the 1939 season, the second base position fell into the reliable hands of Don Curry. The diminutive infielder showed some power in his first years with the Cubs as he sent 17 home runs over the walls of Piedmont League ballparks. By 1940, his home run production dropped to 11 and his batting average hovered around the .250 mark for the season. Despite the drop off in his hitting, Curry proved to be a crucial element in the Cubs infield. Owner Frank D. Lawrence admired the little infielder's leadership skills so much that he convinced Curry to serve as player-manager for the team in 1941 as he led the Cubs to a second place finish with a respectable 75-65 record. (CSTG.)

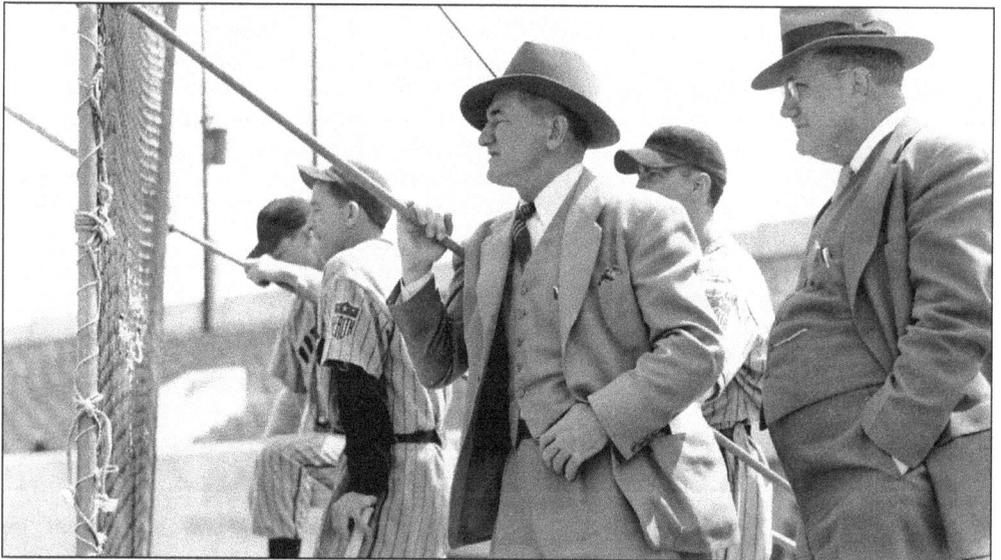

**MILT STOCK AND FRANK D. LAWRENCE LOOK OVER THE TROOPS, 1943.** Pictured here in his everyday attire of a three-piece suit and hat, always dapper Milt Stock (center) takes his place behind the batting cage at Portsmouth Stadium watching his players at batting practice. Unusual as it may seem, Stock never ventured out of the dugout during the entire 1943 season and refused to argue in protest of an umpire's call with face-to-face confrontations. Alongside Stock is Cubs owner Frank D. Lawrence. (From the collection of Ducky Davis and Bobby McKinney.)

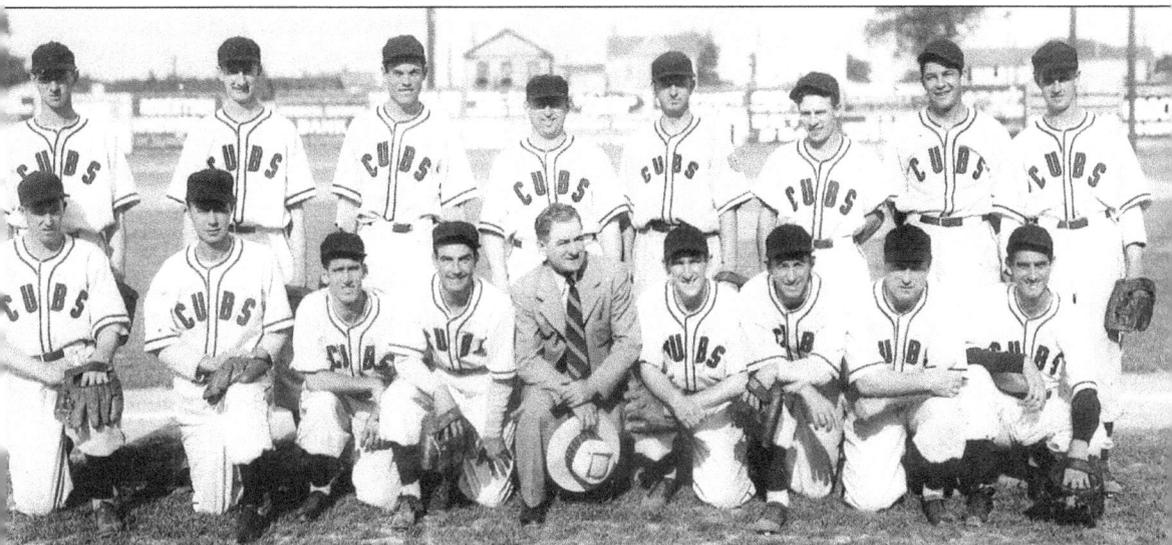

**The Portsmouth Cubs, Pennant Winners of the Piedmont, 1943.** With manager Milt Stock at center stage, the Portsmouth Cubs of 1943 pose for the camera along the third base line of Portsmouth Stadium. The Cubs dominated the Piedmont League in the regular season and finished out the year in first place (90-40), 17.5 games in front of the Richmond Colts. The following are pictured from left to right: (front row) Red Williams, Ralph Pate, Tony Ordenana, Wilmer Skeen, Milt Stock, Charles Hoffman, John Zontini, Bill Steinecke, and Jorge Comellas; (back row) Irv Stein, Henry Glor, Jody Howington, Jake Levy, Hunky Archer, Bill Smith, Furman Owens, and Al Godfredson. (From the family archives of Hunky Archer.)

**Portsmouth's "Sheik of Seth."** Known in his native West Virginia as a multi-facetted and talented athlete, John Zontini excelled in many sports. Nicknamed the "Sheik of Seth" for his athletic prowess as a teenager, Zontini was once showcased in a *Ripley's Believe It Or Not* segment for the amazing stats he accumulated during his 1929 high school football season. That fall, Zontini rushed for a total of 2,135 yards while handling the ball only 79 times resulting in an incredible average of 27 yards per carry. Portsmouth fans will remember John Zontini as a speedster on the base paths and smart with the glove. He first appeared in a Portsmouth Cub uniform in 1939 and was a regular with the team on and off through the war years. In 1948, Zontini was selected by owner Frank D. Lawrence to manage his team in the Class D Virginia League, the Franklin Cubs. (From the family archives of Tony Zontini.)

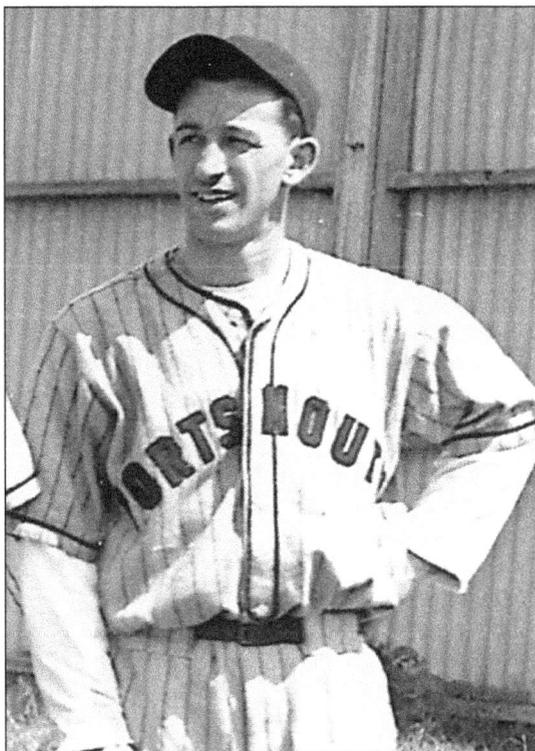

Opening of 1944 Baseball Season

# OFFICIAL SOUVENIR PROGRAM

**Norfolk Naval Training Station**

vs.

**Portsmouth Cubs**
1943 Piedmont League Champions

**N. T. S. Stadium**
Sunday, April 9

CUBS AND BLUE JACKETS, 1944. This program was one of many from the Easter Sunday game held on April 9, 1944, pitting the Portsmouth Cubs against the Norfolk Naval Training Station (NTS) Blue Jackets. The contest was staged at the brick-walled NTS stadium on the naval base as more than 7,000 sailors filled the bleachers to watch their team dismantle the Cubs 12-2. By 1944, the Navy team lacked many of the former big league stars that were regulars in 1942 and 1943, however manager Gary Bodie's Blue Jackets roster was still staffed with plenty of talent including Russ Meers (Chicago Cubs), Glenn McQuillen (St. Louis Browns), and Johnny Rigney (Chicago White Sox). Navy Ensign and Portsmouth native "Ace" Parker served as one of the umpires for the game. Cub manager Bill Steinecke penciled seven Cuban players into his starting lineup and eventually used all 11 Cubans on his roster in the game. Interestingly, only one of the Cubans could speak English: catcher Ramon Couto. (CSTG.)

JAKE LEVY, CUB FIDDLER. The sweet sounds of strings echoed through the stands of Portsmouth Stadium on the evening of June 15, 1944, as Portsmouth pitcher Jake Levy fiddled for the fans. In honor of owner Frank D. Lawrence receiving *The Sporting News* Minor League Executive of the Year Award, Levy played a rendition of "Dark Eyes" for his boss, dignitaries, players, and fans on hand for the celebration. The Cub pitcher and part-time fiddler was the ace of the team from 1943 through 1944, posting winning records each year and an impressive ERA. (NPL.)

46

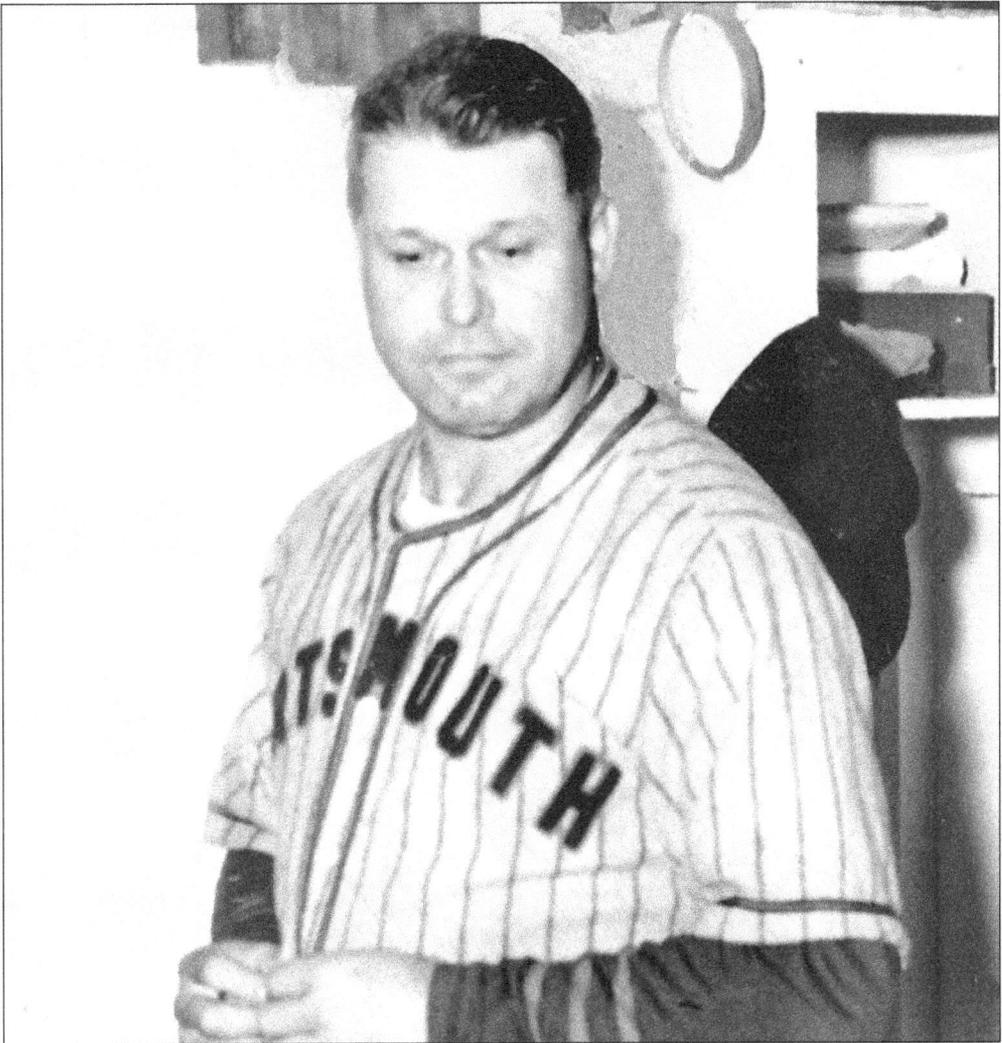

JIMMIE FOXX SUITS UP FOR THE PORTSMOUTH CUBS, 1944. In the final weeks of the 1944 season the Cubs' player-manager Bill Steinecke was sold to the New York Yankees and replaced with one of the greatest sluggers in the history of baseball, Jimmie Foxx. Shown here putting on his Portsmouth flannel in the locker room, Foxx arrived in the city with much fanfare and hype as curious fans flocked to the ballpark in hopes of seeing him step to the plate. On the evening of September 4, 1944, the Cubs visited their rivals, the Norfolk Tars at High Rock Park for a scheduled doubleheader. Portsmouth took the first game on the chin and lost 4-1 and fell behind by the same score in the top of the seventh in the second game of the twin bill. In the final inning of the game, the Cubs staged a rally as the first two batters rapped clean singles to the outfield against Tars pitcher Garland Braxton with no outs. The stage was set for Foxx and he confidently strode to the plate as the potential tying run. As the fans roared and stood in anticipation the mighty slugger took a prodigious swing at the first pitch for a strike. With the count at two balls and a strike Foxx swung and sent sharp grounder to shortstop Al Baker who began a quick twin killing. As the Tars first baseman pocketed the ball, the remaining Portsmouth baseman ended up in no man's land between third and home and was caught in a rundown and tagged out. In his first appearance at the plate in the Tidewater area, the great Jimmie Foxx had hit into a triple play. (CSTG.)

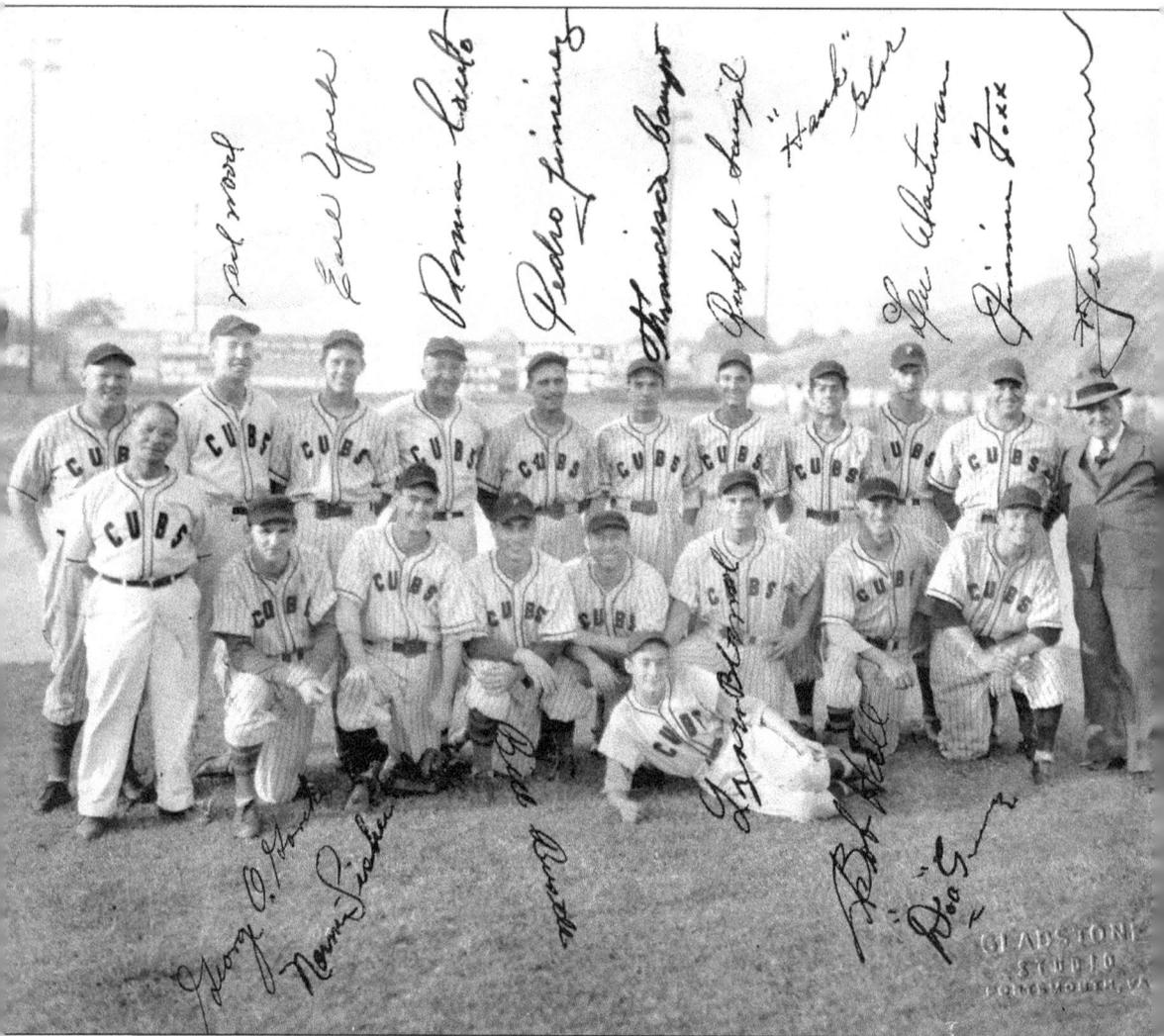

**SKIPPER JIMMIE FOXX AND THE 1944 PORTSMOUTH CUBS.** This unique team photo was taken in the closing days of the 1944 campaign. The original photograph was discovered in the family archives of a former Portsmouth player living in Cuba and is signed by the majority of players and staff pictured. The 1944 Cubs pressured front-running Lynchburg during the course of the season, but fell just short of overtaking the Cardinals in the dog days of August. During the pennant drive owner Frank D. Lawrence sold player-manager Bill Steinecke to the New York Yankees and replaced him with major league veteran Jimmie Foxx. While "Double X" led the Cubs into the post season playoffs, they were eliminated 4 games to 3 by the Cardinals in the championship round. The team's dominant pitcher proved to be Pedro Jiminez with a 15-5 record and league leading ERA of 1.51. Part-time first baseman Earl York led the team in hitting with a .359 average, but failed to get enough at bats to qualify for the league batting title. The players and staff in the photo are, from left to right, (front row) the unidentified Cub trainer, George Ogorek, Norman Fisher, Bill Bustle, Jake Levy, Lazero Bernal, Bob Hall, and "Doc" Greene; (back row) an unidentified player, Verl Wood, Earl York, Ramon Couto, Pedro Jiminez, Rafael Sangil, Hank Glor, Lee Wortman, Jimmie Foxx, and Frank D. Lawrence. (CSTG.)

# PORTSMOUTH BASEBALL NOTES
## 1935–1945

Interesting facts about the game in Portsmouth's baseball history

♦ At the winter baseball meetings held in Cincinnati, owner Frank D. Lawrence approached recently retired baseball legend Roger Hornsby to manage the Cubs for the 1940 season. His offer required the future Hall of Famer to play in a minimum of 100 games while pocketing a salary of $10,000 for the season. Hornsby told Lawrence he could no longer play so many games and the Cubs' owner terminated negotiations. Despite the astronomical monetary offer, Lawrence felt that if he could get the renowned hitter into a Portsmouth uniform, the money spent would be a sound investment and draw larger crowds to the ballpark.

♦ On April 5, 1942, the Norfolk Training Station Blue Jackets visited Portsmouth for a Navy Relief game, drawing a large crowd of 4,500. The top-notch Navy squad was led by pitcher Bob Feller, who held the Cubs hitless during his four innings of work. The ex-Cleveland Indians ace was overpowering as he managed to baffle the home team, including their manager Tony Lazzeri. The New York Yankee legend came to the plate twice against "Rapid Robert" and went down swinging both times.

♦ On April 14, 1942, the Portsmouth City Council officially designated that beginning at 3 p.m. on April 23 a resolution would take affect creating a holiday throughout the city, thus giving all municipal employees a holiday and allowing them to attend the opening game of the Piedmont League season. The resolution was adopted to support President Roosevelt's recent proclamation to keep baseball going despite the declaration of war.

♦ Cubs' pitcher, Jake Levy, holds the all-time Piedmont League record for complete game shutouts in a season. The husky Portsmouth hurler held opponents scoreless in seven of the fourteen complete games he pitched during the 1943 campaign.

♦ Bill Steinecke, catcher and manager for the 1944 Portsmouth Cubs, held an interesting job during the off-season. In the winter months he grew a full beard and played on the House of David basketball team as they barnstormed across the country.

♦ On the evening of June 15, 1944, to honor Frank D. Lawrence for winning *The Sporting News* coveted "Minor League Executive Award," a group of Portsmouth businessmen awarded the Cubs owner a unique gift of appreciation: a full size DeLuxe touring bus for the team. The ever-benevolent Lawrence immediately announced that the bus would be available to the Wilson High School football and basketball teams after the Piedmont League season was completed.

♦ During the 1944 Piedmont League postseason Shaughnessy Playoffs, newly appointed Cub manager Jimmie Foxx received a special telegram from his home in Chicago. His wife had just given birth to their third child, a baby boy.

♦ To say that center fielder John Zontini took it up a notch during the 1945 postseason would be an understatement. The fleet-footed Cub, known more for his speed than his power, hit a record five home runs over six consecutive playoff games as Portsmouth eliminated the Norfolk Tars and eventually the Richmond Colts to capture the postseason league trophy. Interestingly, Zontini hit a total of only two homers during the entire regular season that year.

♦ For winning the 1945 Piedmont League Shaughnessy Playoff trophy, the Portsmouth Cubs were awarded $2,200 from the commissioner's office, which resulted in a $108 bonus to each player for their efforts.

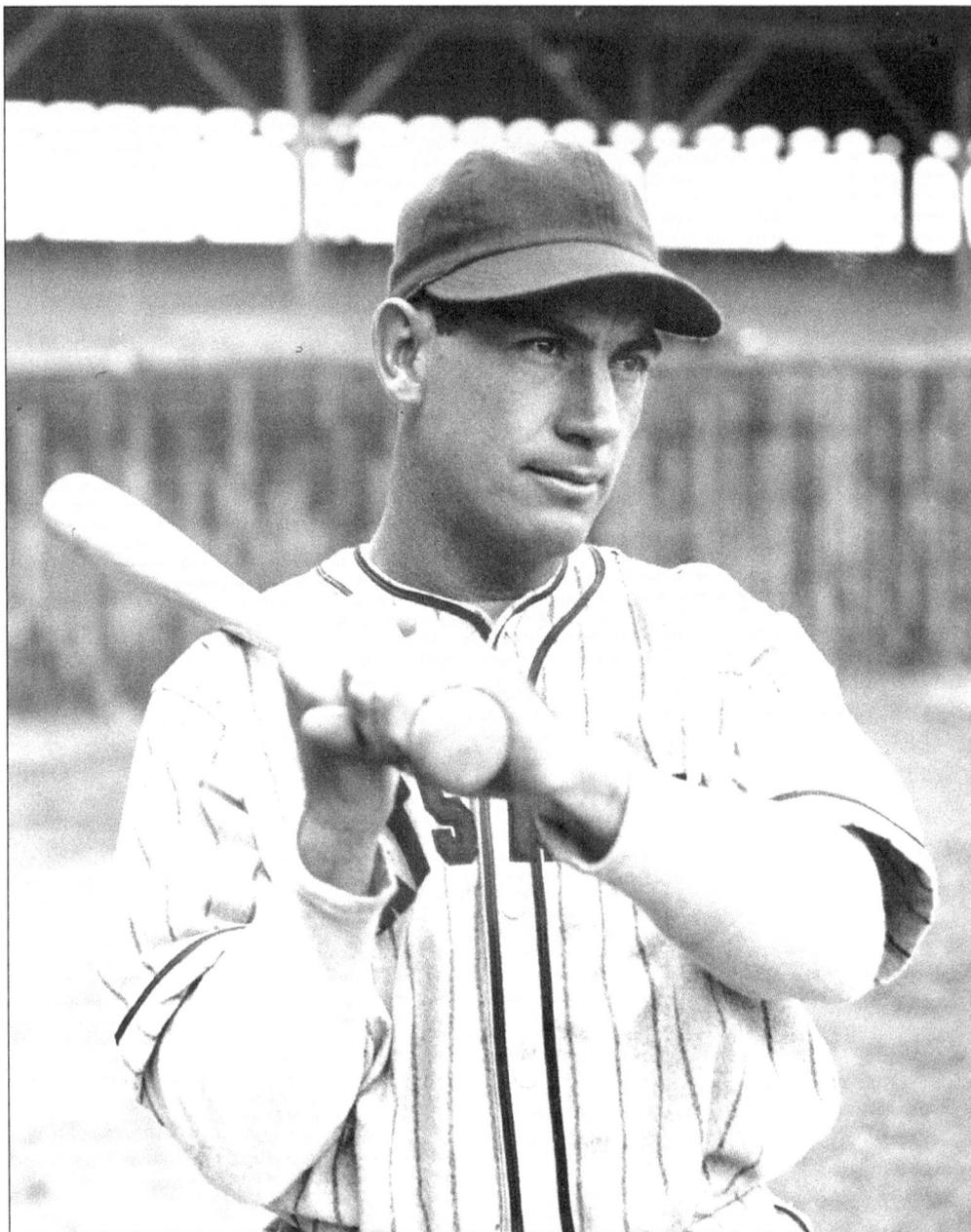

**ACE PARKER, PORTSMOUTH'S SLUGGING SHORTSTOP, 1939.** With the grandstands of Sewanee Stadium looming behind him, Clarence "Ace" Parker poses for the photographer in the early days of the 1939 Piedmont League season. Several years earlier, as a star athlete with Wilson High, "Ace" dominated opponents on the Sewanee turf in baseball, football, and track. At the time of this picture he had already logged two seasons with the Philadelphia Athletics, but proved less than effective at the plate, struggling to master major league pitching and failed to break the .230 barrier. Upon his return to the Portsmouth Cubs he quickly established himself as a force with the bat by compiling an impressive .303 average during the 1939 campaign. (CSTG.)

# FOUR

# The Ace of Them All
# Portsmouth's Hometown Hero
# Clarence "Ace" Parker

Without question, Clarence McKay Parker proved to be one of the most gifted all-around athletes the Commonwealth of Virginia has ever produced. Growing up in Norfolk County, currently the city of Portsmouth, Parker first realized his talents while enrolled at Woodrow Wilson High School. It soon became evident to teachers, coaches, and fellow students that the young athlete was adept on all fields of competition and by his senior year he dominated the Tidewater area in baseball, football, track, and golf, leading the Presidents to a number of city, state, and regional championships. His athletic exploits prompted a local sports writer, Bill Cox, to label Parker the "Ace of them all" and the name stuck. Soon the most talented athlete in the area was no longer referred to as Clarence, but became well known throughout Tidewater as "Ace" and the legend began.

As college beckoned, Parker expressed a desire to play for Virginia Tech but selected Duke University because of his family links to North Carolina. By his senior year in 1936, his exploits on the gridiron were legendary, earning him All-American honors. When people met Parker for the first time, they were surprised at his unassuming personality and diminutive physique. Ace stood just a tad less than six feet and often walked with a slouch that made him look even shorter while his playing weight rarely exceeded 175 pounds. By the time he completed college he was known as a legitimate triple threat on the turf with exceptional talents in passing, running, and kicking that were second to none. Following graduation, the professional ranks beckoned and Ace found himself drafted 13th overall by the Brooklyn Dodgers of the National Football League.

Surprisingly, with his natural ability and All-American status on the gridiron, football did not figure prominently in Parker's future plans. Following the NFL draft, he informed the Dodgers that he was most interested in playing baseball and he agreed to a contract offered by Connie Mack, the grand old master of the Philadelphia Athletics. Without playing a single day of minor league baseball, Ace made the final cut with the team and began his major league career in the spring of 1937. On April 30, Connie Mack sent Ace to the plate as a pinch-hitter late in a game against the Red Sox at Boston's Fenway Park. Bosox hurler Wes Ferrell delivered and Parker connected for a home run, becoming one of only a select few to accomplish this feat in their first professional at bat. Despite this impressive beginning Ace managed only another homer and struggled during the season against major league pitching as his meager .117 average shows.

As the 1937 baseball season was winding down, the Brooklyn Dodgers of the National Football League became more adamant in their desire to have Ace finish out what was left of the campaign. With

permission granted by Mack, Parker stored his Philadelphia flannels and stepped into the padding and helmet of the hapless Dodgers. In his first professional football game, Ace played 57 minutes against the Philadelphia Eagles in a 14-10 loss; he completed 10 passes for 122 yards in his NFL debut. During the final games of the season with Ace as their field general, the Dodgers posted a dominating victory over the Pittsburgh Steelers and a surprise tie with their most hated rivals, the New York Giants, in the season finale. Known for his skills on offense as well as defense, Ace could do it all. He served as a quarterback with an uncanny touch for precision passing and could avoid tacklers while scrambling down the field. He proved to be one of the best in catching passes and returning kicks for the Dodgers that year. He topped it off by kicking the extra points after each touchdown scored.

As the 1938 baseball season approached, Ace continued thinking that football was still only a diversion. Re-signed by the Athletics for a second season, it did not take long for opposing pitchers to discover Parker's weakness in hitting the elusive curve ball and he was fed a steady stream of junk ball pitches when he stepped to the plate. In 56 games he managed only a .230 average. Instead of waiting until the end of the major league season, Ace was granted permission by the Athletics to report to the NFL for preseason training at Princeton and soon established himself as leader and savior for the lowly Dodgers. In his first full National Football League season, Parker quickly became one of the best in the gridiron circuit, leading the Dodgers to a 4-4 record and garnering All-Pro honors as he dominated the league in passing.

During the winter, Connie Mack reluctantly sold Ace to the Chattanooga Lookouts of the Southern Association who in turn allowed Portsmouth Cubs owner Frank D. Lawrence to acquire Parker. The 1939 season at Portsmouth's Sewanee Stadium proved to be a breakout year for Ace on the diamond while serving as the Cubs' shortstop in 116 games and batting an impressive .303 during the campaign. Upon returning to the National Football League in the fall of 1939, Ace found himself on a team with few equals. The Dodgers continued to struggle and could post only a 4-6-1 record, well behind the New York Giants and the Washington Redskins.

In the spring of 1940, with a chance to break into baseball's major leagues, Ace failed to make the final cut with the Pittsburgh Pirates and was optioned to the Syracuse Chiefs. Parker immediately responded to International League pitching and surfaced as the leading hitter during the first month of the season. In a heart wrenching moment on the afternoon of May 11, 1940, the scrappy shortstop broke his left leg and dislocated his right ankle sliding across home during a game against the Toronto Maple Leafs. With an impressive .396 average in his pocket, Ace had been informed only hours earlier that the National League Pirates were ready to call him up to join the club. He was finished for the season and his football career appeared in jeopardy. Despite the seriousness of the injury, Ace surprised his critics and found himself on the Ebbet's Field gridiron for the opening game of the1940 football campaign sporting a 4-pound brace strapped to his leg. With no one expecting him to continue at his previous levels, he put together the best season of his career and led the Dodgers to their first winning record in years. His credentials for the year say it all: 49 points scored; 306 yards rushing; 3 touchdowns scored; 817 yards passing; 10 touchdown passes thrown; 139 yards receiving; and 2 touchdown receptions. His exploits for the 1940 season earned him the league's Most Valuable Player award and All-Pro honors.

Suiting back up with the Portsmouth Cubs in 1941, Parker suffered another setback, this time fracturing his right leg sliding into second base during a game early in the season. He recuperated fast enough to find himself with the NFL Dodgers in 1941 until he joined the Navy. Ace played for and managed the Norfolk Naval Training Station Blue Jackets throughout the course of World War II.

After the war, Parker logged two years in professional football and continued to play baseball from 1946 until 1952 with the Portsmouth Cubs and Durham Bulls. Following his pro career, he returned to Duke University and served as baseball coach for the Blue Devils until 1965. For his exploits on the gridiron, Clarence "Ace" Parker was inducted into the National Football Hall of Fame in 1972.

**A THREAT IN ANY SPORT AT WILSON HIGH.** This collage of photos show a young Clarence Parker doing what he did best: setting the standard for high school athletics in the Hampton Roads area in the early 1930s. While enrolled at Wilson High School, "Ace" dominated every sport in which he suited up, whether it was track and field, football, or baseball. His talents also extended to the links and he often challenged, and at times bested, fellow schoolmate Chandler Harper on the local greens. Both local legends continued to play the local greens well into their senior years. (CSTG.)

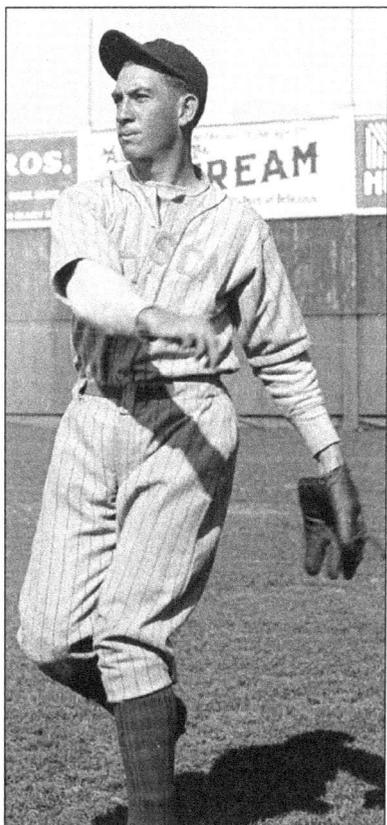

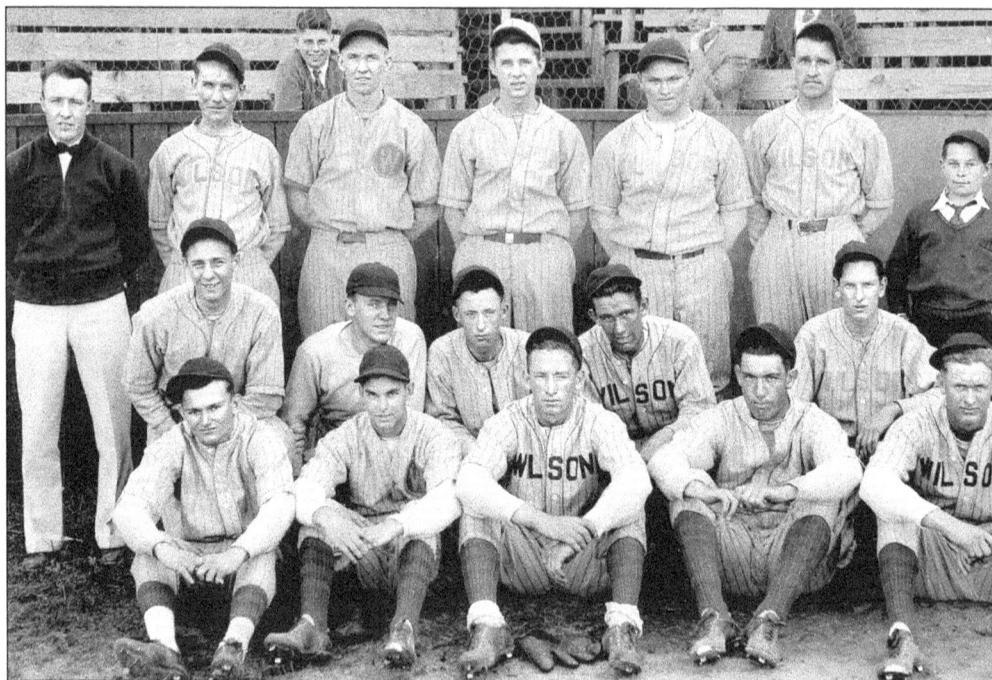

**ACE AND THE PRESIDENTS, 1933.** The Wilson High School baseball squad poses in front of the bleachers at the Washington Street ballpark in the spring of 1933. The members of the Presidents are, from left to right, (front row) Captain George Howard, "Lefty" Pendleton, Glen Lawson, Ace Parker, and Edgar Hollowell; (middle row) Harry Brownley, Butler, Mason Vincent, Charles Andrews, and Elwood Batten; (back row) Coach Kibler, Virgil Ala, Moore, Doxey, William Harrell, Theodore Gartman, and manager Shirley White. (NPL.)

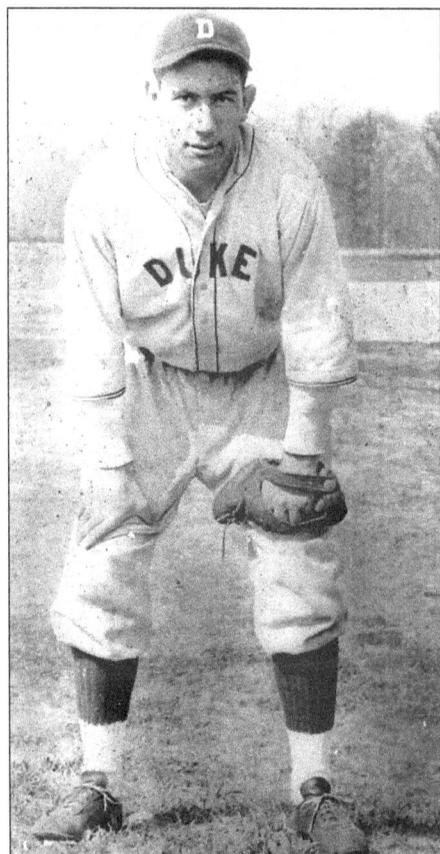

**ACE PARKER AT DUKE UNIVERSITY.** Once Ace decided that he wanted to be a Blue Devil and attend Duke University, it was only a matter of time before he continued his legacy in a variety of sports. While his most memorable days came on the gridiron, his skills with a bat and ball were well known throughout the campus. In this photo, Ace strikes a defensive pose during his final year at Duke before beginning his professional career with the Philadelphia Athletics in the spring of 1937. Despite his exemplary skills on the gridiron, Ace was adamant that his future would be in professional baseball and not with the National Football League. (From the collection of Mike Haywood.)

**TWO HOMBRES AND A BALKY BURRO, 1937.**
Connie Mack's Philadelphia Athletics held
their spring training south of the border in
Mexico to prepare for the upcoming 1937
season. This March 4 photo shows rookie first
baseman Gene Hasson attempting to persuade a
hesitant burro to carry fellow rookie Ace Parker
to where he wants to go. The two young recruits
impressed the A's enough to earn spots on their
opening day major league roster. Ironically,
their paths crossed in the future when Hasson
joined Parker as a member of the Portsmouth
Cubs in 1946 and 1947. (National Baseball Hall
of Fame.)

**CRUISING TO BROOKLYN, 1937.** Looking dapper
in overcoat and hat, Clarence "Ace" Parker
strikes a pose on the deck of the *Virginia Lee*
as he begins his journey to Brooklyn and his
inaugural season in the National Football
League. With Connie Mack granting Ace
permission to leave the Athletics late in the
major league season, the two-sport star joined
up with the Dodgers in November and served
as a catalyst for the Brooklyn doormats as they
completed the 1937 season with some new
found respectability. (NPL.)

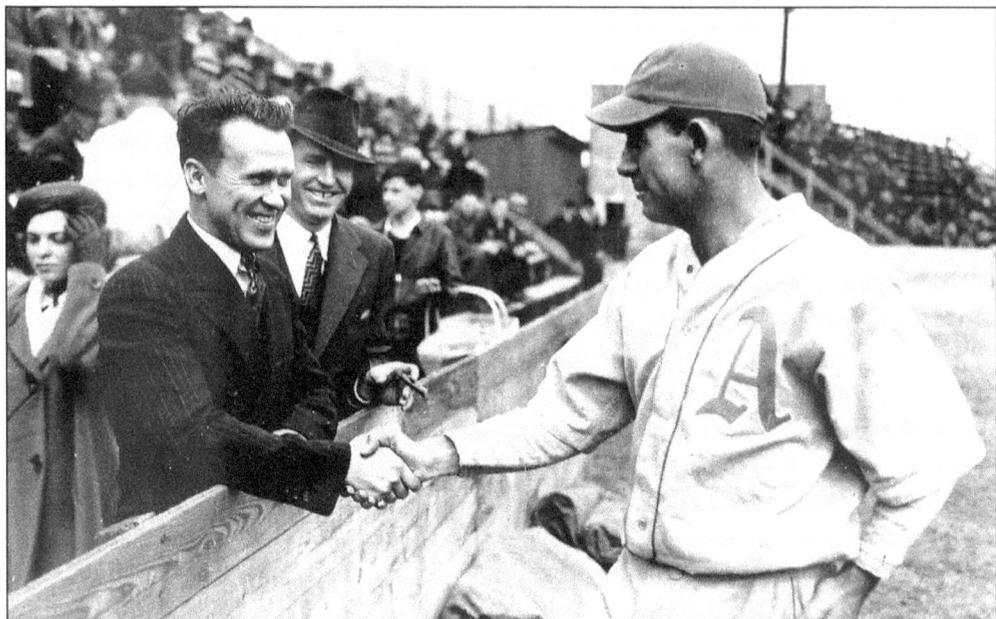

**ACE COMES HOME TO PORTSMOUTH, 1938.** On Saturday, April 9, 1938, homegrown hero Clarence "Ace" Parker returned to his old stomping grounds as a bonafide major leaguer. Starting his second year with Connie Mack's Philadelphia Athletics, "Ace" is shown in the top photograph renewing acquaintances with an old friend and fellow athlete from his Wilson High School days, Teddy Carson. The Mackmen arrived in the Hampton Roads area and staged contests with the Norfolk Tars and the Cubs before heading north to begin the official American League season. The game in Portsmouth drew 1,501 diehard fans as they braved a stiff wind and chilly temperatures on the bleachers of Sewanee Stadium. The hometown Cubs came up short in the exhibition, losing to the Athletics 7 to 4, as the National Leaguers sent three wind-aided homers over the wooden outfield fences. "Ace," shown in the bottom photo, readies himself to take a cut in the batter's box during the match, but was unable to contribute to the fireworks and went one for five as the Cub pitchers held the local legend to a single. (NPL.)

ACE WITH THE ATHLETICS, 1938. Displayed here is a home program for the Philadelphia Athletics showcasing the team, including Portsmouth's own Ace Parker, surrounding their legendary manager, Connie Mack. In 1938, the A's continued their entrenchment in the National League cellar by finishing 43 games behind the pennant winning Chicago Cubs. Only two of the regulars batted .300 or above and none of the pitchers on the staff boasted a winning record. Mack began to pencil Parker into the starting lineup with some regularity during the 1938 campaign as Ace appeared in a total of 56 games. Despite an increase in plate appearances, he continued to struggle with the bat and posted only a .230 batting average while serving in a number of infield positions for the Mackmen. (CSTG.)

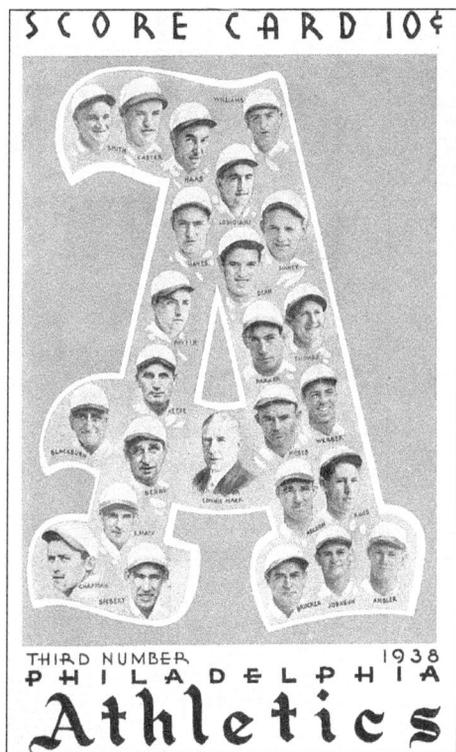

A FLORIDA TRIO, 1940. In the spring of 1940, Portsmouth Cubs owner Frank D. Lawrence was touting hometown hero, Ace Parker, to as many major league teams as possible and soon discovered that the National League Pittsburgh Pirates were anxious to sign the Portsmouth slugger to a contract. Parker reported to the Bucs for spring training and remained on the roster until just before the opening of the season when he was optioned to the Syracuse Chiefs of the International League. Posing in the Florida sunshine during an off day from the diamond are *Virginian-Pilot* sports writer Abe Goldblatt (left), Ace (right), and his wife, Thelma. (CSTG.)

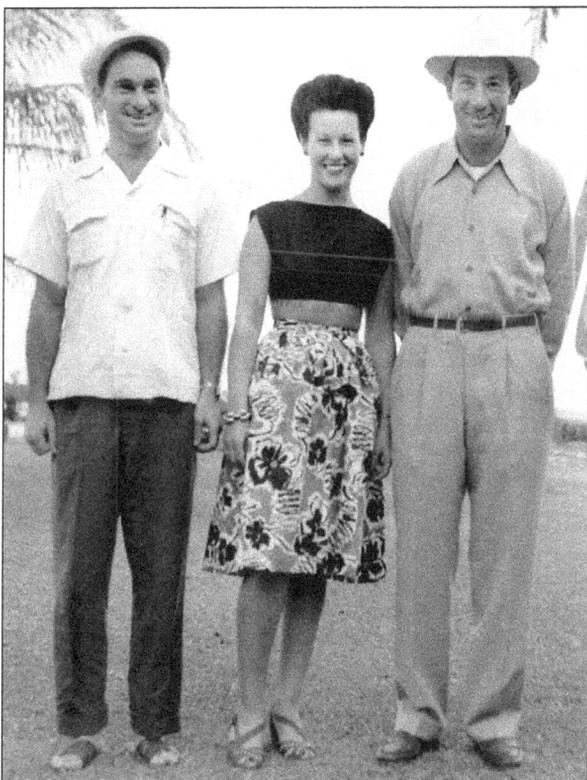

# BROOKLYN DODGERS
### VS.
# WASHINGTON REDSKINS

**EBBETS FIELD**

**Sunday**
**NOV. 10**
**1940**

ACE PARKER
Dodger Star of Stars

**NEXT HOME GAME**
**Sunday, November 17, at 2:05 P. M.**
**DODGERS vs. CLEVELAND RAMS**

BROOKLYN DODGERS NATIONAL FOOTBALL LEAGUE PROGRAM, 1940. By 1940, Ace had already firmly established himself as one of the top players in the NFL. This program features his likeness on the cover for a game between the Brooklyn Dodgers and the powerhouse Washington Redskins at Ebbets Field. The November 10th game resulted in an exciting victory for the Dodgers as Ace led the team to a 16-14 upset of the 'Skins. Ace did it all during the 1940 season as he displayed unequalled excellence in passing, rushing, and punting. The 28-year-old tailback and defensive back scored a total of 49 points, threw 10 touchdown passes, and rushed for 2 more from the ground. He earned the 1940 National Football League's Most Valuable Player Award for his dominance on the gridiron. (From the collection of Mike Haywood.)

**SERVING THE WAR EFFORTS IN PINSTRIPES, 1942–1945.** Like a number of professional baseball and football players, Ace Parker put his sports career on hold and joined the military to support the war effort in 1942. Pictured above, Parker and his Norfolk Naval Training Station Blue Jackets teammates share a light moment before a spring game staged at McClure Field located on the Norfolk Naval Base. Pictured from left to right are Sam Chapman, Bob Feller, Fred Hutchinson, and Ace Parker. The Blue Jackets visited Portsmouth Stadium on April 4, 1942, for a Navy Relief game and drew 4,500 fans as the sailors drubbed the Cubs 8 to 0 with Bob Feller on the mound. In the photo below, the NTS Blue Jackets pose for the final time in 1945 with player-manager Ace Parker seated on the far left of the bottom row. The team boasted a number of major leaguers including Clyde McCullough, Max Surkont, and Jack Robinson. Local scout Harry Postove takes a central position in the back row in his Navy uniform, serving as official scorer for the team. (CSTG.)

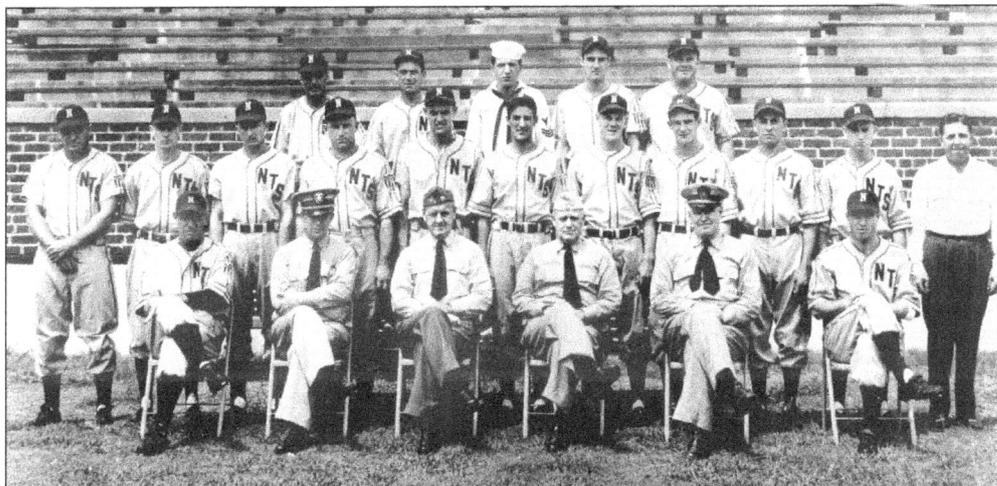

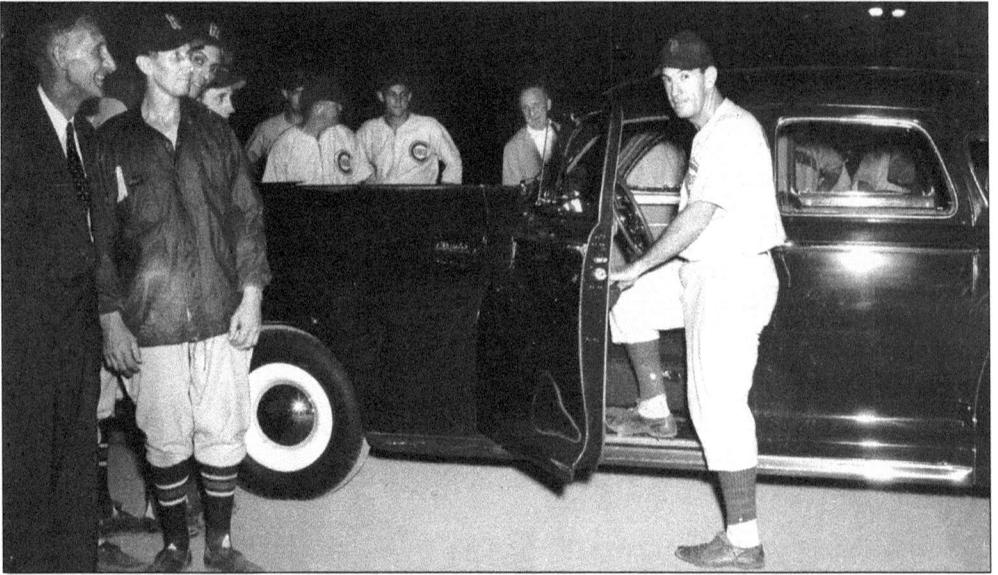

**ACE GETS AN AUTO, 1946.** On the evening of July 29, 1946, the city staged "Ace Parker Night" with 5,640 fans filling the seats at Portsmouth Stadium to honor one of their own. As a special gesture of appreciation, the Portsmouth Sports Club presented Ace with a brand new 1946 Chrysler sedan. The photo above shows club president George T. McLean (far left), Richmond manager Ray Berres (second from left), and Portsmouth Cub players watching as Ace climbs behind the wheel of his new car. (CSTG.)

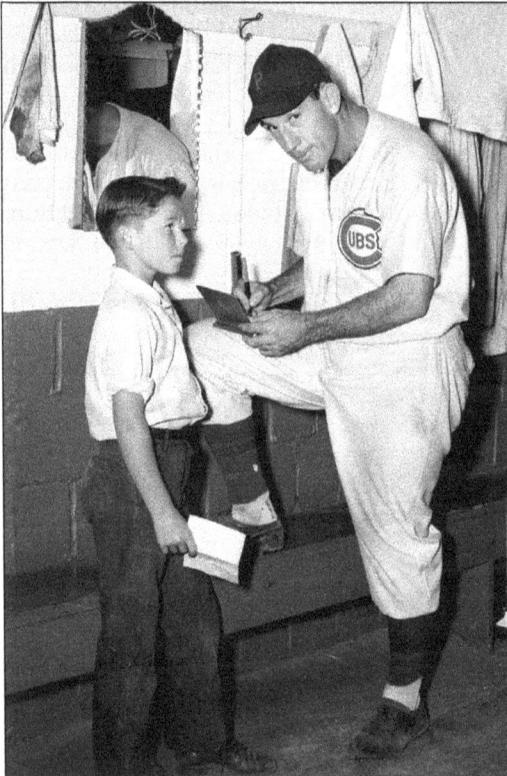

**AN AUTOGRAPH REQUEST, 1946.** In the clubhouse within the bowels of Portsmouth Stadium, Ace Parker grants a request for an autograph from an admiring young fan. Fresh from being honored on "Ace Parker Night" at the ballpark, the hometown hero was more than willing to take the time for the autograph before dressing and leaving the stadium for the last time as he completed the 1946 season. Despite logging only 92 games with the Cubs, Ace captured the Piedmont League batting title with an impressive .331 average. The next day he was on his way to preseason training with the New York Yankees of the All-American Football Conference and his last year as a professional on the gridiron. (NPL.)

**ACE WITH THE YANKS, 1946.** In his final year of professional football, Ace Parker found himself a member of the newly formed All-American Football Conference. Organized by Arch Ward, the sports editor of the *Chicago Tribune*, the rival league enticed over 100 National Football League players to their fold for the 1946 season. Ace Parker signed a lucrative contract with the New York Yankees and served as the team's veteran playmaker, recapturing some of his old fire as he led the squad to a first place finish. In the championship game with Cleveland, the contest was nip and tuck until the final moments when a pass from Parker was intercepted during the Yankees' final drive giving the trophy to the Browns. (CSTG.)

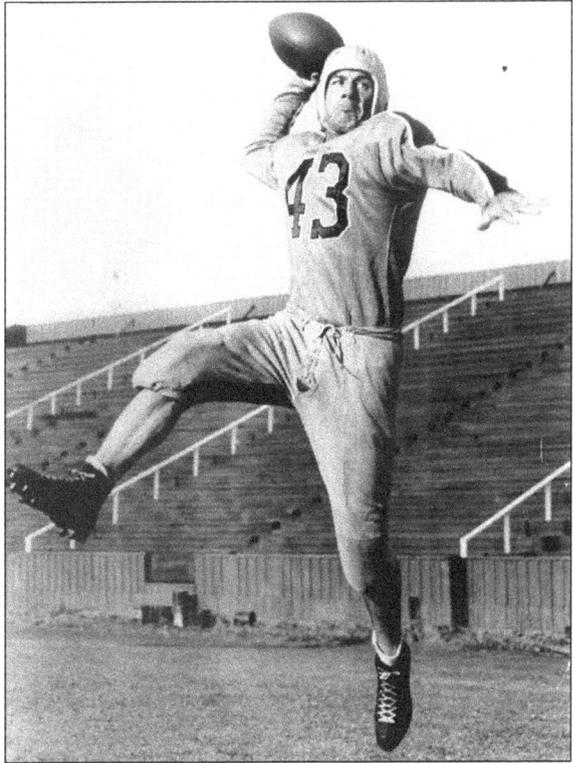

**SPORTSMAN OF THE YEAR.** On January 27, 1956, the Portsmouth Sports Club honored Clarence "Ace" Parker as the city's "Sportsman of the Year" for 1955. Presenting the trophy to Ace is W.N. Cox, sports editor of the *Virginian-Pilot* newspaper. It was Cox that gave Parker the nickname of "Ace" during his sophomore year at Duke University, where he earned All-American status for his exploits on the gridiron. At the time of the presentation, Ace was the baseball coach at Duke. (PPL.)

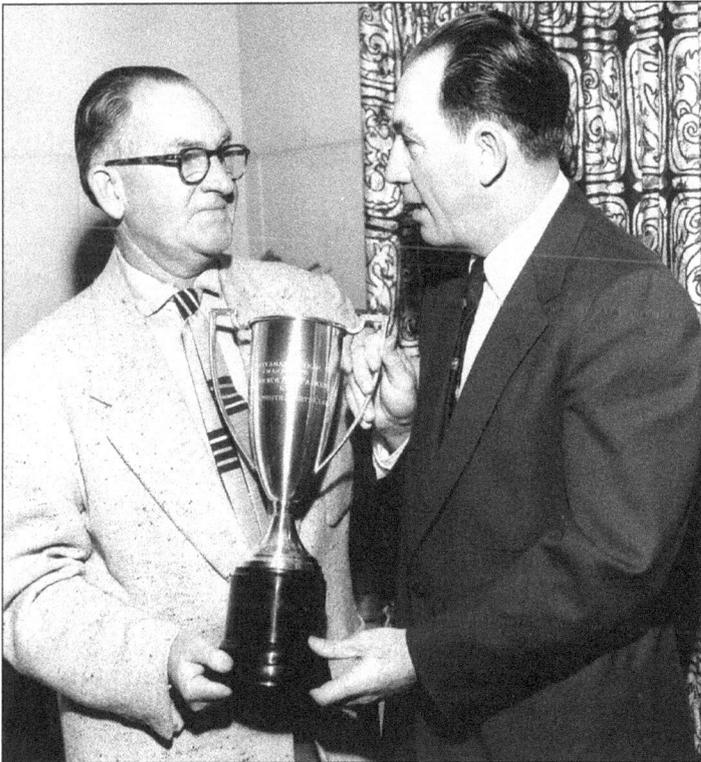

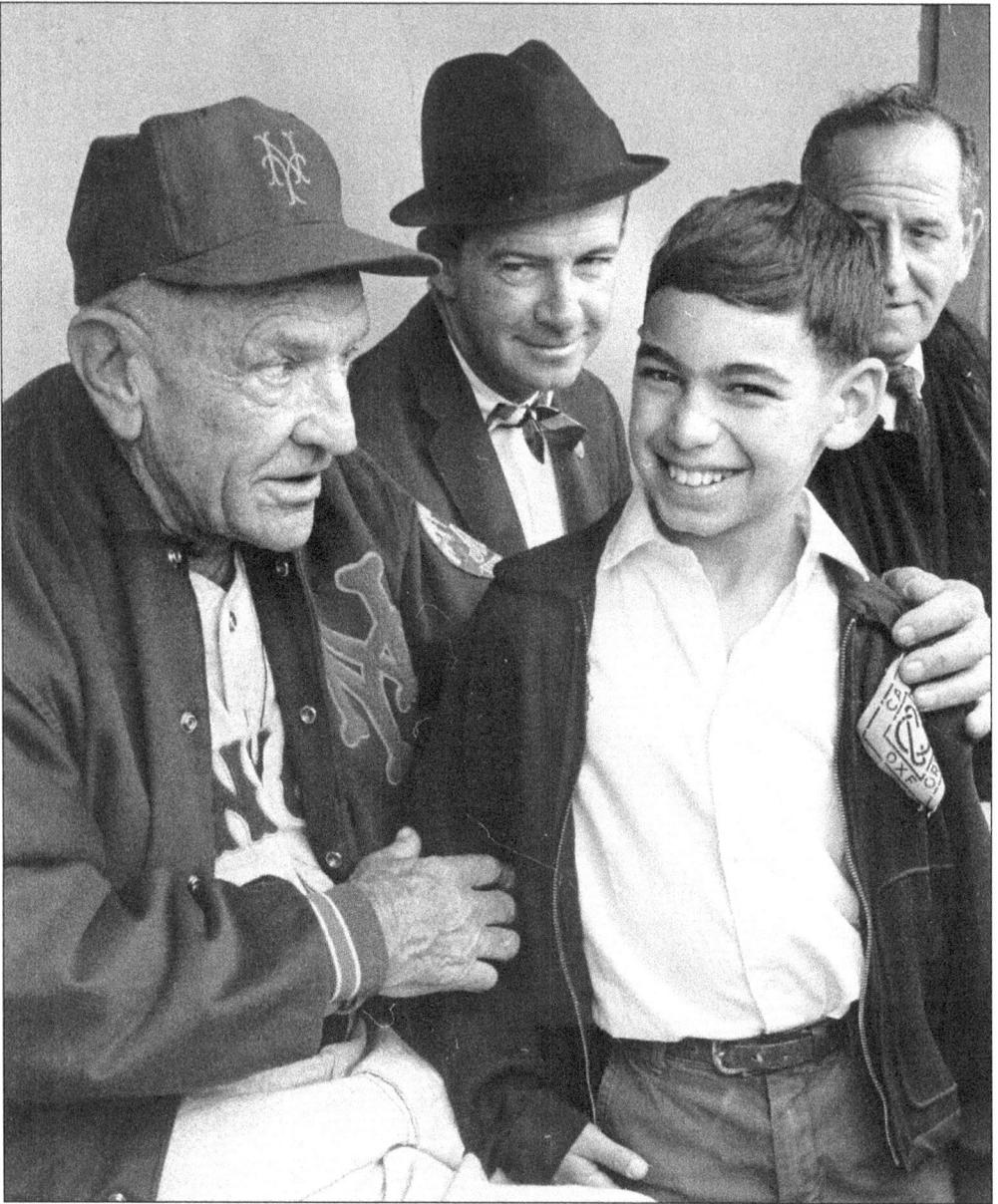

THE "OLD PROFESSOR" AND A YOUNG PORTSMOUTH BASEBALL FAN, 1964. As can be seen in this candid photograph, it was a special day for Danny Goldblatt, the younger son of *Virginian-Pilot* sports reporter, Abe Goldblatt. On April 11, 1964, the New York Mets came to town to stage an exhibition game against the Baltimore Orioles. The lovable losers of the National League continued to be guided in their third year by 75-year old baseball legend Casey Stengel, shown here giving young Danny a bit of advice on the game or possibly life itself. Known as the "Old Professor" out of respect for his managerial skills, Stengel began his playing career with the Brooklyn Dodgers in 1912, and served as a reliable outfielder for a number of clubs before his retirement in 1925. After his playing career, he took his first managerial job in the Pacific Coast League. He will be forever remembered as the skipper for the New York Yankees during their years of dominance from 1949 until 1960. (CSTG.)

# FIVE

# The Legends Come
# to Cubville

Beginning before the turn of the century, it was not unusual for a distinctive thrill and enthusiasm to permeate throughout the city when it was announced that the ballpark would play host to the celebrity and notoriety of a major league ball club. Fans of baseball in Portsmouth proved to be knowledgeable and venerable scholars of the game, keeping up with the exploits of their own team but also enjoying and studying the game at the national level. Longtime Portsmouth patriarch, Frank D. Lawrence, admired the talent at the major league level and made every effort to bring the big name teams to the city for scheduled exhibitions. Since the Piedmont League Cubs were not directly affiliated with any major league club on a formal basis, it provided him the freedom to contract with a variety of teams to visit Portsmouth Stadium.

On one special day in 1927, the reigning commissioner of baseball, Kenesaw "Mountain" Landis, honored Portsmouth with a visit. Portsmouth Trucker owner Frank D. Lawrence invited the cranky baseball icon to take in a Virginia League game at High Street Park and an ensuing cyclone nearly destroyed the stadium with Landis narrowly escaping with his life. Despite repeated invitations to the commissioner for a return visit over the subsequent years, Landis never again set foot in the city and was quoted as saying that every time he experienced a windy day his thoughts go back to his day spent in Portsmouth, Virginia.

From 1935 until the final years of baseball in Portsmouth, a virtual parade of stars and celebrities who performed for the fans of the city was chronicled in the daily press. In 1936, the bleachers of old Sewanee Stadium were packed when Casey Stengel and his Brooklyn Dodgers arrived in town along with former Norfolk Tar Buddy Hassett to take on the Truckers. In 1941, just before the advent of World War II, Roger Peckinpaugh's Cleveland Indians arrived with the most dominating of all pitchers in the majors, Bob Feller. While "Rapid Robert" did not appear in the exhibition game, he thrilled local fans by pitching batting practice and mingling with the crowd before and after the contest.

As the 1942 baseball season began, numerous major league stars had enlisted in the Armed Forces for the war effort. Many of the players were assigned to the Norfolk Training Station, including Bob Feller, Sam Chapman, Vinnie Smith, Ace Parker, and Fred Hutchinson. In the spring of 1942, the "Blue Jackets" visited Portsmouth Stadium and took on the Cubs, skippered by Yankee legend Tony Lazzeri. The Navy team proved that they were untouchable with Feller on the mound as he struck out Lazzeri twice during the contest. With both the Norfolk Tars and the Portsmouth Cubs in their backyard, the Navy ball teams were frequent visitors to the local ballparks.

With the city christening a new ballpark, Portsmouth Stadium, in the spring of 1941, owner Frank D. Lawrence wanted to stage a special event for the local fans. Lawrence sent out invitations to many of the most notable players who suited up for the Truckers and Cubs over the years. The list of players

that accepted his invitation and pledged to play in a game against the current Cubs looks like a Who's Who in baseball: Hack Wilson, Pie Traynor, Eddie Stanky, Ace Parker, Jimmy Viox, Joe Heving, Les Bangs, Minnie Manning, Sam Post, and Molly Craft. The stars of yesteryear beat the 1943 Cubs in an exciting contest before more than 4,000 appreciative fans.

Over the years, Frank D. Lawrence invited two of baseball's most admired and loved icons to the city for special celebrations: Connie Mack and "Happy" Chandler. Mack, "The Grand Old Man of Baseball," accepted invitations to the city on four occasions and brought his Philadelphia Athletics to town for exhibitions either against the local nine or other major league teams. Lawrence usually filled the day of Mack's arrival with special events including luncheons, parades, and cookouts on the riverfront lawn of his home. Baseball commissioner Happy Chandler made special visits to the city whenever requested by Lawrence. He served as master of ceremonies at Lawrence's 40th year celebration of his career in banking and baseball and was even persuaded to serenade the crowd with his famous rendition of "My Ole Kentucky Home" during the event. Sharing the stage with Chandler was Broadway dancer and movie star Bojangles Robinson who showed off his footwork on a special platform constructed over home plate.

In the era of the Tidewater Tides, the most regular visitor to the city proved to be the hapless New York Mets. With the "Ole Professor," Casey Stengel, managing the team, the Mets won over many fans with their somewhat uninspired style of play that always seem to produce entertaining contests for the many spectators that filled the ballpark.

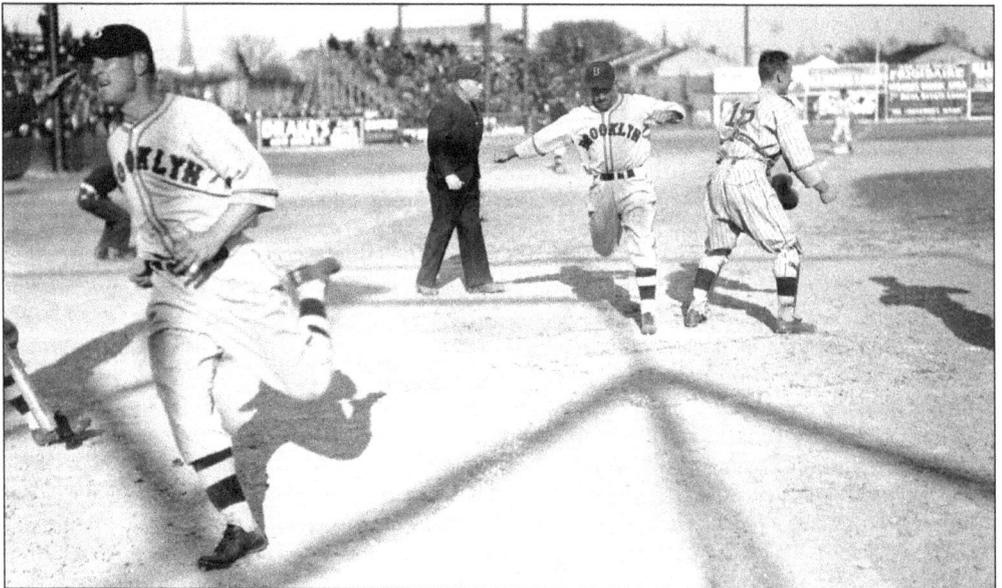

THE BROOKLYN DODGERS COME TO TOWN, 1936. On April 4, 1936, Casey Stengel brought his Brooklyn Dodgers to Portsmouth to take on the Cubs in a preseason exhibition game. With a crowd of almost 2,000 bundled in overcoats and gloves trying to stave off a brisk and chilly wind, the National Leaguers easily shutout the hometown heroes 6 to 0. The action-filled photograph above shows Dodger shortstop Jack Radtke touching the plate as third baseman Frank Skaff heads to the dugout after both were driven in by a single off the bat of Frenchy Bordagaray. George Barr, the National League umpire officiating the contest, watches the action as the Cub catcher waits for a late throw from the outfield. (CSTG.)

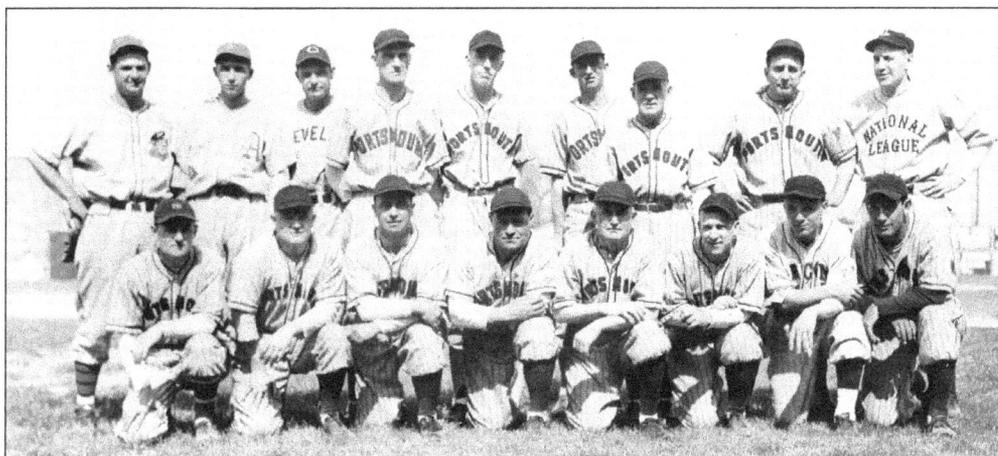

PORTSMOUTH'S BASEBALL ALUMNI RETURN, 1941. Owner Frank D. Lawrence assembled an impressive group of former players to participate in a celebratory game to christen the newly completed Portsmouth Stadium on Sunday, April 13, 1941. In the top photo, the following players are listed from left to right: (front row) Allie Watt, Bill Dietrich, Stuffy McCrone, Hack Wilson, Jimmy Viox, Les Bangs, Eddie Stanky, and Ace Parker; (back row) Ed Yount, Hal Wagner, Joe Heving, Molly Craft, Sam Post, "Cowboy" McHenry, Minnie Manning, Dixie Parker, and Pie Traynor. In the bottom photo Hack Wilson (with bat on shoulder) holds court with (left to right) Joe Heving, Jimmy Viox, Pie Traynor, and "Ace" Parker before the game. (CSTG.)

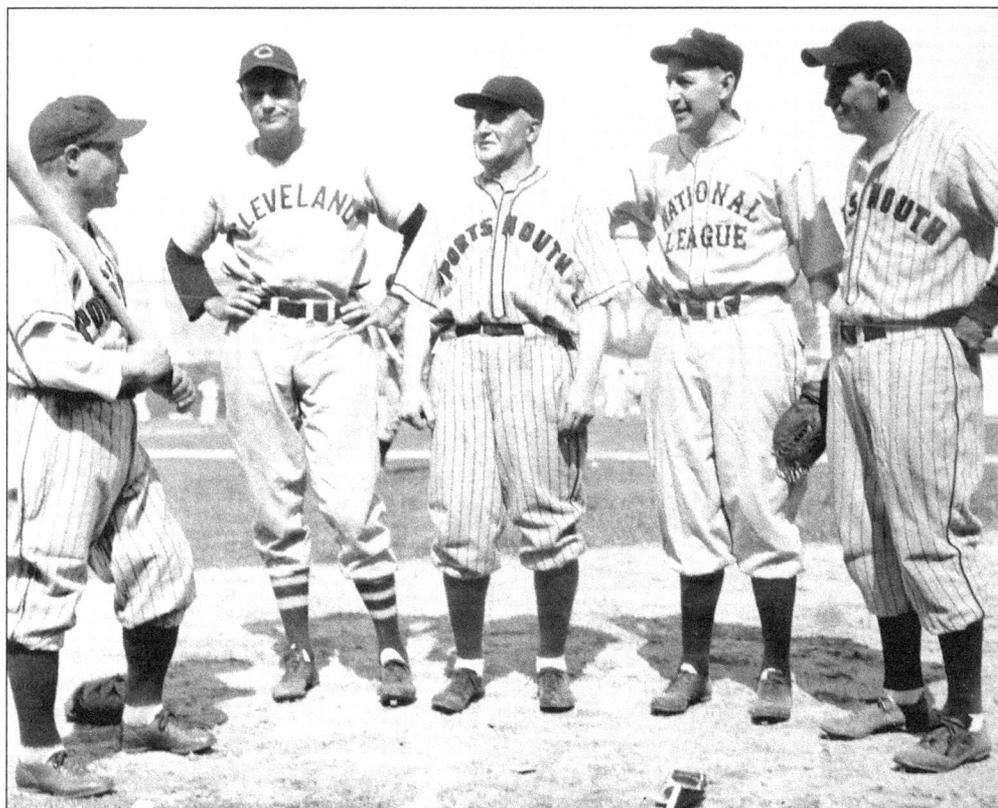

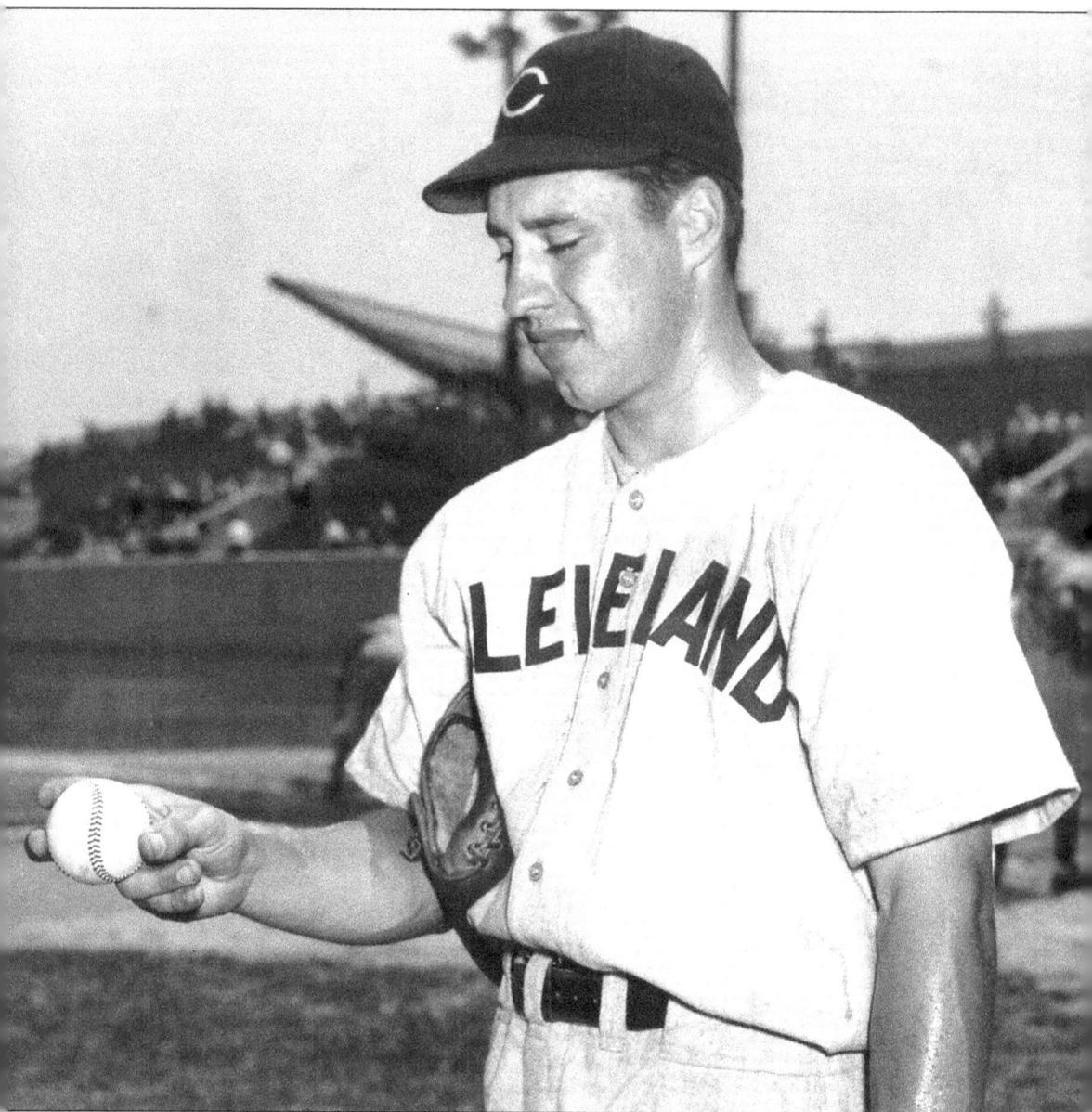

**BOB FELLER AND THE CLEVELAND INDIANS VISIT PORTSMOUTH, 1941.** "Rapid Robert" Feller and the Cleveland Indians stopped by the newly constructed Portsmouth Stadium on July 28, 1941, for an exhibition game against the hometown Cubs. Feller, shown here glistening with sweat after pitching 15 minutes of batting practice to the delight of the 3,000 plus fans, shows off the grip for his famous two-fingered fastball. The game proved to be a scorcher on the diamond and in the stands as temperatures soared into the 90s. Tribe first baseman Hal Trosky sent a pitch streaking over the outfield wall of Portsmouth Stadium with the bases loaded as Cleveland nipped the home team in an exciting game, 7 to 6. Bob Feller would enjoy one of the best years of his storied Hall of Fame career during the 1941 season. The big right-hander posted a 25-13 record and led the league in wins, strikeouts (260), innings pitched (343), shutouts (6), game appearances (44), and games started (40). There was simply no one better in all of baseball when pitching from the mound. (CSTG.)

BOJANGLES ROBINSON, 1945. On the evening of August 20, 1945, Portsmouth owner Frank D. Lawrence held a celebration at the stadium to honor newly appointed baseball commissioner "Happy" Chandler. Lawrence, never one to miss an opportunity to spice up any promotional event, invited renowned Broadway legend and movie star Bill "Bojangles" Robinson to perform for the fans. When Lawrence asked the star how much he would charge to dance, he replied that his going price was $3,000. When told that the event was to honor Chandler, Bojangles, an ardent baseball fan, stated he would do it for free. A platform was built over home plate and, with the local Coast Guard band supplying the music, the 67-year-old "hoofer" tapped and sang to the delight of the large crowd on hand. (CSTG.)

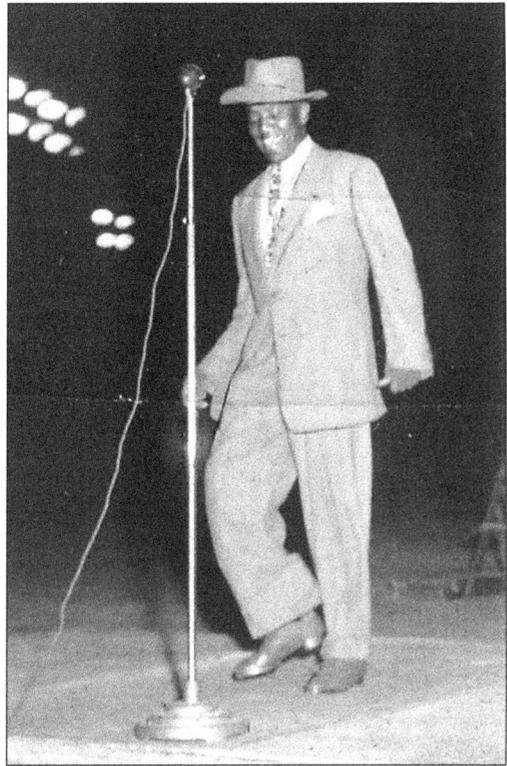

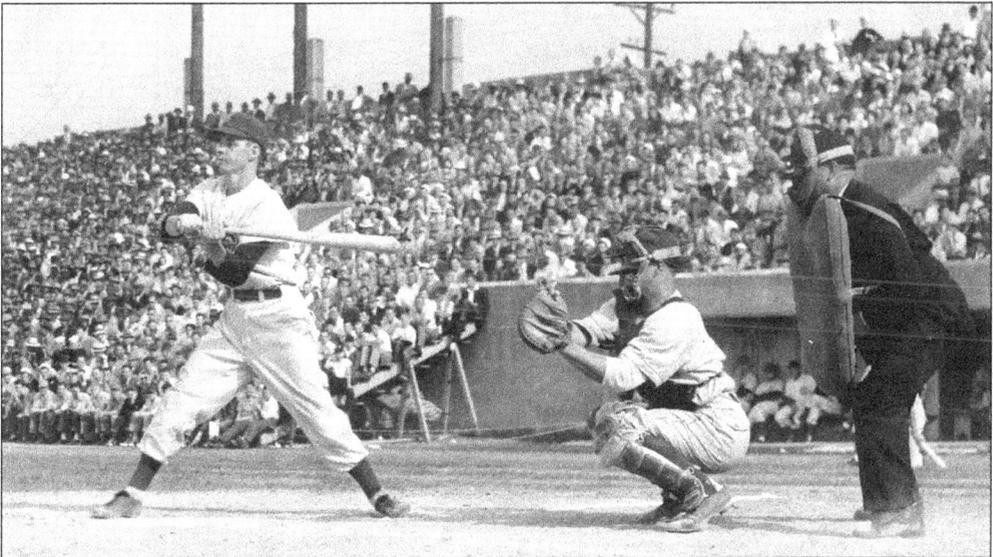

CUB PITCHER EARL MOSSOR TAKES ON THE ATHLETICS, 1949. On the afternoon of May 16, 1949, the Portsmouth Cubs played host to Connie Mack and his Philadelphia Athletics in an early season exhibition game that drew 7,465 fans to the ballpark. Shown taking a tentative cut against the likes of Philadelphia hurler Carl Scheib is Cub pitcher Earl Mossor as A's backstop Joe Astroth pockets the pitch. The American League visitors topped the locals 7 to 2 with Mossor taking the loss while giving up four walks and six hits in less than five innings of work. (From the family archives of Harry Land.)

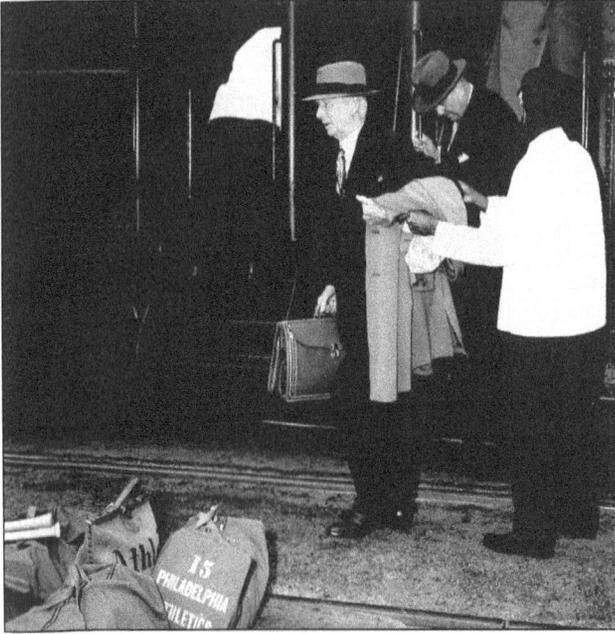

TAKING THE "A's" TRAIN, 1949. At precisely 10 o'clock on the morning of May 16, 1949, the Philadelphia Athletics pulled into Norfolk's Union Station for a full day of celebration and baseball in the city of Portsmouth. With help from a porter, "The Grand Old Man of Baseball," manager Connie Mack, disembarks the train as team baggage is unloaded on the platform. The Philadelphia entourage was met at the station by Frank D. Lawrence and escorted in a street parade to the Norfolk city docks with the group boarding a ferry to the Portsmouth side of the Elizabeth River. (PPL.)

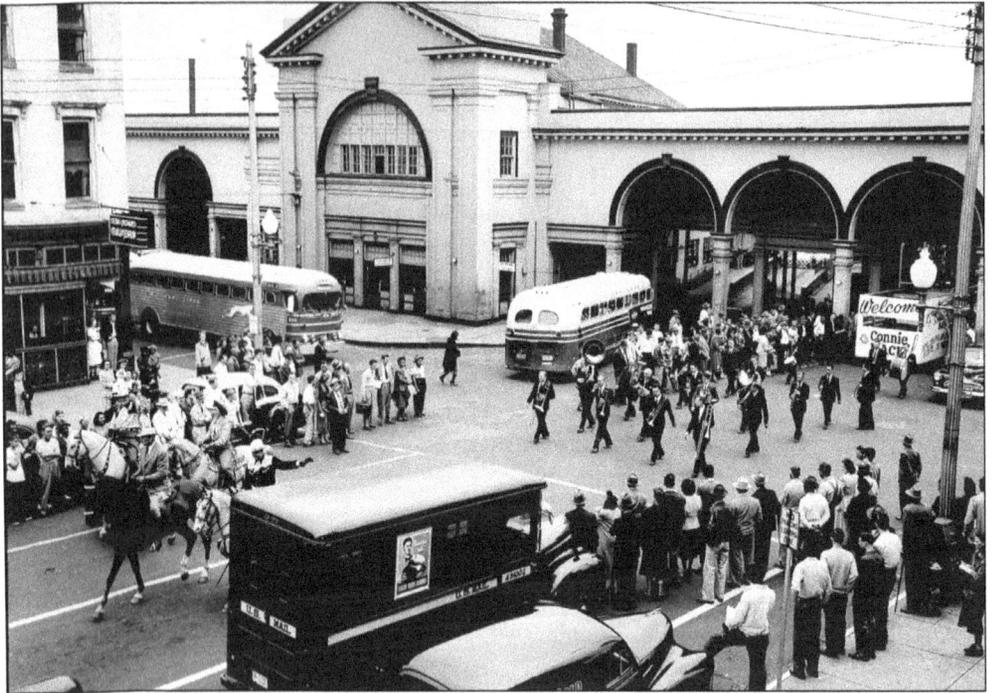

THE MACK PARADE COMMENCES AT THE PORTSMOUTH FERRY TERMINAL. Once the Connie Mack entourage arrived at the Portsmouth ferry terminal, a festive parade proceeded down High Street as enthusiastic local fans and well wishers cheered the visitors. Western riders and a marching band lead the honored guests who are housed in a special bus with "Welcome Connie Mack" painted on the front (far right side of photograph). The photo captures the stately architecture of the waterfront terminal, which housed the ferry that transported citizens and vehicles across the Elizabeth River to and from neighboring Norfolk. (PPL.)

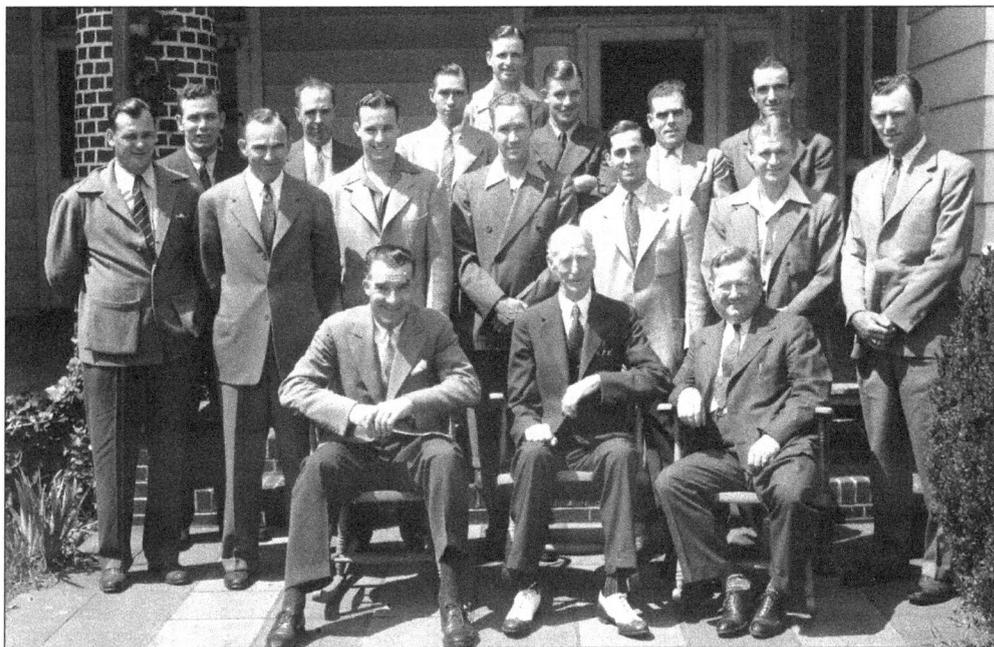

THE PHILADELPHIA ATHLETICS VISIT PORTSMOUTH, 1949. This group photograph taken on the steps of the Suburban Country Club on May 16, 1949, features Al Simmons (left), Connie Mack (center), and Cubs owner Frank D. Lawrence (right) seated in the foreground. Standing behind the trio are the Philadelphia Athletics featuring Sam Chapman, Ferris Fain, Pete Suder, Eddie Joost, Elmer Valo, Bobby Shantz, and a young second baseman by the name of Nellie Fox. The day was filled with parades, a luncheon, an exhibition between the Cubs and the National Leaguers, and finally a cookout at the home of Frank D. Lawrence. The ticket pictured below was one of 600 sold to fans attending the luncheon honoring Mack and his team. (CSTG.)

The Portsmouth Sports Club

SOUVENIR

presents

Connie Mack

AND HIS

Philadelphia Athletics

AT THE

Suburban Country Club

Luncheon: 1 P. M.

on Monday, May 16, 1949

CONNIE MACK
Mr. Baseball

TIDEWATER
BASEBALL FANS
—— HONOR ——
Eddie Stanky
Most Valuable Player 1950

Wednesday, Feb. 7, 1951
PETITE BALLROOM

Cocktails 6:00-6:30 P. M.
Dinner 6:30 P. M. (Promptly)

Stanky must leave at 9:30 to catch plane

EDDIE STANKY
Portsmouth 1937

EDDIE STANKY
N. Y. Giants 1950

PRESENT AT DOOR

No. 572

PORTSMOUTH CUBS VETERAN EDDIE STANKY HONORED, 1951. On the evening of February 7, 1951, Frank D. Lawrence threw a special banquet to honor Eddie Stanky, second baseman with the Portsmouth Cubs from 1936 to 1939. The ticket shown above allowed a lucky fan access to the Petite Ballroom to partake in cocktails, dinner, a floorshow, and remarks by Stanky and his admirers. In the photo below, Frank D. Lawrence poses with the guest of honor and wife, the former Dickie Stock. Interestingly, Mrs. Stanky was the daughter of Milt Stock, the manager of the 1943 Piedmont League champion Portsmouth Cubs. Lawrence is shown pointing out Stock's accomplishment in 1943 as they all admire the pennant from that successful campaign. (CSTG.)

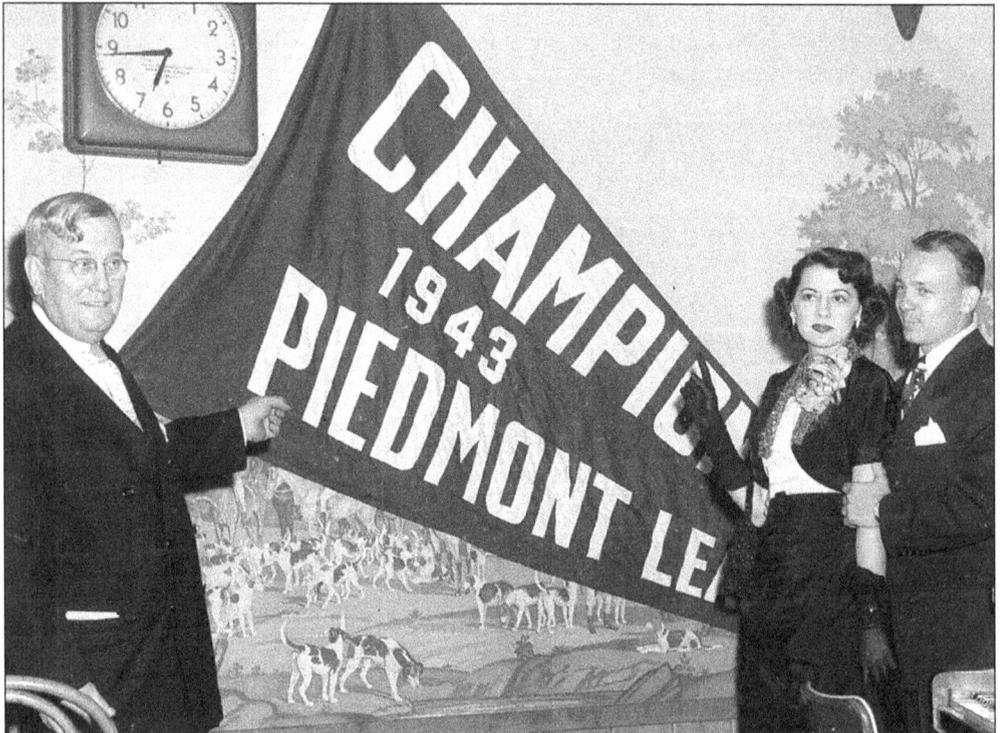

**SHOWING THE MANAGER THE GOODS, 1953.** Robin Roberts (left), the young ace of the Phillies, proudly shows off the cover of *Parade* magazine to manager Steve O'Neill before a scheduled exhibition game in Portsmouth. The Phillies were in town to take on their cross-town rivals, Connie Mack's Athletics, on April 9, 1953. The game was an overwhelming success at the gate with more than 7,000 fans on hand to watch Roberts go the distance as the Phils blanked the Athletics 4-0. The Phillies' hurler held his opponents to 5 hits and struck out seven without giving up a single base-on-balls. (NPL.)

**GEORGIE JESSEL, 1953.** Celebrated comedian and television star George Jessel was an invited guest in the pressbox to watch the Phillies and Athletics game in Portsmouth on April 9, 1953. He was in Norfolk for an Israel Fund meeting the previous night and took in the game at Portsmouth Stadium. Interestingly, Jessel was part owner of the Hollywood Stars of the Pacific Coast League. Pictured next to Jessel is local sports reporter Abe Goldblatt. (CSTG.)

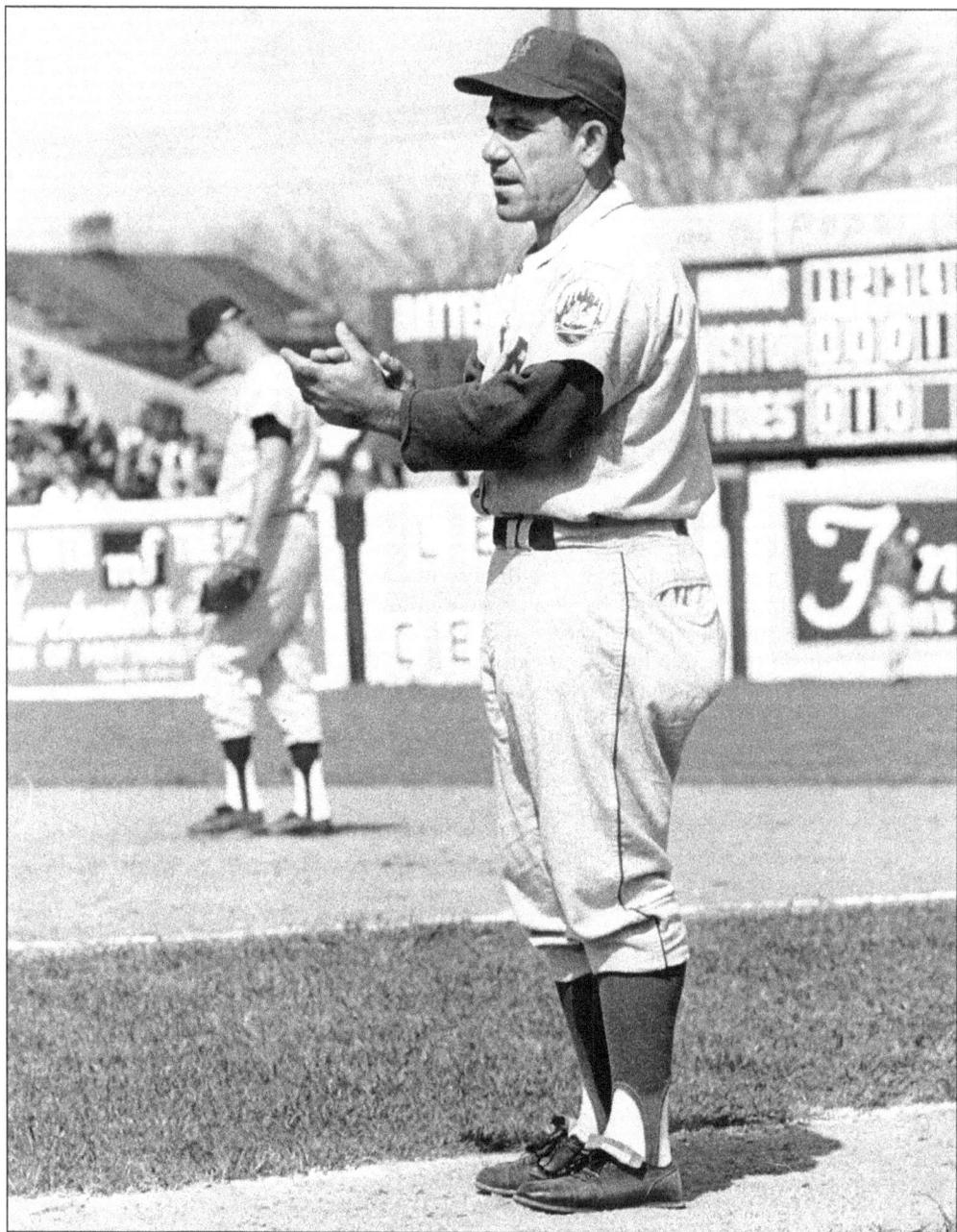

**Yogi Berra Returns to Tidewater with the Mets, 1965.** In 1943, 17-year-old Yogi Berra first appeared in the Hampton Roads area as a raw and inexperienced catcher with the Norfolk Tars. Pictured here in his new role as first base coach for Casey Stengel's New York Mets, Yogi cheers on a batter in the bottom of the fourth inning at Frank D. Lawrence Stadium. The preseason exhibition game was staged before over 7,000 fans on April 10, 1965, as the Mets took on the Minnesota Twins. The New Yorkers staged a late eighth inning comeback to top the Twins 5-4. In 1965 Berra appeared in four games for the Mets and finished his career with a .285 average and 358 home runs. The former Norfolk Tar catcher was elected to the National Baseball Hall of Fame in 1972. (VP.)

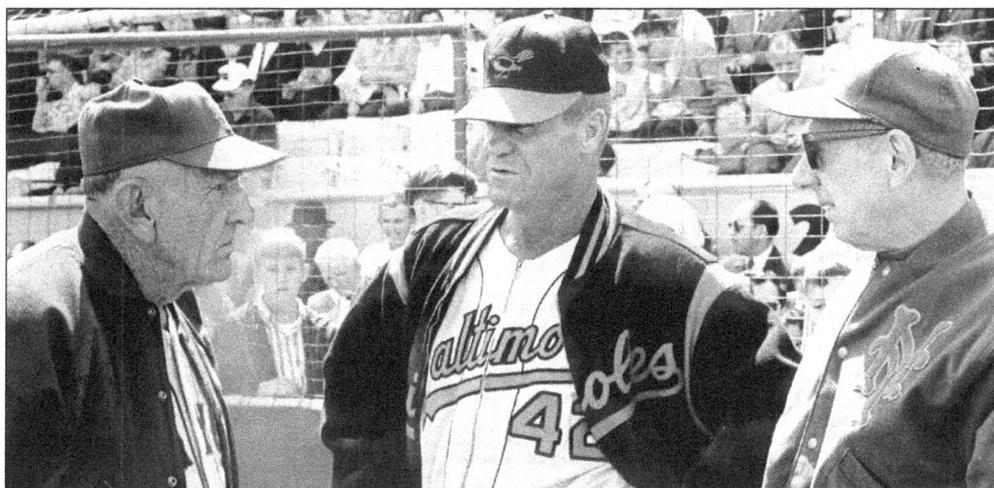

**CASEY AND FORMER STUDENT HANK BAUER, 1964.** Before a scheduled preseason exhibition game at Frank D. Lawrence Stadium in Portsmouth, New York Mets manager Casey Stengel and Baltimore Orioles skipper Hank Bauer appear to be reliving a few memories from when both wore the pinstripes of the New York Yankees of the American League. Bauer returned to the area to manage the Tidewater Tides in 1971 and 1972. Pictured alongside Bauer is New York Mets trainer Gus Mauch. (CSTG.)

**TWO METS AND A VET, 1969.** With the New York Mets in town for an exhibition game at Frank D. Lawrence Stadium, several members of the team paid a goodwill visit to the Portsmouth Naval Hospital to cheer up the injured veterans. Pictured at the bedside of an unidentified patient are ace hurler Tom Seaver (holding notebook) and outfielder Art Shamsky (right). (CSTG.)

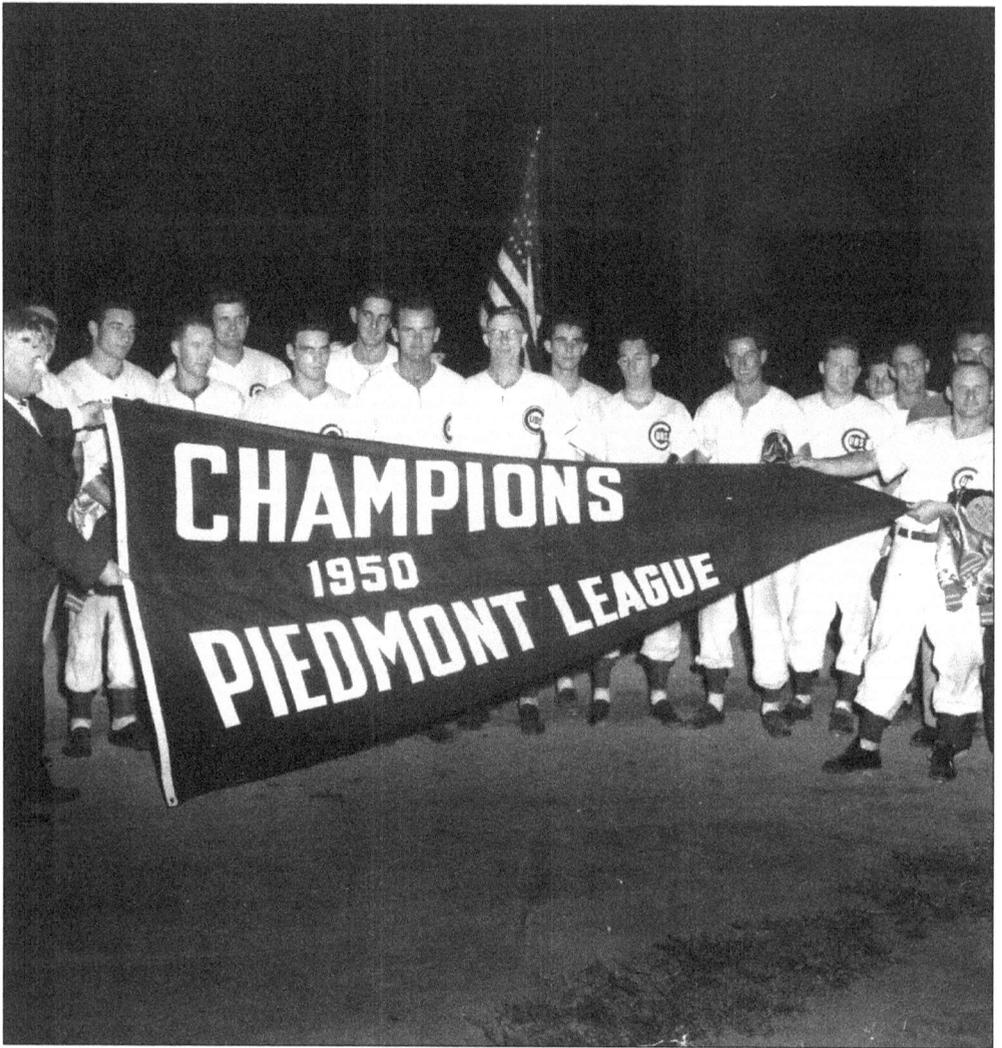

**A Banner Year for the Cubs, 1950.** Owner Frank D. Lawrence (far left) and manager Skeeter Scalzi (far right) stretch an oversized pennant proclaiming the Portsmouth Cubs as Piedmont League Champions for the 1950 season. The event took place during the opening series of the Shaughnessey Playoffs and was the brainchild of owner Lawrence to honor the team before the season came to an end. The Cubs drew over 100,000 fans to Portsmouth Stadium during the year and finished three games ahead of their nearest contender, the Roanoke Red Sox. The pennant was won on the arms of pitchers Earl Mossor (20-11) and Duke Markell (219 strikeouts), as well as the bats of Reggie Otero (.353 average), Danny Lynch (68 RBIs), "Red" Treadway (.324), and Bob Broome (15 home runs; 75 RBIs). All of these dominating players, along with manager Scalzi, were selected to the Piedmont League All-Star team for 1950. This season was the first of many for Portsmouth powerhouse Kenny Guettler. The big, strapping newcomer immediately won over the fans by slugging 21 home runs and knocking in 72 RBIs during his inaugural season with the Cubs. The season ended on somewhat of a sour note as the Cubs initially swept the Richmond Colts in four quick contests, but had the postseason trophy snatched from their grasp by the Roanoke Red Sox in a hard fought series, four games to three. (CSTG.)

# SIX

# From Contenders
# to Champions
## The Piedmont League Years
## 1946–1952

With euphoria emanating throughout the country at the end of World War II, America began to settle back into more normal day-to-day routines. The post-war era proved to be the golden age of minor league baseball and the historic Piedmont League basked in the glow as attendance flourished and intense rivalries created entertaining match-ups on the diamond. In 1946 alone, more than 32 million fans sat on the old wooden bleachers of the nation's ballparks and enjoyed minor league games. With little competition for the entertainment dollar, the National Pastime grew at unprecedented levels. Portsmouth Cubs fans passed through the turnstiles in ever-burgeoning numbers and owner Frank D. Lawrence was more than pleased as the franchise set a standard with more than 150,000 tickets sold during the 1947 season. With solid play, winning records, and consistent playoff berths the team and its fans seemed to enjoy the best of times.

One of the benefits of the end of the war was the return of many professional ballplayers to major and minor league rosters. As the 1946 season began to take shape, owner Frank D. Lawrence convinced local sport legend Clarence "Ace" Parker to return to Portsmouth and suit up for the Cubs. The former Philadelphia Athletics infielder and MVP of the National Football League quickly re-established his talents at the plate and posted a banner year for the Cubs by capturing the Piedmont League batting title with a .331 average. With manager Gene Hasson at the helm, Portsmouth stormed to a second-place finish, recording an impressive 83-57 record. Despite the strong showing in the regular season, the Cubs were swept in the first round of the postseason by the Newport News Dodgers. The "Baby Bums" of the peninsula had given the Cubs trouble all season and the rivalry between the two teams was turned up a notch as the Dodgers' slugging first baseman, Chuck Connors, challenged Ace Parker for the batting title. In one crucial game staged at Portsmouth Stadium, Connors hit what appeared to be a single, grazing the glove of a Cub infielder before rolling to the outfield. The official scorer for the game, local sports writer Abe Goldblatt of the Virginian-Pilot, ruled the hit an error, thus robbing Connors of the chance to improve his average. After the contest, when Connors was told of the ruling, he stormed out of the visitor's dugout and climbed the wire-enclosed cage that housed Goldblatt. The muscular and imposing Dodger threatened the terrified scorer with his bat, yelling derogatory remarks for the seemingly unjustified ruling. It took several police officers to safely escort Goldblatt from the scorer's cage and

out of the ballpark. The big Newport News first baseman requested that the ruling be overturned, but was unsuccessful. The hit in question would have done little in improving his average as he finished the season at .293, well behind Ace Parker's league-leading mark of .331. Despite losing out on the batting title, Connors topped the league in homeruns with 17 dingers. Later, his career path was diverted from the diamond to Hollywood and he will be forever remembered as the gentleman cowboy in the classic television series "The Rifleman."

In 1947, with Gene Hasson returning as skipper for the Cubs, the team fell on hard times, going 69-71 for a third place finish in the Piedmont. Vern Shetler led the league in homeruns (20) and Ace Parker was selected to the league All-Star team as a utility player. The bright spot of the 1947 campaign was not found on the field, but in the stands. At no other time in the history of the franchise had more spectators filled the ballpark.

Owner Frank D. Lawrence rewarded Ace Parker with the position of manager for the Cubs in 1948. Now formally retired from professional football, Ace promised to devote his time and energy throughout the season to his baseball career. Under the guidance of Parker, the Cubs returned to their winning ways and finished in third place with a 71-69 record. The makeup of the team's roster began to display more of a Cuban influence with flashy first baseman Reggie Otero becoming an integral part of the squad. Otero seemed to have it all as he exhibited great defensive skills and a solid bat as he finished a close second in the league batting title with a .326 average.

With Ace Parker appointed as manager of the Durham Bulls for the 1949 season, the Cubs found a one-of-a-kind, temperamental, and enthusiastic leader to take the reins of the team: Frank "Skeeter" Scalzi. With Scalzi at the helm, the Cubs finished the regular season in second place, only 3.5 games behind the Lynchburg Cardinals. A 74-66 record earned them a spot in the playoffs and the Cubs immediately broke their long running jinx of elimination in the first round as they topped Richmond in 6 games. Lynchburg proved to be too much to handle in the finals and the Cubs again went home empty handed. Despite the season ending letdown, Portsmouth had a wealth of talent to be proud of, including veteran Bud Metheny, who was among the league leaders in hitting with a .336 average and hurler "Wimpy" Nordella, the circuit's only 20 game winner.

In 1950, with Skeeter Scalzi back as skipper, the Cubs found themselves 8 games behind the pace-setting Roanoke Red Sox on August 11. The fiery manager rallied the troops and the Cubs responded, finishing out the year by winning 25 of the final 30 games and capturing the Piedmont League crown with an 83-54 record. Portsmouth made it to the post season finals, but was edged out by Roanoke in seven games. Scalzi's boys seemed to have it all: great pitching and heavy hitting. From the mound the Cubs had two aces, Earl Mossor (20-11) and Duke Markell (219 strikeouts), while from the box the team continued to be paced by the consistent hitting of Reggie Otero (.353). What made the 1950 season special was not so much the league pennant, but the introduction of an unheralded outfielder by the name of Kenny Guettler. The reserved Guettler quickly earned a spot in the Cubs starting line-up as he slugged 21 homeruns and sent more than 70 teammates during his rookie year with Portsmouth. It was only a matter of time before his offensive talents became legendary in the history of the Piedmont League.

For the final two seasons of this era, managerial duties for the Cubs were placed in the reliable hands of Cuban first baseman, Reggie Otero. With Otero recommending prime Cuban players for Lawrence to sign along with the heavy hitting of Kenny Guettler, the Cubs posted winning seasons both years, but came up short again in the playoffs. The dominance of Guettler at the plate peaked in 1952 when he won the coveted Triple Crown in the Piedmont as he led the league in homeruns (28), batting average (.334) and RBIs (104).

As the 1952 season ended, so did Portsmouth's formal working relationship with the National League Chicago Cubs. Owner Frank D. Lawrence vowed to continue to financially support a baseball team in the city, but would develop players in a truly independent fashion. As attendance continued to drop at a precipitous rate, the franchise struggled both financially and on the diamond. The 1953 season arrived with a new name for the club: The Portsmouth Merrimacs. Despite the enthusiasm for the new season, the death knoll was beginning to peel and resound throughout the city—and the league.

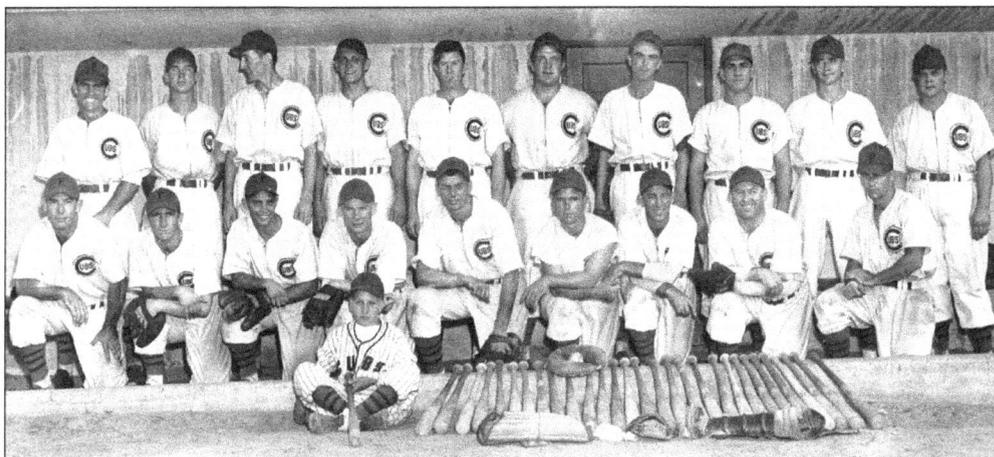

**PORTSMOUTH CUBS, 1946.** This photo, most likely taken at the start of the season, shows the Cubs posing in the home dugout at Portsmouth Stadium. The Cubs finished the 1946 Piedmont League campaign in second place (83-57), six full games behind the Roanoke Red Sox while local native "Ace" Parker captured the circuit's batting title with an impressive .331 average. From the mound the Cubs had a strong group of hurlers as Bruno Somenzi led the team with 18 victories and Woody Johnson, Harry Potts, and Paul Purcell each won more than ten games. The following are pictured from left to right: (front row) "Ace" Parker, Chas Hoffman, Frank Arevelo, Minky McGuire, Bruno Somenzi, Harry Land, John Zontini, Jake Levy, and Billy Smith; (back row) Woody Johnson, Paul Varner, Gene Goforth, John Warsaw, Red Williams, Gene Hasson (player-manager), George Purcell, Max Goldsmith, Harry Potts, and Ordie Timm. The batboy is Charles "Pooger" Wilkins. (From the family archives of Harry Land.)

**BANANAS AND BATS.** As with most ballplayers of the era, Cubs catcher Harry Land supplemented his income by working odd jobs in the off-season. Harry is shown here during the winter of 1946 when he sold bananas at a local produce warehouse. His nickname soon evolved into "Bananas" with the Portsmouth fans. On one long and dismal night at the stadium the Cub catcher suffered through an evening of miscues and passed balls, going hitless in every plate appearance, as he stepped into the batter's box for his final at bat, a fan threw a large banana stalk onto the field and yelled, "Try to hit with this Harry, since that bat isn't doing the job." (From the family archives of Harry Land.)

77

**PORTSMOUTH'S MOST POPULAR PLAYER, CATCHER HARRY LAND, 1946.** Photographed at home plate near the end of the season, Cub catcher Harry Land receives a special award for being voted the "Most Popular Player" on the Portsmouth squad during the 1946 season. Not the most dominating hitter on the squad (.247), Land proved his worth as a defensive specialist behind the plate overseeing the mound corps of the Cubs. The happy-go-lucky catcher was a favorite of the fans and of his teammates as well. (From the family archives of Harry Land.)

**SUPER SOMENZI, 1946.** In 1946 the Cubs finished six games behind Eddie Popowski's Roanoke Red Sox for the consolation prize in the league. With an 83-57 record, the Cubs proved to be one of the most feared teams in the league with an awesome combination of lethal bats and potent arms. Pictured here in a classic wind-up is right-hander Bruno Somenzi. A one-year wonder with the Cubs, Somenzi found a home in Portsmouth for only the 1946 season, but was a major contributor to the team's success on the field. For the year he compiled an impressive 18-5 record and a low ERA of 2.25. (CSTG.)

A BRIEF LESSON IN BASEBALL.
Southpaw Woody Johnson,
shown in casual summer attire of
briefs and a tee shirt, is caught
on film in a special moment in
the family's backyard. The Cub
pitcher appears to be modeling
the grip he uses on the mound at
Portsmouth Stadium as his son
watches intently. Johnson was
legendary throughout the league
for his deceptive pick-off move to
first, which often caught runners
flat-footed. Woody proved to
be one of the most dominating
pitchers in the Piedmont during
the 1946 season as he posted
an impressive 15-7 record and
a respectable 2.15 earned run
average. (From the family archives
of Harry Land.)

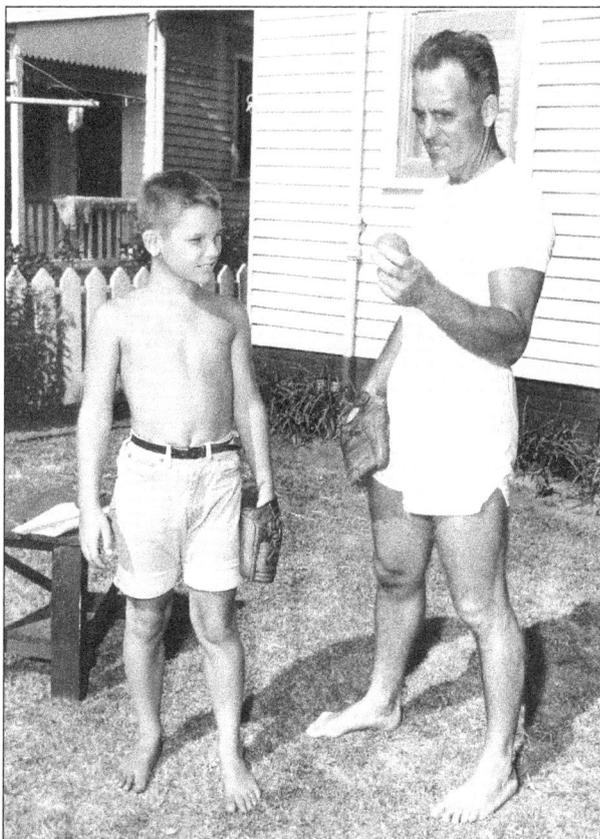

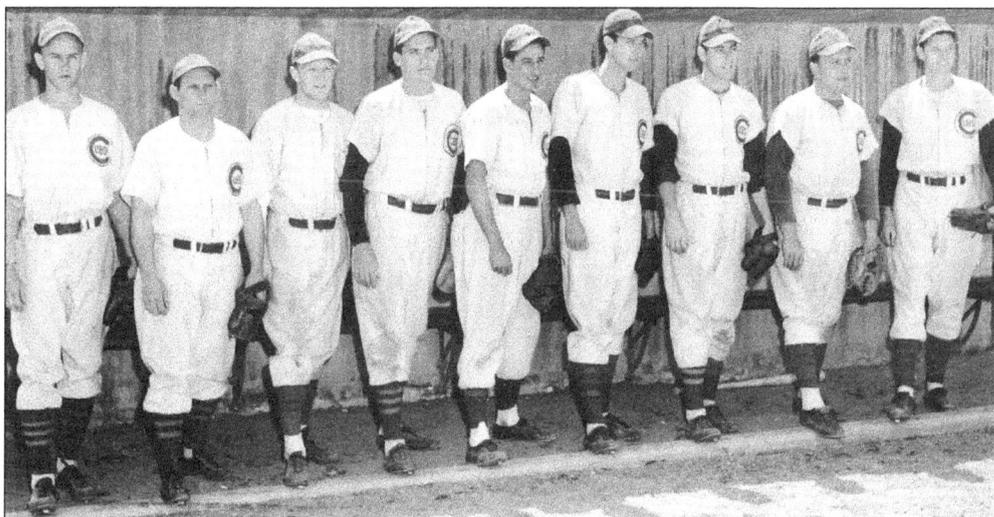

BATTING ORDER AND OPENING NIGHT STARTING LINEUP, 1949. The starting nine for the Cubs
pose for *Virginian-Pilot* photographer Charles Borjes in the Portsmouth dugout just before taking
the field on April 22, 1949. Lined up in the order in which they will appear at the plate are (left
to right) Lou Zam, center field; Cubs manager Skeeter Scalzi, shortstop; Ken Black, right field;
Russ Kerns, third base; Reggie Otero, first base; Adrian Thompson, second base; Mauri Partain,
left field; Ted Pawelek, catcher; and Earl Mossor, pitcher. (VP.)

**BASEBALL AND BAGELS, 1949.** Two Portsmouth Cubs break bread at a local restaurant before heading to the ballpark for an early morning workout. "Wimpy" Nardella (left) and Bob Broome (right) appear to be discussing the ballgame from the previous night or analyzing the opponent scheduled for the evening match-up at Portsmouth Stadium. Hurler Nardella posted a stellar year in 1949, with a 20-7 record, tops in the Piedmont League. Outfielder Bob Broome put up respectable numbers over the course of the campaign with a .310 average, seven homeruns, and 53 RBIs. (VP.)

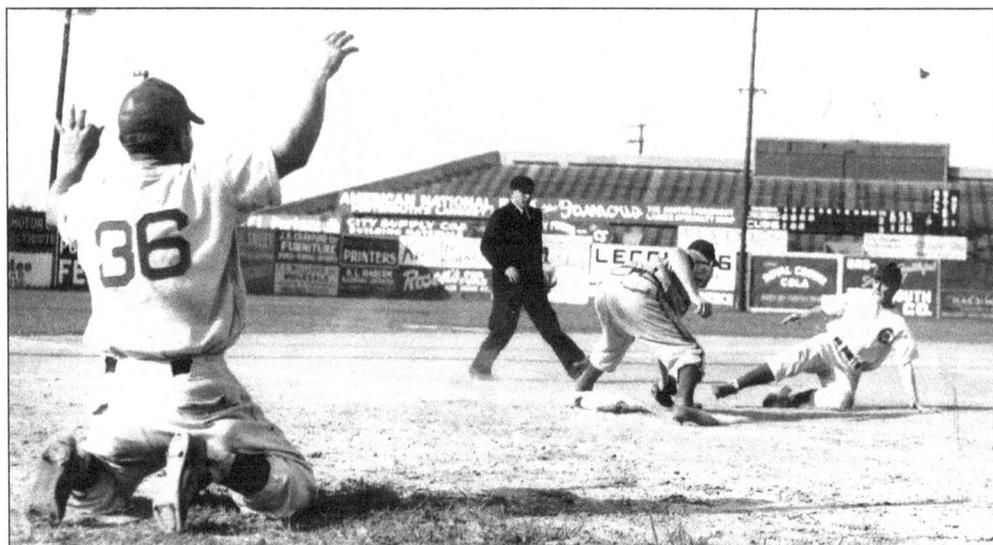

**CLOSE PLAY AT THIRD.** Portsmouth third base coach Harry Land (#36) gives the "hit the dirt" sign to a fellow teammate during an action filled moment at Portsmouth Stadium. The throw was perfect and the runner was tagged out. (From the family archives of Harry Land.)

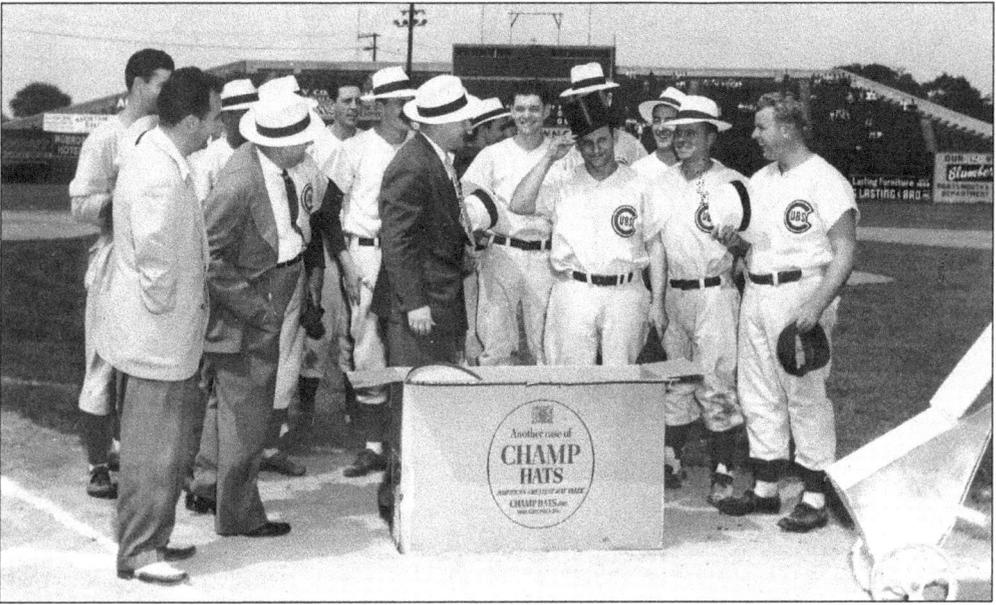

NEW HEADGEAR FOR THE CUBS, 1949. Owner Frank D. Lawrence (second from left in suit) and representatives of the Champ Hat Company hand out stylish straw toppers to the Portsmouth players during a practice session at the ballpark. Cub manager "Skeeter" Scalzi (center) tries on a special top hat selected especially for the Portsmouth skipper. (From the family archives of Harry Land.)

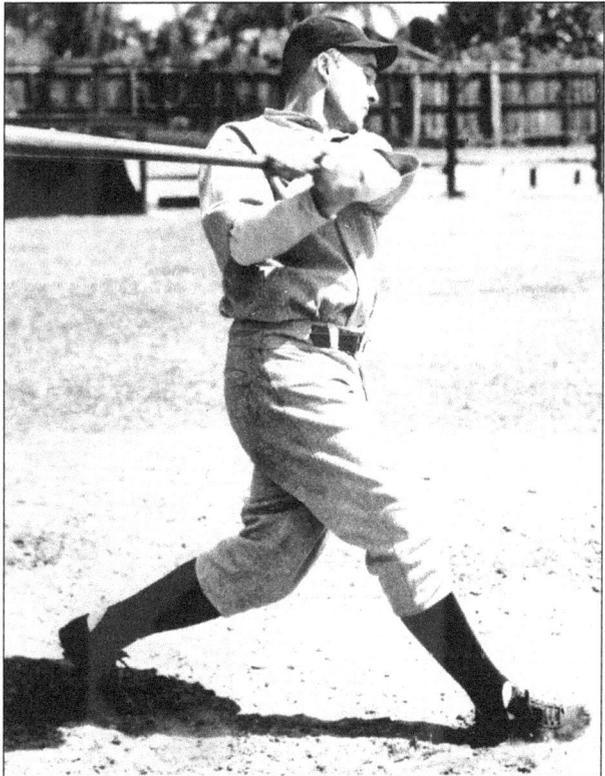

BUD METHENY, 1949–1950. Taking his cuts during spring training, Arthur "Bud" Metheny was one of the most effective hitters in the league during the 1949 season. He hit an impressive .336 from the plate, finishing second in this category and earning a spot on the Piedmont League All-Star team. Earlier in his career Metheny suited up for the 1938 Norfolk Tars and was a fixture in the New York Yankees outfield during the war years. Once he hung up his spikes, Metheny returned to his alma mater, Old Dominion University, and served as baseball coach for the Monarchs for many years. The baseball stadium on the Norfolk campus is named in his honor. (National Baseball Hall of Fame.)

**"RED" TAKES THE CAKE.** Veteran outfielder Thadford Leon "Red" Treadway gives a once over to the cake presented to him at Portsmouth Stadium during Opening Night festivities on April 28, 1950. Known for his shocking red mane and lethal bat, the Cub outfielder proved to be an integral part of the team's drive for the pennant in 1950 as he slugged .324 from the plate and led the circuit with 177 hits, earning a spot on the 1950 Piedmont League All-Star team. "Red" first made the grade in the majors with the New York Giants in 1944 and stroked an even .300 against opposing National League pitchers. (VP.)

**THE "DUKE" OF PORTSMOUTH, 1950.** Along with pitcher Earl Mossor, the other strong arm that manager Skeeter Scalzi had on his roster was right-handed flame-thrower Harry "Duke" Markell. Born Harry Makowsky in Paris, France, the Portsmouth hurler compiled an impressive 19-12 record during the 1950 championship season for the Cubs. Piedmont League batters feared his fastball and Markell topped the circuit with 219 strikeouts. Following his impressive inaugural season with Portsmouth, he was sold to the St. Louis Browns and appeared in five games during the 1951 season, producing a mediocre 1-1 record and 6.33 ERA before he was released. (VP.)

**EARL MOSSOR, ACE OF THE CUBS.** One of the main reasons Skeeter Scalzi's Portsmouth Cubs captured the 1950 Piedmont League pennant was the effective pitching of ace hurler Earl Mossor. The tall, lanky right-hander posted an impressive ERA of 2.98 and a 20-11 record, a significant improvement over the previous season when he struggled to win only 2 games. In 1951, the Brooklyn Dodgers gave the right-hander an opportunity to prove his worth during spring training and promoted him to the major league roster after an effective preseason. Once suited up in a Dodgers uniform, Mossor's luck quickly changed. He appeared in relief for three games and tallied little more than an inning of work. Despite his potential on the mound, he never could locate the strike zone, walking a total of seven batters thus ending his major league experience with a horrific 32.40 career ERA. (NPL.)

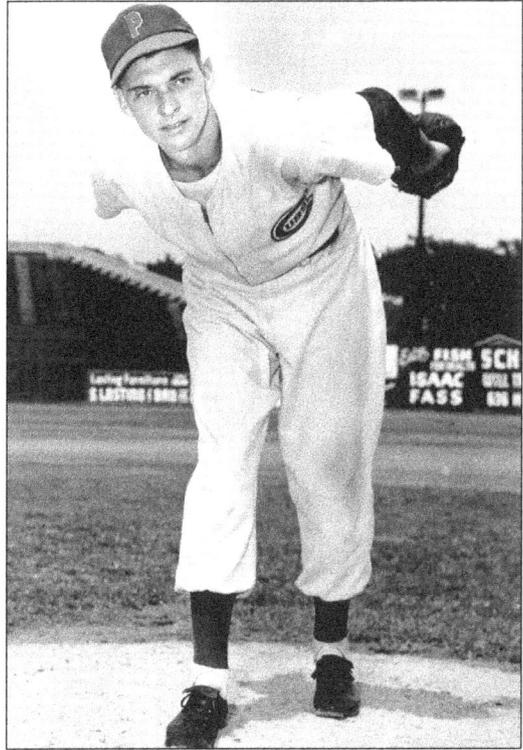

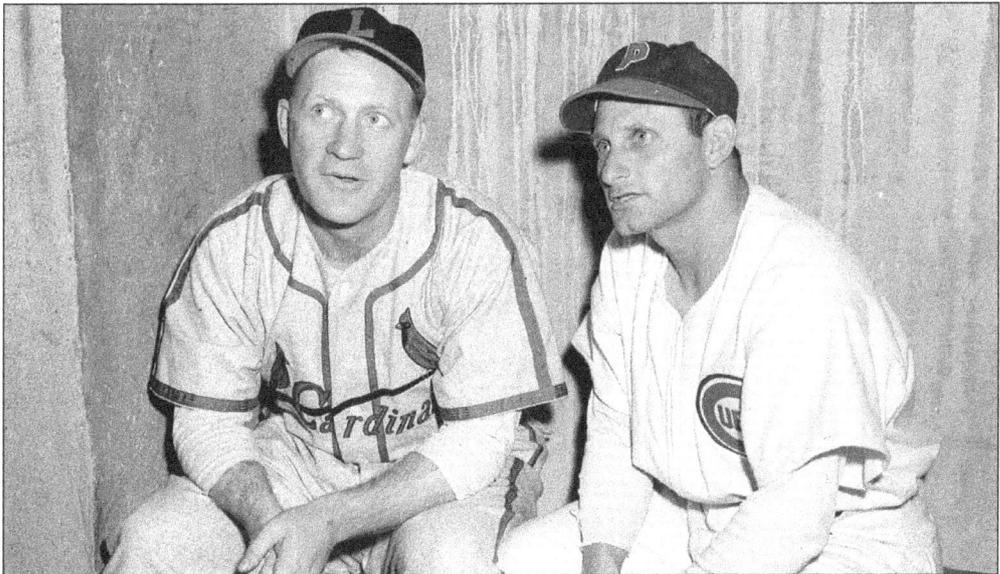

**RIVAL MANAGERS TALK IT OVER, 1950.** Portsmouth Cub manager "Skeeter" Scalzi (right) and Whitey Kurowski, skipper of the Lynchburg Cardinals, find time to chat before the Piedmont League opener on April 28, 1950. Kurowski, a major league veteran of nine years with the St. Louis Cardinals, had an unusual anomaly: he was missing four inches of his wrist bone due to childhood osteomyelitis. The deformity did not hamper his play on the diamond, as he became one of the finest fielding third sackers in all of major league baseball in the 1940s. (PPL.)

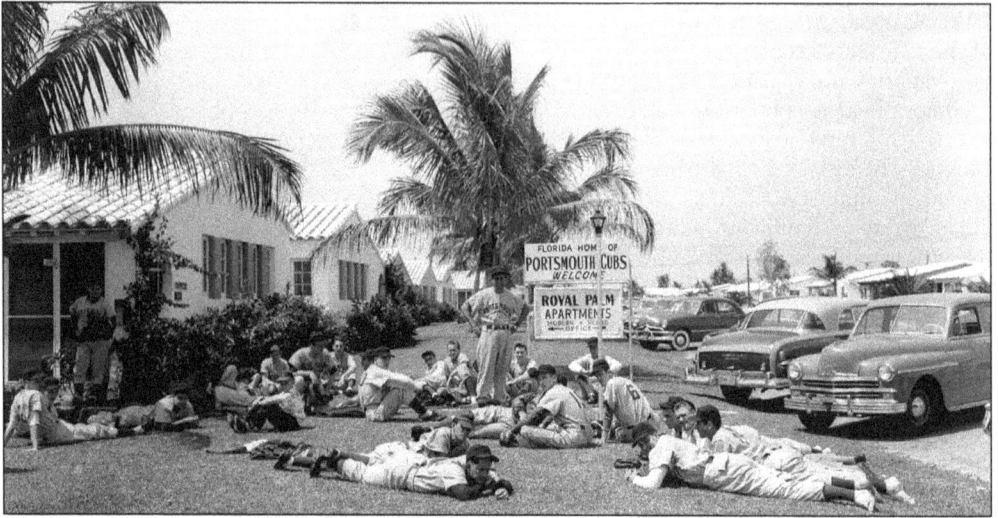

**PORTSMOUTH CUBS SOAK UP THE FLORIDA SUN, 1951.** Over the years Frank D. Lawrence would pack up his Portsmouth Cubs and head south to the Sunshine State for spring training. This candid photo catches the team suited up and waiting for the bus to arrive and transport them to the ballpark in Hollywood to begin their daily workout. The Royal Palm Apartments welcomed the Cubs with open arms and proudly placed a sign proclaiming the residence as the "Florida Home of the Portsmouth Cubs." Lawrence booked the complex for two weeks at the beginning of April and brought along the team and trainers, the benevolent owner also convinced Mrs. Dodson, the mother of Cub batboy "Bucky" Dodson, to allow her son to come along for the experience. (PPL.)

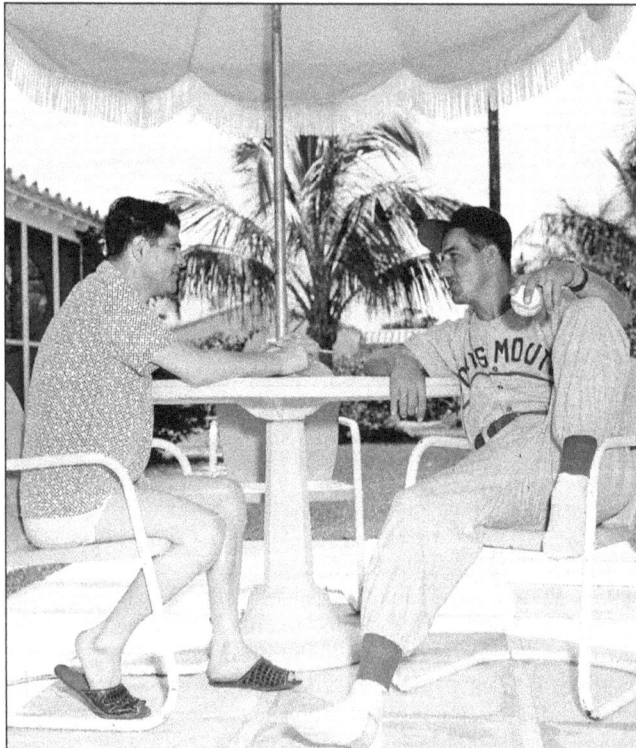

**TALKING BASEBALL, 1951.** *Portsmouth-Star* sports editor Pete Glazer (left) interviews Portsmouth Cubs manager Reggie Otero (right) on the grounds of the Royal Palm Apartments in Hollywood, Florida, on April 4, 1951. Glazer accompanied the Cubs to spring training and ran a daily column in the sports section of the Portsmouth paper to keep fans abreast of the team's progress during preseason training in sunny Florida. (PPL.)

**TICKET PROMOTION, 1951.**
Owner Frank D. Lawrence, never one to miss an opportunity to bring more fans to Portsmouth Stadium, devised a plan that would allow the Cub faithful to purchase a book of 100 tickets for the 1951 season at a cost of $50. This letter, encouraging fans to take advantage of the cut-rate deal on tickets, was mailed to citizens throughout the city in an effort to boost attendance at the ballpark. With the Cubs coming off an impressive 1950 season by capturing the Piedmont League pennant, fans of the game were ready for the new season to begin and quickly took advantage of Lawrence's "New Deal." (From the collection of Ron Pomfrey.)

*Portsmouth*
CUBS
PIEDMONT LEAGUE
OPERATED BY
PORTSMOUTH BASEBALL CORPORATION
FRANK D. LAWRENCE, President
JOHN W. LAWRENCE, Business Manager
HEGIE OTERO, Manager
PORTSMOUTH, VIRGINIA

## A NEW DEAL FOR 1951

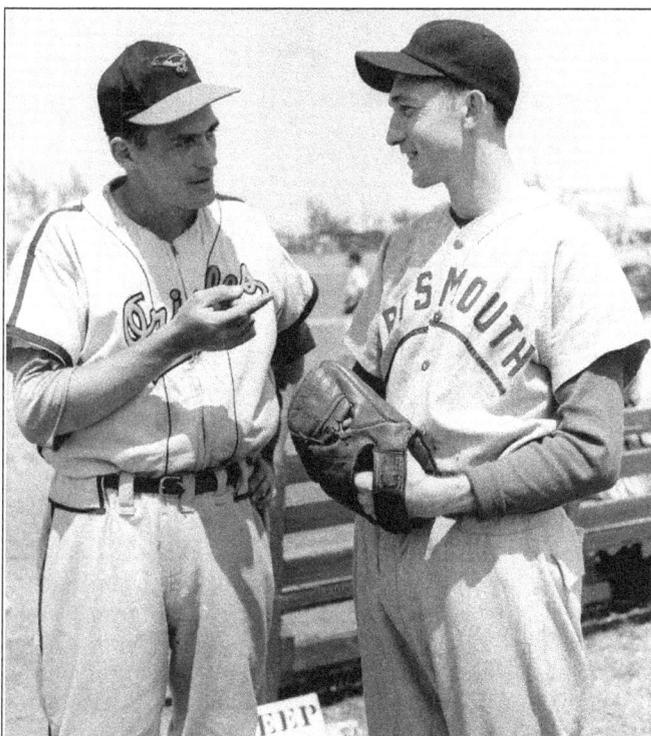

**KERNS BENDS AN EAR, 1951.** Pictured here before a spring training exhibition game in Hollywood, Florida, Russ Kerns appears to be giving some encouraging suggestions to "Ears" Caldwell of the Portsmouth Cubs. Kerns was the starting third baseman for the Cubs in 1949 before owner Frank D. Lawrence sold the prized infielder to the Baltimore Orioles of the International League. Caldwell was the number one prospect to hold down the hot corner for the Cubs in 1951, but was released before the season began. (PPL.)

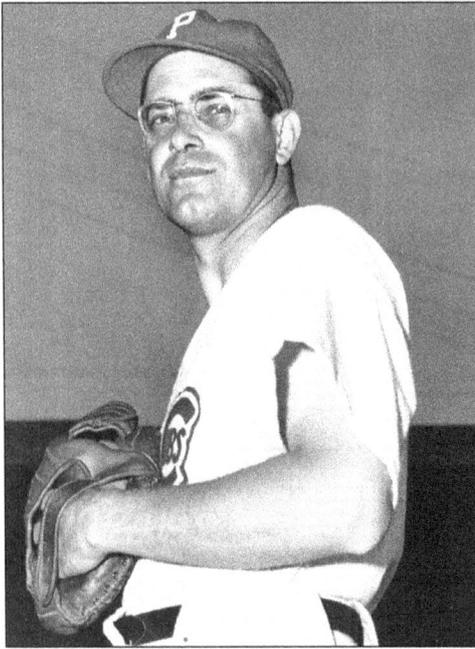

**THE COMEBACK KID.** Ed Hurley first appeared with Portsmouth in 1941 and proved to be a reliable arm, posting a 16-9 record for the Cubs. He returned in 1942 and continued his dominance, winning a total of 15 games. Drafted at the height of World War II, Hurley was deployed to Europe and remained overseas at the American Embassy in Paris after the conflict. In the spring of 1951, he sent a letter to Frank D. Lawrence requesting a tryout, admitting to his former boss that he had not picked up a baseball in nine years. An unabashed rooter for the underdog, Lawrence gave the former Cub an opportunity to attend spring training without much of a chance in making the squad. The 35-year-old quickly dusted off the cobwebs on his fastball and found his old form. To everyone's surprise Ed Hurley made the team's final cut and posted a respectable 10-7 record. (VP.)

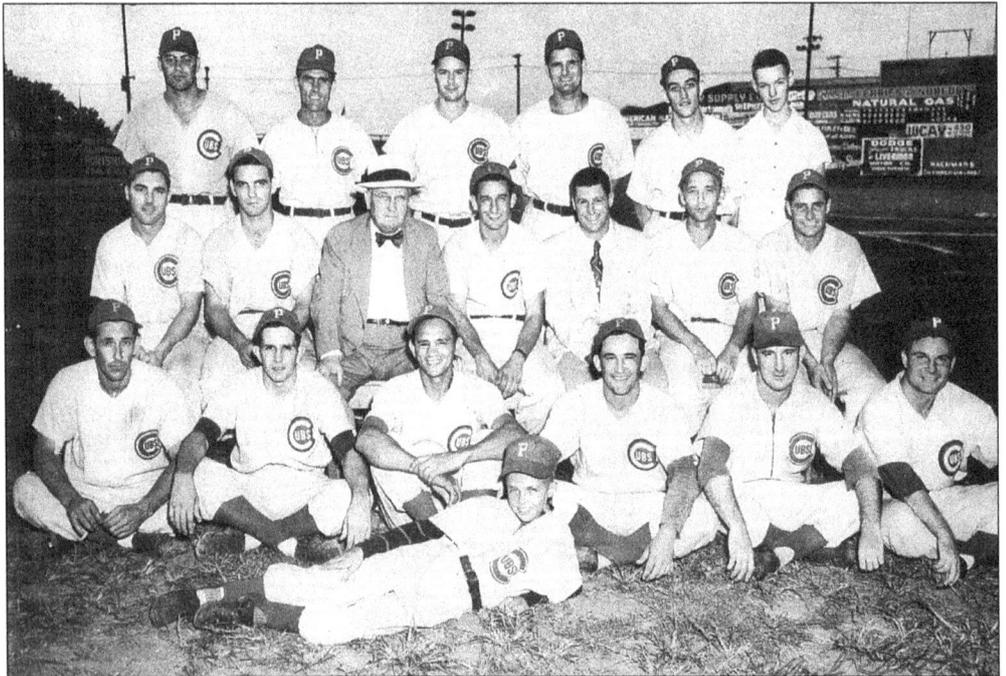

**THE 1951 PORTSMOUTH CUBS.** Announcer Mark Scott and owner Frank D. Lawrence flank manager Reggie Otero (middle row, center) as the 1951 Cubs pose for their annual team picture at Portsmouth Stadium. The 1951 Cubs failed to repeat as Piedmont League champions, but could boast of a plethora of stars including slugger Kenny Guettler (middle row, second from left), defensive whiz Cisco Gallardo (bottom row, third from right) and hurler Jim Barnhardt (top row, second from right). Cubs batboy Roland "Bucky" Dodson reclines in the foreground. (CSTG.)

CUBS AT THE CAGE, 1951. Two of the most enduring players in the history of the Portsmouth Cubs surely had to be Kenny Guettler (right) and Joe Wheeler (left). The slugging Guettler first appeared with Portsmouth in 1950 and continued with the team until the league folded in 1955. Wheeler arrived in 1951 and held down the third base position through 1953. Here the two Cubs watch batting practice at Portsmouth Stadium and wait for their turn at the plate. (From the collection of Ducky Davis and Bobby McKinney.)

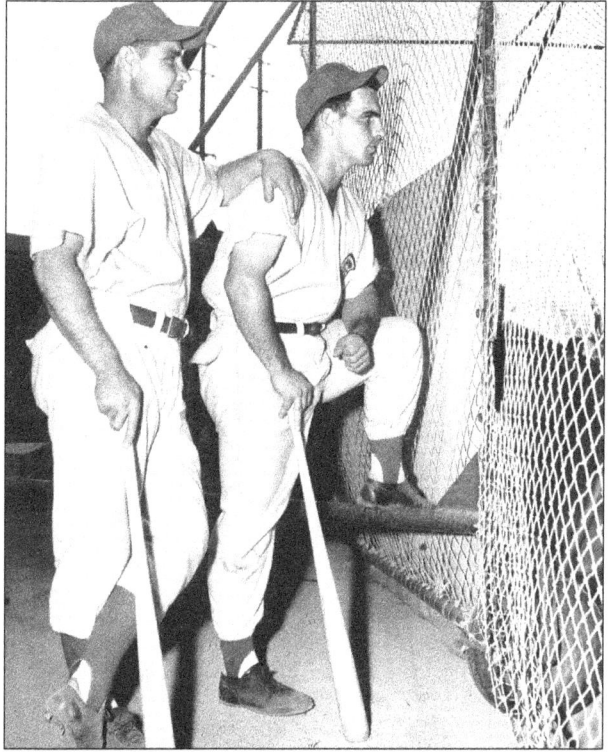

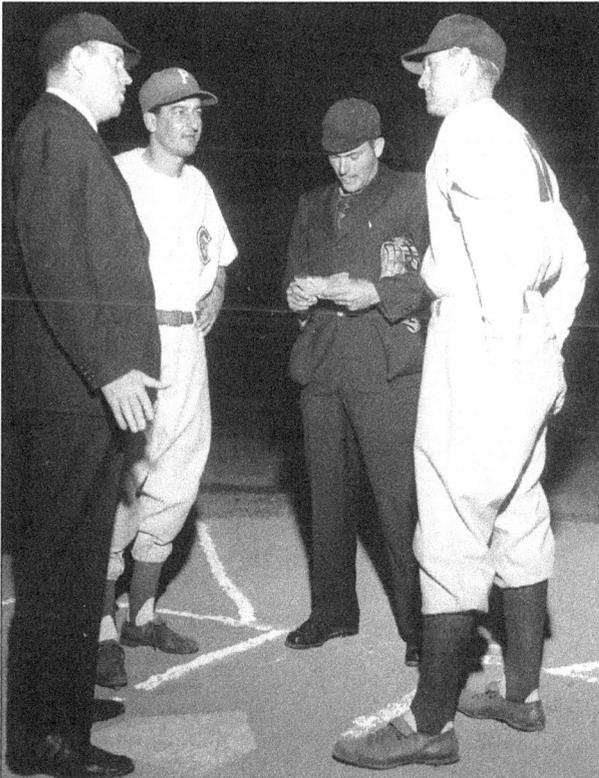

MEETING OF THE MINDS, 1951. Discussing the ground rules at the plate of Portsmouth Stadium are the umpires assigned to the 1951 Piedmont League season opener and the two rival managers for the night's contest, Portsmouth's Reggie Otero (second from left) and Norfolk Tars skipper Mayo Smith (right). Both managers were beginning their first season overseeing their respective clubs. Manager Smith guided the Tars to their first of four consecutive Piedmont League championships in 1951 with an impressive 81-58 record for the year. While the Tars manager preferred the confines of the dugout, Otero continued to play a flashy first base and was selected to the Piedmont League All-Star squad for his accomplishments on the diamond. (PPL.)

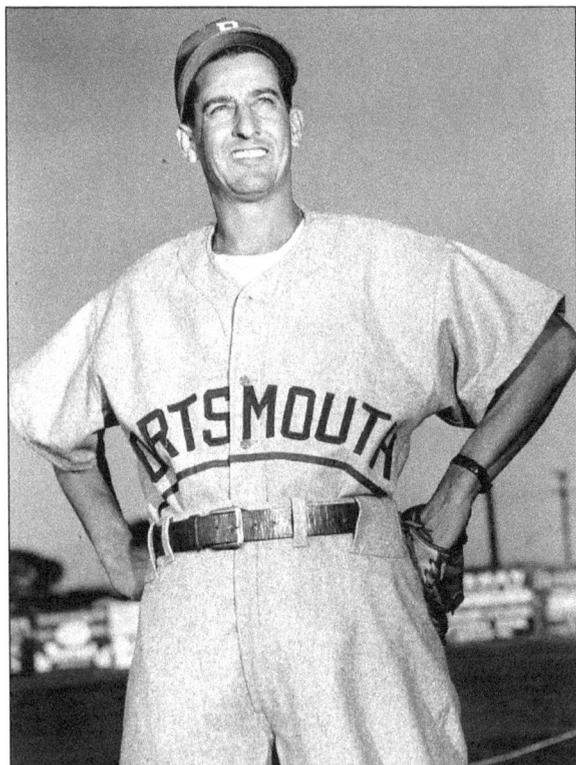

**REGGIE OTERO, 1951.** Confidently posing for the photographer in this 1951 picture is Portsmouth Cub legend Reggie Otero. Born in Havana, Cuba in 1915, Otero was a favorite of owner Frank D. Lawrence and was selected to serve as the Cubs' manager at the start of the 1951 campaign, continuing in that role until 1952. Beginning with his early playing days in Cuba and throughout his lengthy baseball career, Otero was known for his flashy defensive moves at first base and a solid bat. From 1948 through 1951, while with the Cubs, he finished consistently in the top five for hitting in the Piedmont League with his best year coming in 1950 when he batted .353 from the plate. His major league career was limited to a partial season with the Chicago Cubs in 1945, but he proved he could hit major league pitching: the Havana flash batted .391 in 14 games. (PPL)

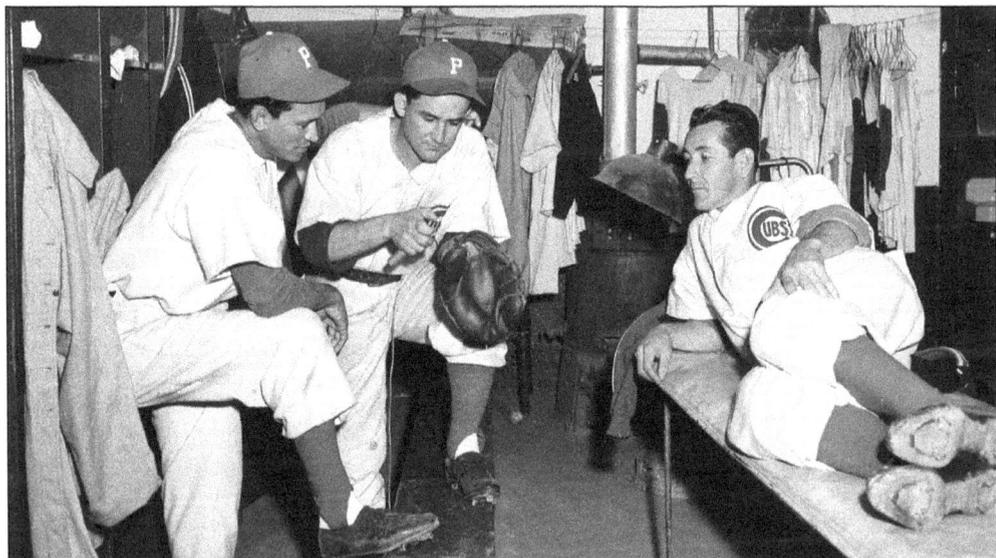

**PRE-GAME PREP AND RELAXATION, 1951.** Pictured above is a trio of Cuban Cubs preparing for an evening of baseball in the home team dressing room deep within Portsmouth Stadium. Shortstop Manuel Hidalgo (left) and pitcher Ramon Garcia (reclining on cot) are watching second sacker Cisco Gallardo (center) restring his glove. Hidalgo was considered by many to be the premier shortstop in all of minor league baseball and, with Gallardo serving to his left, the two formed an effective and deadly double play combination. Cub hurler Ramon Garcia tallied 16 victories over the season while being tagged for 10 losses. (PPL.)

**BIG IKE, 1951.** Ike Seaone is pictured in a classic pose on the dirt and grass of Portsmouth Stadium. Hailing from Cuba, the Cub catcher served as a steady backstop for Portsmouth during the 1951 and 1952 seasons, providing manager Reggie Otero with solid defense and a reliable bat. Seaone was signed by Portsmouth Cubs owner Frank D. Lawrence on a recommendation from Otero after logging successful seasons with the Charlotte Hornets in the Tri-State League and later with the Havana Cubanos of the Florida International League. (PPL.)

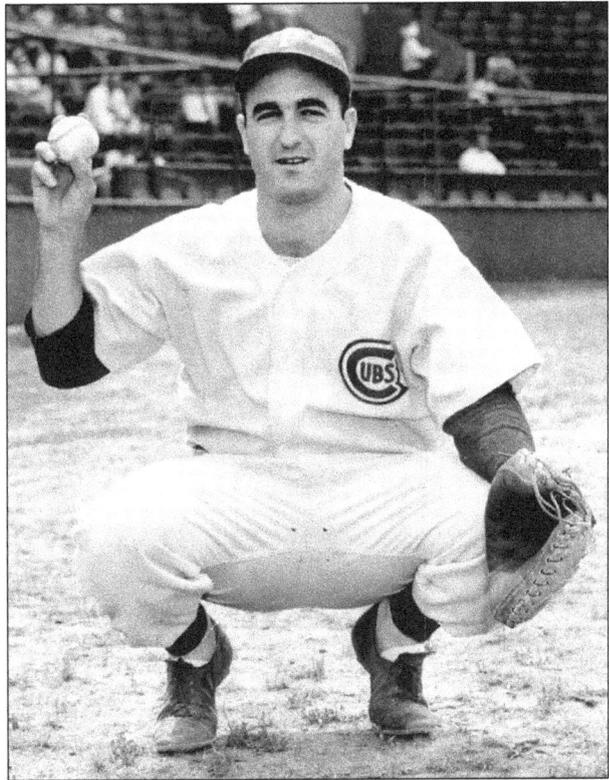

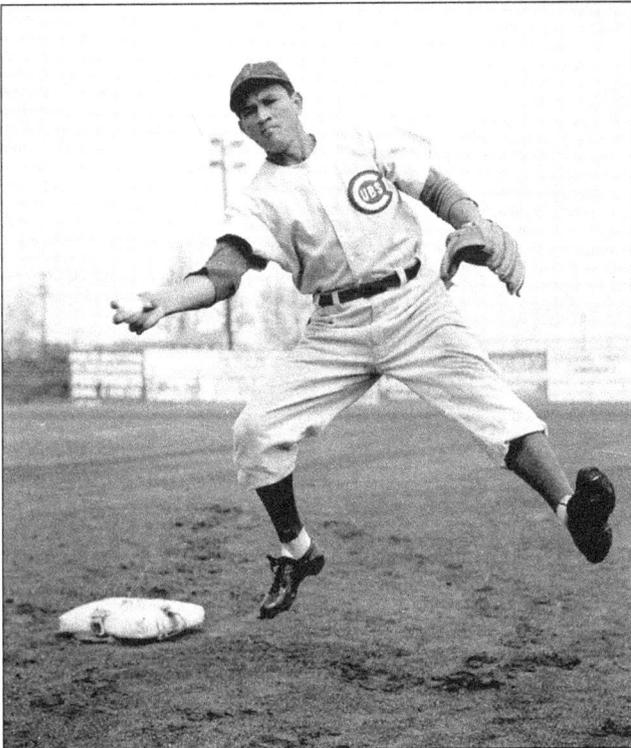

**MANNY HIDALGO, 1951.** Cubs shortstop Emanuel Hidalgo is pictured airborne and displaying his trademark sidearm throw to first. Another one of Reggie Otero's discoveries, Hidalgo dominated the Florida International League from 1949 through 1950 and was a contributing factor in the Havana Cubans back-to-back pennant winning seasons. With the Cubs in 1951, he continued to show brilliance as a solid defensive specialist, however his usually reliable and potent bat failed him and he could only muster a .262 average, well below his usual performance at the plate. Manny Hildalgo is a member of the Cuban Baseball Hall of Fame. (PPL.)

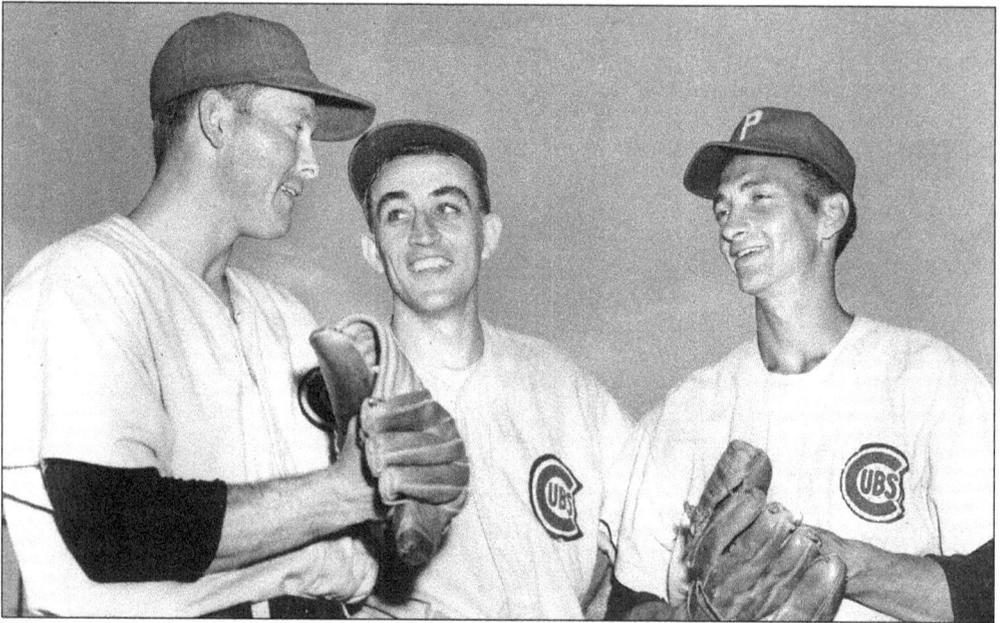

CUB MOUND CORPS, 1952. This trio of Portsmouth hurlers proved to be the heart of the 1952 Cub pitching staff as the team finished the Piedmont League season in second place. In the center is ace Jim Barnhardt (15-8), flanked by Bill Chambers (8-8) to his right and Billy Williams (10-10) to his left. (VP.)

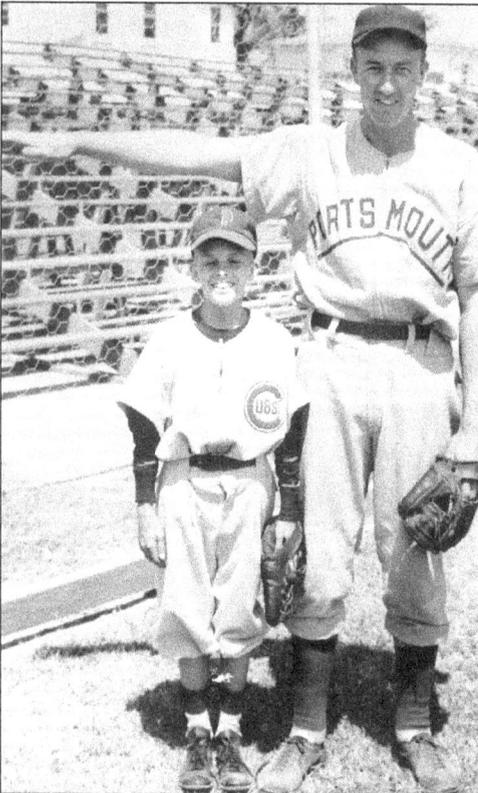

THE TALL AND SHORT OF IT, 1952. Pictured in a comical pose are Portsmouth batboy Roland "Bucky" Dodson and center fielder Eddie Neighbors, who appears to have literally taken Dodson "under his wing." The diminutive batboy was a fixture with the ball club through the early 1950s and developed a special bond with owner Frank D. Lawrence and the players. In the spring of 1952, Neighbors returned to Portsmouth following two solid years as the club's starting center fielder and was well known for his defensive skills and speed. Neighbors remained with the Cubs for more than half the season and then found himself across the Elizabeth River in a Norfolk Tars uniform for the remainder of the campaign. (From the family archives of Roland Dodson.)

# PORTSMOUTH BASEBALL NOTES
## 1945–1952

Interesting facts about the players in Portsmouth's baseball history

- During the 1946 season, owner Frank D. Lawrence took drastic measures to end a crucial nine-game losing streak by the first place Cubs that was eroding a substantial lead over their cross-river rivals the Norfolk Tars. On the evening of July 18, the owner gathered his players on the diamond and had them bury a small box behind home plate before their scheduled Piedmont League game with the Tars. The box, with the word "Jinx" spelled on its side, was lowered into the dirt by manager Gene Hasson and outfielder Ace Parker as players from both sides removed their hats in respect during the solemn ceremony. The crowd of 3,700 fans stood reverently in silence as Frank D. Lawrence proclaimed that the losing "jinx" was done and buried. The event, a bit unusual to say the least, worked and the Cubs defeated the Tars that evening 4 to 3 in an exciting 10-inning battle.
- In 1948, Portsmouth catcher Harry Land was the top defensive backstop in the Piedmont League. A veteran of the minors since 1940, the Cub catcher was notified by owner Frank D. Lawrence that his contract had been purchased by the Boston Braves of the National League. The Cub owner asked that Land remain on the Portsmouth roster through the end of the season since the club was battling for a playoff berth and, with some reluctance, he agreed. On August 18, 1948, the Cubs were in Lynchburg for a game against the Cardinals and, with Land at the plate against pitcher Bob Habenicht, he suffered a catastrophic beaning. The injury resulted in the Cub catcher losing 80% of his vision in his left eye and required a stay in the hospital for a solid week. Needless to say, Land was lost for the season. At the time of his injury he was batting a solid .275 and was named to the Piedmont League All-Star squad. After the beaning he was considered "damaged goods" to the Boston Braves and the contract was revoked.
- Just before opening day of the 1949 season, Cubs owner Frank D. Lawrence announced that all youngsters of school age would be admitted to every Portsmouth home game free of charge. Lawrence called the group the "Cub Kids" and gave the young fans free reign to watch the game from the center field bleachers.
- There was no one on the 1949 Portsmouth squad that incited fans both at home and on the road more than temperamental Cub manager Frank "Skeeter" Scalzi. The fiery skipper and second sacker was a master at provoking the crowds and was often greeted at opposing ballparks with rocks and other items thrown from the stands. On one occasion during the 1949 season, the Cubs were on the road to play the rival Newport News Dodgers in old War Memorial Stadium. During the journey, the bus was required to cross the James River Bridge to arrive on the Peninsula. As the team bus was stopped for the draw to rise, allowing a ship to maneuver down the river, the Cubs lined the rail of the bridge stretching their legs. On the water below, a group of local fisherman spotted the team bus and immediately began to yell at Scalzi with some less than appropriate language. Skeeter, never one to let a good insult go without some response, asked the equipment manager to bring over the bag of balls designated for the game. Without warning he began to pummel the startled fishermen with as many fastballs as he could send their way before the anglers found it wise to locate a less threatening spot to drop their lines.
- The radio announcer for the 1951 Portsmouth Cubs was none other than Mark Scott. Hired despite his inexperience, Scott went on to greater heights in the Pacific Coast League and will be forever remembered as the TV host of that great baseball program from the 1960s "Home Run Derby."

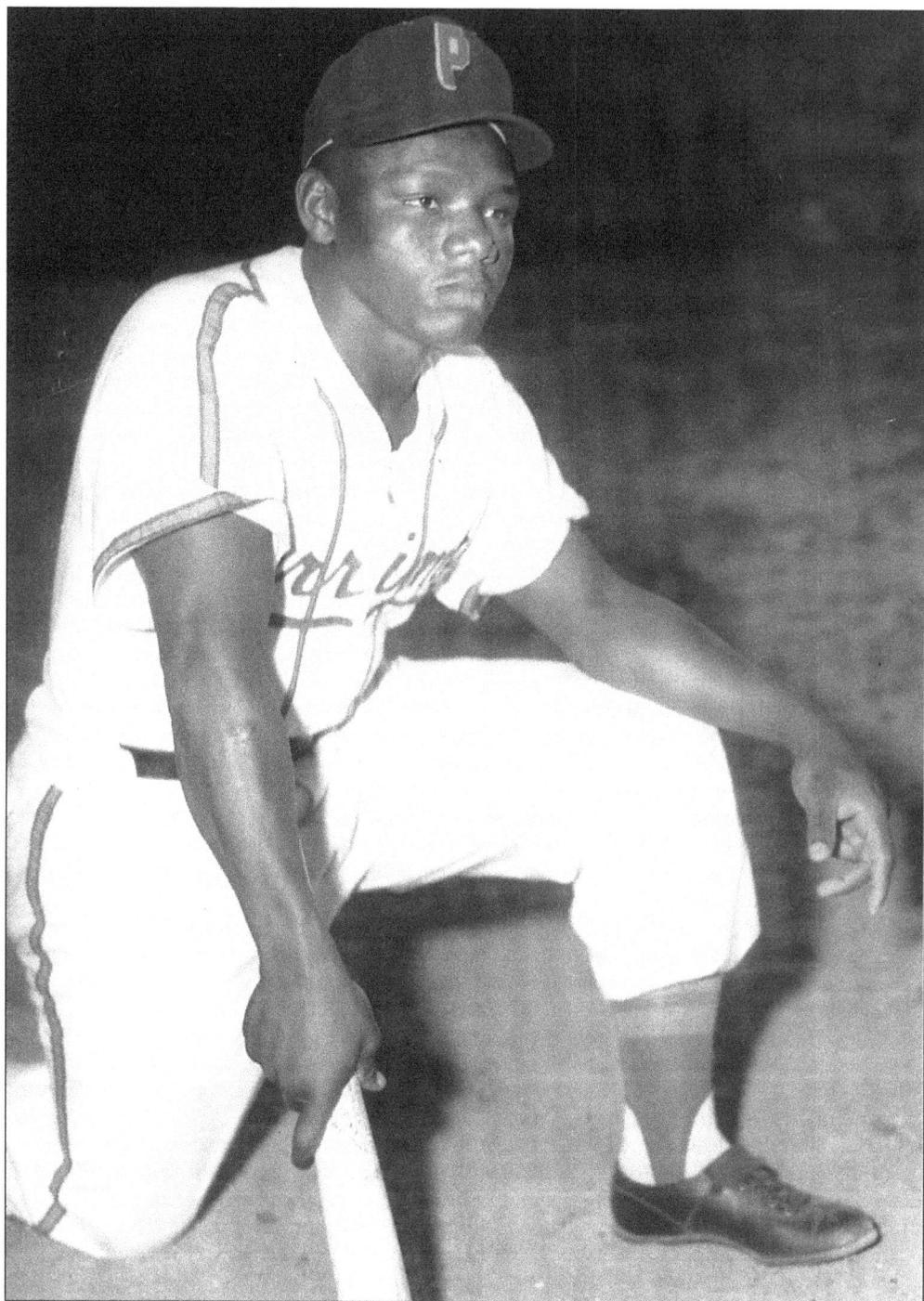

THE "MULE" OF THE MERRIMACS, 1953. No one epitomized baseball in Portsmouth's African-American community more than Charles Peete. Growing up in the shadows of Portsmouth Stadium and playing on area diamonds with local semi-pro teams, Peete's power and skills became legendary to the black community where he was tagged with the nickname "Mule." (PPL)

# Black Baseball in the City of Portsmouth

The story of baseball in Portsmouth would not be complete without a chapter on the rich and colorful history of black baseball in the city and surrounding area. From the early 1900s until the 1950s, black semi-pro teams were an important part of the sports scene for Portsmouth's African-American community. Over the years teams such as the Portsmouth Pirates, Lincolnsville Giants, Brighton Blue Sox, Daughtry's Black Revels, Belleville Grays, Portsmouth Quicksteps, Portsmouth Barons, and Portsmouth Eagles provided opposition to African-American teams from Norfolk and surrounding communities. But no team was more popular with the African-American citizens of the city than the Portsmouth Firefighters, a team located in Brighton, a black neighborhood of the city. For many years the Firefighters were one of the best semi-pro teams in the area, along with Norfolk's Battling Palms and the Berkley Black Sox. Home games were played at Sewanee Stadium (also known as Washington Street Park) when Portsmouth's minor league team the Truckers was out of town. In 1936, the Firefighters built their own ballpark, which was located near Truxton Elementary School and recognized as one of the best black-owned parks in the south.

Portsmouth, Norfolk, and Newport News were regular stops on the schedules of many Negro League and black barnstorming teams. In the 1930s these games were often held at Sewanee Stadium while in the 1940s and 1950s, Portsmouth Stadium served as the playing venue. The African-American community and area baseball fans filled the stands to catch a glimpse of Negro League teams as they brought their exciting brand of baseball to the area. Each year, teams such as the New York Black Yankees, New York Cubans, Philadelphia Stars, Newark Eagles, Homestead Grays, and Indianapolis Clowns would schedule a series of games to be played in the city.

Over the years fans were treated to the baseball prowess of Negro League stars such as Ben Taylor, Judy Johnson, Oscar Charleston, Leon Day, Monte Irvin, Willie Wells, Mule Suttles, and Buck Leonard. They also cheered for Portsmouth native, Buster Haywood, and North Carolina transplant, Leon Ruffin. Both of these marquee players were members of several semi-pro teams in the area and went on to long careers in the Negro Leagues. Two interesting anecdotes illustrate the excitement and enthusiasm the players, fans, and promoters brought to baseball games staged in Portsmouth. On a Sunday afternoon in May 1940, former Negro League great and future Baseball Hall of Fame member, Oscar Charleston, brought his Toledo Crawfords to Portsmouth's Sewanee Stadium to play a double-hitter against the Miami Ethiopian Clowns. The teams split two tightly played contests before more than 2,500 fans. As exciting as the games were to the large crowd present at Sewanee Stadium, the spectators were really there to watch an exhibition put on by Olympic champion, Jesse Owens, who toured the country with the Crawfords. Between games Owens ran the 100-yard dash against local track stars that were given suitable advantages. Jesse swept across the finish line far ahead of his closest competitor. So successful was the promotion that later in the summer the Crawfords returned to Portsmouth for a twin bill where they swept the Brooklyn Royal Giants 3-1 and 8-1; Owens put on

another exhibition stunt racing a motorcycle from left field to second base and beating the motorcycle by several yards. The cycle, attempting to come to a stop near first base, skidded on the damp grass and the driver was thrown from the cycle and slightly injured.

The second anecdote happened several years later, sometime between 1942 and 1946, when one of the Negro Leagues marquee stars, Josh Gibson of the Homestead Grays, hit a mythical and mammoth home run in Portsmouth Stadium. The muscular right-handed Gibson hit a ball that rocketed over the centerfield football press box and landed on Glasgow Street. Although never confirmed, it was estimated that the ball traveled 585 feet. This epic homerun will forever remain a part of Portsmouth's rich baseball lore.

Until 1953 the stands at High Street Park, Sewanee, and Portsmouth Stadium remained segregated for the African-American patrons who supported the Truckers and Cubs over the years. Living in the South, Portsmouth's black citizens had to endure and follow the archaic Jim Crow laws of the state and city. These regulations were enforced while watching ballgames at the stadiums; blacks had to enter the stadiums through Jim Crow gates and watch games from a designated segregated area in the bleachers and grandstands. Blacks flocked to the stadium when teams from the Negro Leagues played as they were able to sit anywhere in the bleachers or grandstands. There was even a small segregated section in the grandstand reserved for whites only, but many whites chose to sit alongside the black patrons. Frank D. Lawrence respected the African-Americans who came to watch his teams. He enjoyed the brand of baseball Negro League teams played when they visited, but being a shrewd businessman, he also loved the gate receipts the black patrons provided. Lawrence and the Cubs rented the stadium from the city and Lawrence sublet the stadium to a promoter of Negro League games. In the August 11, 1942, issue of the Norfolk Journal and Guide, Editor Lem Graves wrote, "In Portsmouth's City Stadium, the owner, one of the real friends of colored activities in that city, genuinely enjoys having the good colored ball teams play in his park."

In the spring of 1953, the Piedmont League dropped the color line that had been in place since the league was founded in 1920. The league left the decision of whether to have blacks on a roster up to individual ball clubs. Lawrence, and his newly renamed Merrimacs, immediately opened the park to African-Americans. By season's end they had a team which included their ace, Brooks Lawrence, Charles "Mule" Peete, a youngster who grew up in the shadows of Portsmouth Stadium and the sandlots of the area, and Negro League legend and future Hall of Fame member, Buck Leonard. In nearby Norfolk, the Tars and the Yankee brass decided to continue Jim Crow regulations, having both a grandstand and team void of blacks. Many of Norfolk's black fans made the ferry ride across the river to Portsmouth to support the Merrimacs. In an editorial by Cal Jacox of the Norfolk Journal and Guide regarding the Norfolk Tar's policies towards blacks he states, "They are seething with indignation over the accommodations that greet them when they file through Myers Field antiquated Jim Crow gate which is in sharp contrast with the fine facilities at Portsmouth and they seem determined to take their patronage across the river." Despite the changes by the league to open up its rosters and grandstands to all, it was too little too late as the Portsmouth Merrimacs and the Piedmont League came to an end on September 22, 1955. Black semi-pro and Negro League teams, which for many years graced the diamonds of the city, are now gone, but have left indelible memories on the baseball history of Portsmouth.

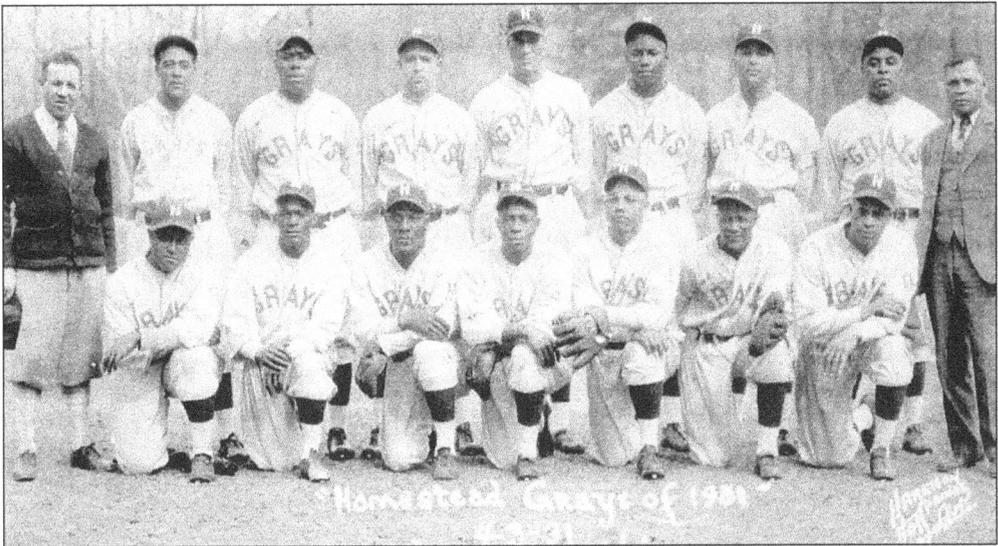

HOMESTEAD GRAYS. In 1931, Cumberland "Cum" Posey (standing far left) brought his Homestead Grays to the area to play a series of games in both Portsmouth's Sewanee Stadium and Norfolk's Bain Field against the Brooklyn Royal Giants. This vintage postcard of the 1931 Grays shows the image of what many consider to be one of the best black teams of all times. The roster included Willie Foster, Vic Harris, "Double Duty" Radcliffe, George Scales, Jud Wilson, and future Hall of Fame members Smokey Joe Williams and a young 18-year-old Josh Gibson. (From the collection of Jeff Eastland.)

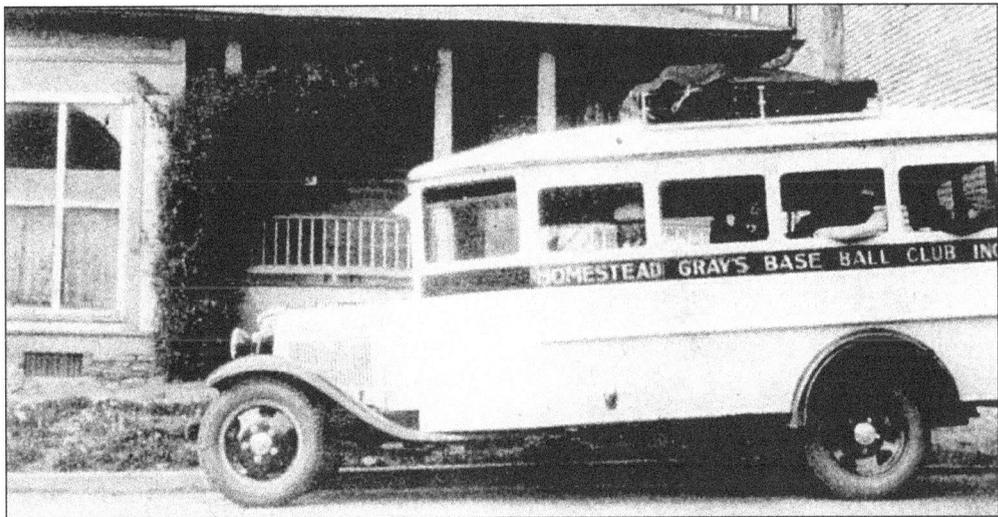

HOMESTEAD GRAYS BUS, 1931. As the legendary teams of the Negro Leagues arrived in the city, Portsmouth fans were quick to buy tickets and fill the stadium to watch the exciting play of teams such as the Homestead Grays. Each contest was a social event with ladies and gentlemen wearing their Sunday best as they mingled and watched the likes of Josh Gibson and Buck Leonard showcase their skills on the diamond. Surely this bus, which transported the Homestead Grays to the stadium, was mobbed by adoring fans as the players disembarked to take the field. This photograph was found in the family scrapbook of Cumberland "Cum" Posey, the longtime owner and manager of the Grays, the most successful franchise in the Negro Leagues. (From the collection of Jeff Eastland.)

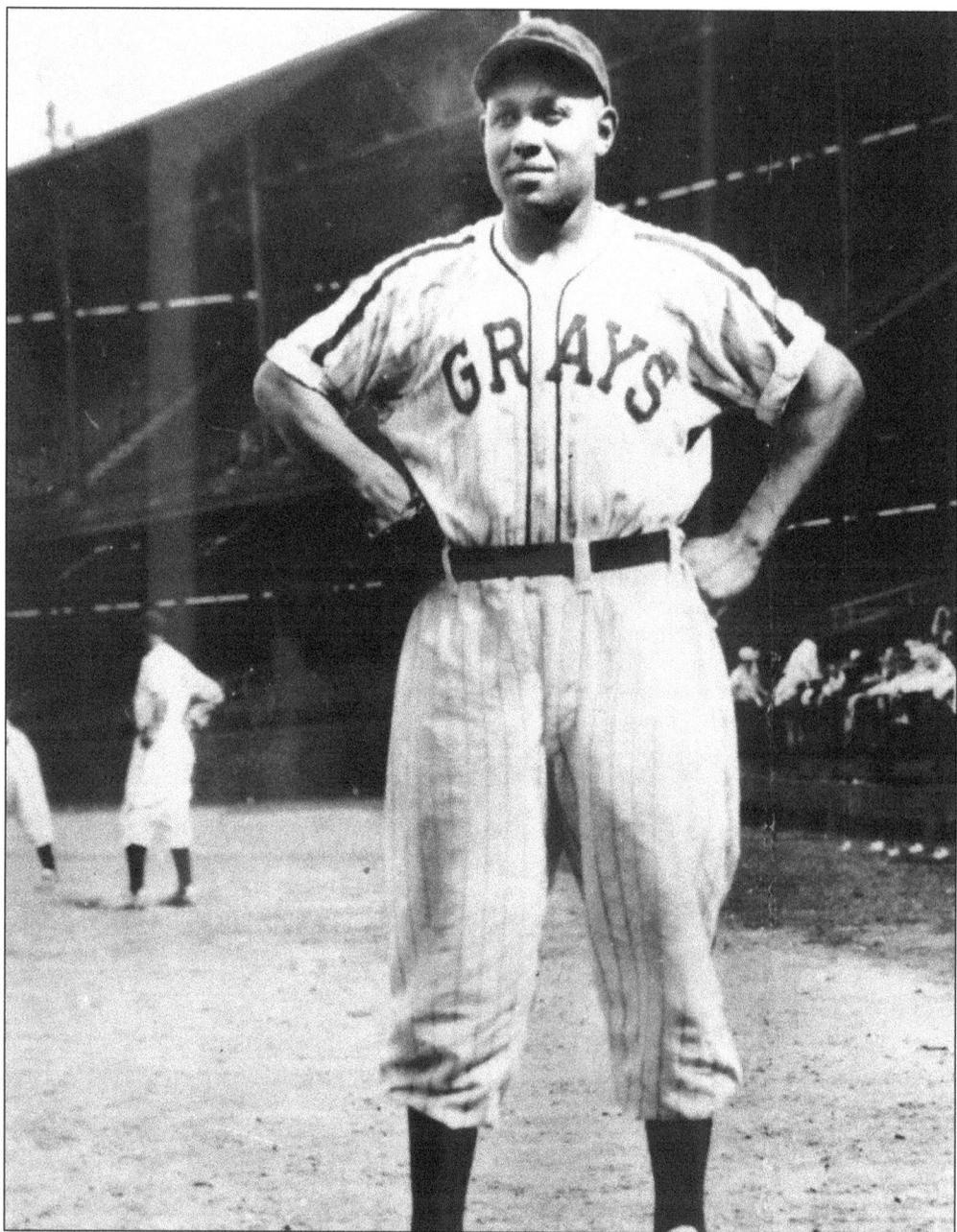

**WALTER "BUCK" LEONARD, 1935.** Leonard wears a Homestead Grays uniform only two years after playing first base for Daughtry's Black Revels, an African-American semi-pro team in Portsmouth. Buck led the Revels and the Tidewater Colored Baseball Association in hitting until his departure in July 1933. In 1934, he began a 17-year Negro League tenure with the Homestead Grays. His only time in "organized ball" was in 1953 at the age of 46, when he returned to Portsmouth to play 10 games for the Merrimacs and lead the team in hitting with a .333 average. One of the Negro League's most feared hitters, he was honored in 1972 with induction into the National Baseball Hall of Fame. In 1998 he was ranked 47th by *The Sporting News* on its list of "Baseball's 100 Greatest Players." (National Baseball Hall of Fame.)

**BARONS IN THE BACKYARD, 1948.** This candid snapshot of several members of the Portsmouth Barons was taken only minutes before a game. The team members in the photo are Arthur Harding, in the pitching pose; Leroy Scott, bunting; and Charles "Mule" Peete, standing on the right side in the image. Harding was a mainstay of several local teams in the 1940s and early 1950s, including the Barons, the Portsmouth Quick Steps, and Norfolk's Battling Palms. In 1950, Peete had a short stint with the Indianapolis Clowns before returning to Portsmouth and playing for the Merrimacs in 1953 and 1954. (From the family archives of Mrs. Arthur Harding.)

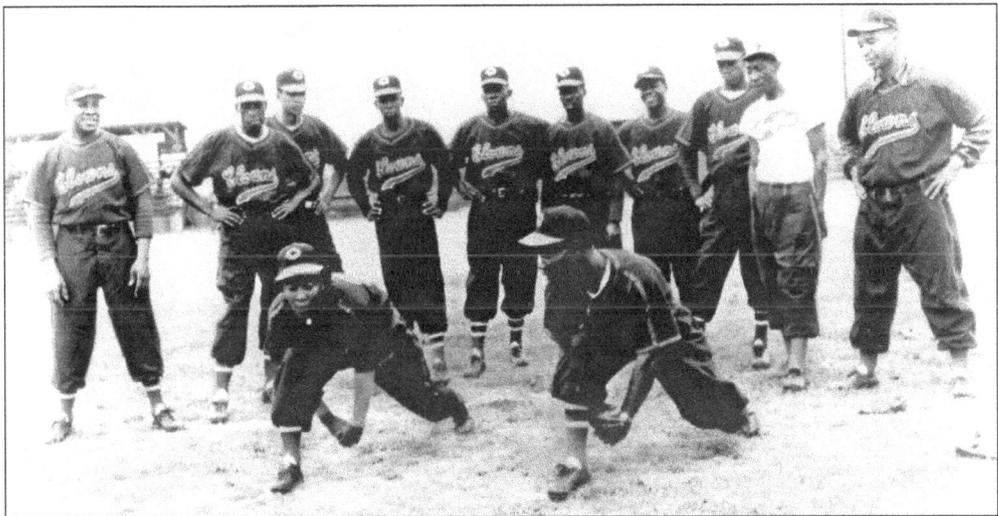

**PORTSMOUTH LOCALS MAKE THE GRADE WITH THE CLOWNS, 1951.** In the above image, Portsmouth locals Albert "Buster" Haywood (fourth from left in rear), the Clowns catcher-manager, and shortstop Thomas Burt (sixth from left in rear) watch as Toni Stone (front left) and an unidentified player go through a ball handling drill. Stone, a slick-fielding infielder, was the first female to play in the Negro Leagues. Burt appeared for two years in a Clowns uniform, but returned home to Portsmouth in 1952 because of family obligations. When Burt left the team, his position on the Clowns roster was filled by future Hall of Famer and home run king Hank Aaron. (From the archives of NoirTech Research.)

97

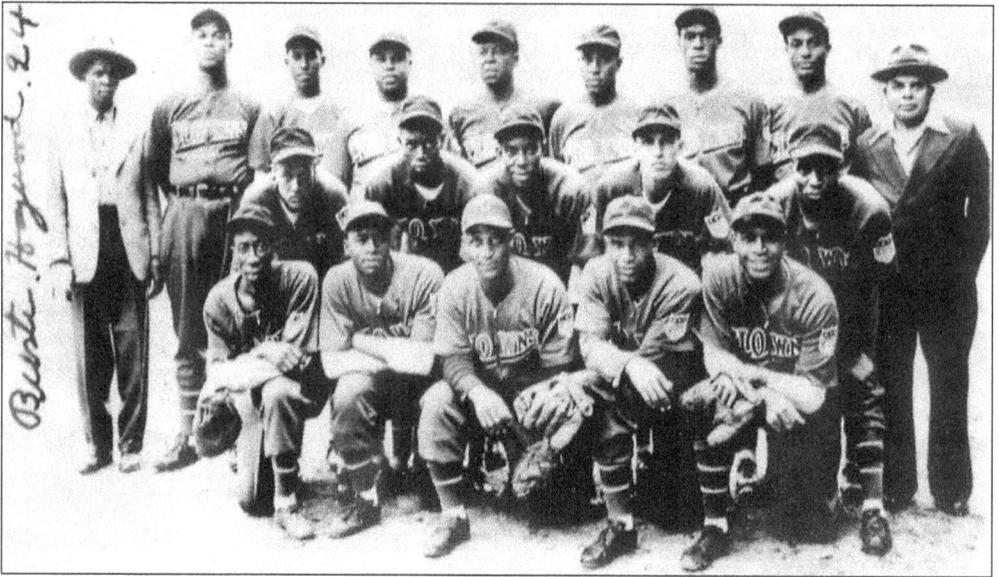

INDIANAPOLIS CLOWNS, 1945. From 1941 until 1955, Portsmouth Stadium was a frequent site of games between the Indianapolis Clowns and a variety of opponents. This postcard of the 1945 Indianapolis Clowns includes Portsmouth native and catcher, Albert "Buster" Haywood in street clothes (left) recovering from a broken hand. Interestingly, the postcard was signed by Haywood who also put his uniform number and position beside his photo for an area fan. (CSTG.)

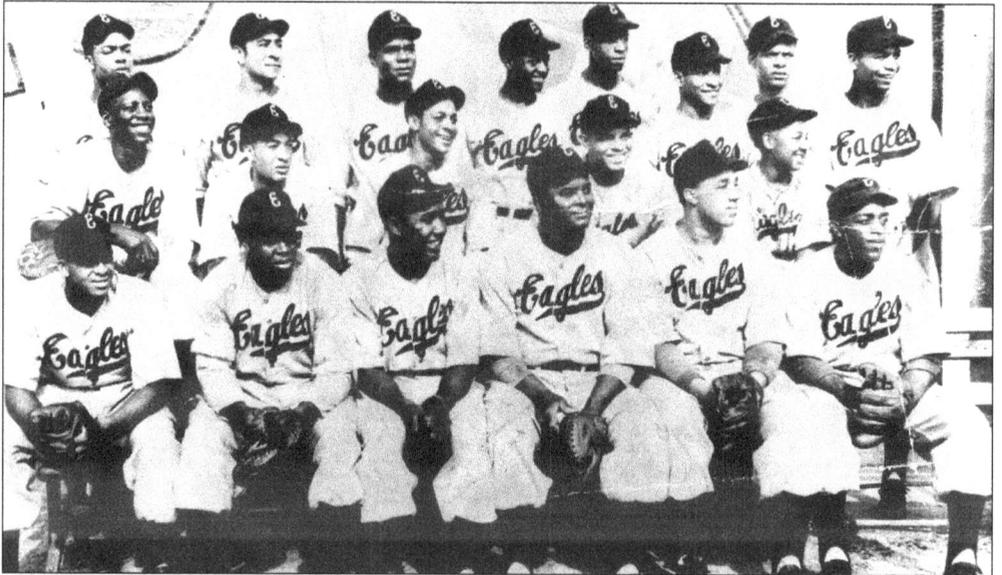

THE NEWARK EAGLES, 1946. One of the most popular Negro League teams to make yearly trips to Portsmouth and Norfolk was the Newark Eagles, crowned league champions for the 1946 season. This image of that team includes stars such as Biz Mackey, Max Manning, Leon Day, Larry Doby, Monte Irvin, Lennie Pearson, and Leon Ruffin. Ruffin, an excellent athlete on the diamonds and gridiron for several Portsmouth and Norfolk semi-pro teams, had a long and successful career in the Negro Leagues. He proved to be an excellent defensive catcher with a strong and accurate throwing arm. (National Baseball Hall of Fame.)

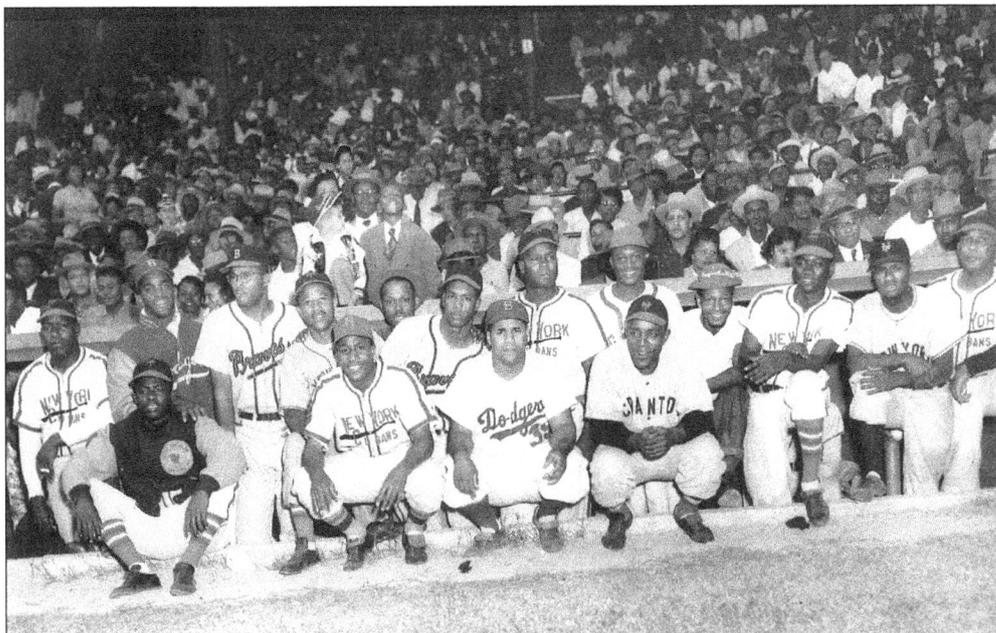

**CAMPY'S ALL STARS COME TO TOWN, 1952.** At the completion of the World Series in 1952, 1953, and 1954, Roy Campanella took a group of African-American major league, minor league, and Negro League players on a month long barnstorming tour across the nation. The Norfolk and Portsmouth area were stops on the tour. The above image of the 1952 team was taken in Memphis several weeks after their visit to the Hampton Roads area. Besides Campanella, the team included Joe Black, Bill Bruton, George Crowe, and future Hall of Fame member Leon Day. As seen in the adjacent 1954 *Journal and Guide* advertisement, a game was scheduled against the Birmingham Black Barons in Portsmouth Stadium. The game, played before 4,500 spectators, saw the All-Stars whip the Barons 10-4. Former 1953 Portsmouth Merrimac star and St. Louis rookie sensation, Brooks Lawrence, returned to the city to pitch for Campy's All-Stars. Joining Campanella and Lawrence in 1954 were future Hall of Fame players Larry Doby and Monte Irvin, as well as major league stars Hank Thompson, Junior Gilliam, Don Newcombe, Gene Baker, Bob Trice, and Joe Black. (CSTG.)

# Baseball!
## Campanella
### All Stars

—VS.—

# BIRMINGHAM
### Black Barons

## Sun. Oct. 10

**Portsmouth Stadium**
Portsmouth Va.
at 2 P. M.

War Memorial Stadium
**Newport News**
at 8 P. M.

General Admission ___$1.50
Box Seats _____$2.00

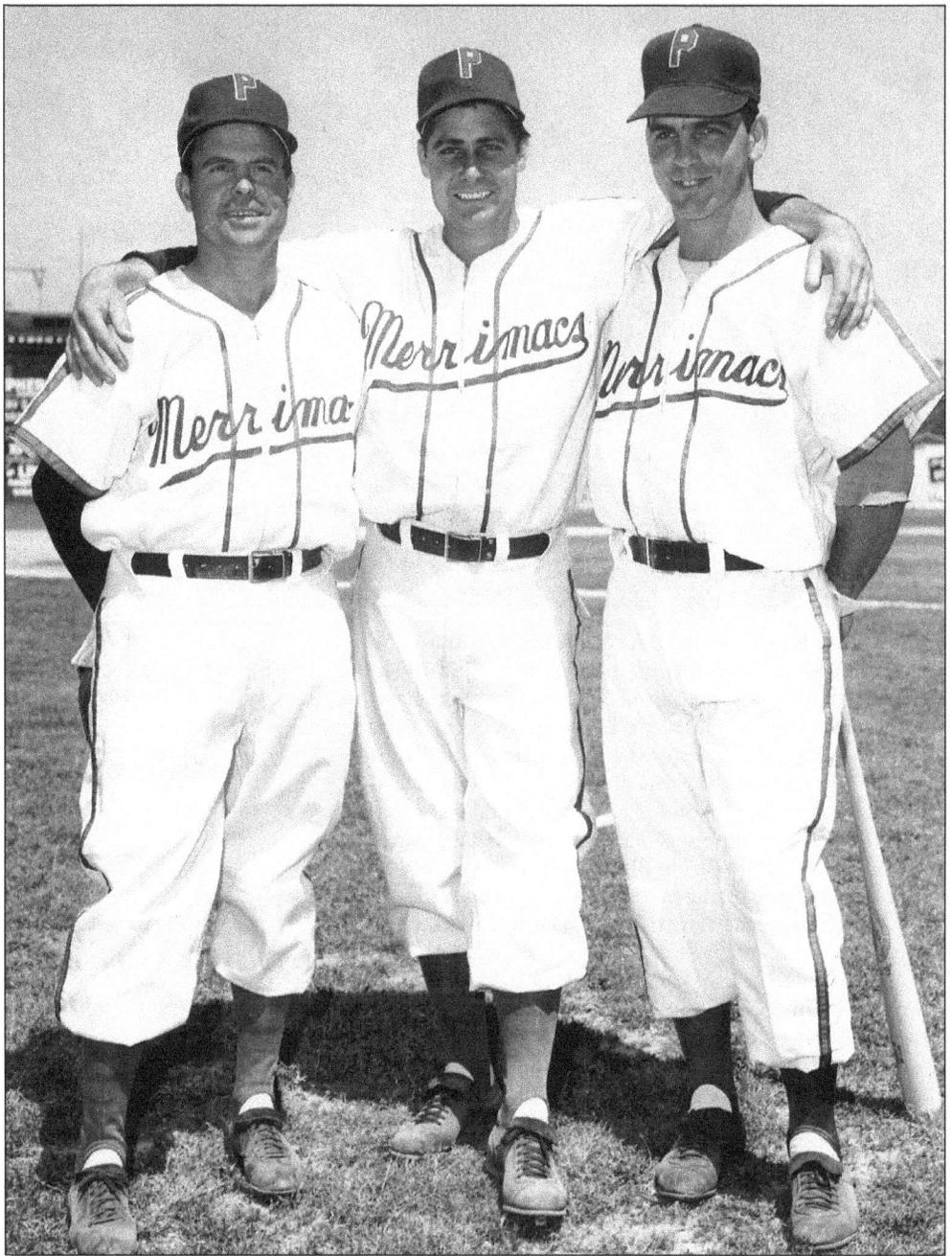

**A Trio of Merry 'Macs, 1953.** Pictured in the newly issued uniforms of the Portsmouth Merrimacs are veteran catcher Harry Land (left), third baseman Joe Wheeler (center), and outfielder Kenny Guettler (right). For years, the team was known as the Cubs due to the fact that owner Frank D. Lawrence had an informal working relationship with Chicago of the National League. With his franchise now clearly an independent organization, he changed the moniker to Merrimacs after a contest was held asking fans to come up with a new name for the ball club. (VP.)

# EIGHT

# The End of an Era
# The Portsmouth Merrimacs
# 1953–1955

As the decade of the fifties began to stitch itself into the country's tapestry, the tightly woven and intricate patterns of minor league baseball began to unravel. The post-war, golden age of professional baseball at the grass roots level sent the game to a dizzying level of popularity with ever-increasing numbers of fans clicking the turnstiles to enjoy the game in small towns and cities across America. With attendance peaking in 1946, as more than 32 million fans purchased tickets, it was a crushing blow to owners when spectator numbers fell by more than seven million in the 1951 season. The statistics proved to be just as brutal in the city of Portsmouth. The acme year for attendance came in 1947 when 154,026 fans were counted. However, by 1955, the final year of the franchise, less than 34,000 patrons passed through the gates of Portsmouth Stadium.

One reason that so many fans stayed away proved to be a device that became an icon associated with the happy-go-lucky decade of the 1950s: television. With more televisions finding their way into homes across America, the consumer felt that they could be entertained adequately in the comfort of their own residence and receive more bang for their buck. It was during this era that television supplanted baseball as the country's new national pastime.

The most publicized impact of television on the game was the disbanding of the historic Class B Inter-State League following the 1952 season due to a saturation of televised Philadelphia Phillies baseball. In 1949, owner Frank D. Lawrence accurately predicted the encroachment of the major leagues into the towns and cities embracing minor league baseball via the airwaves. As early as the mid-1940s he began to prophesize that broadcasts of games would draw fans away from the ballpark and ten years later he sued major league baseball for treading into his market through the medium of television and radio. His suit rattled the very core of major league baseball and he demanded that the American and National League teams profiting from the broadcasts share their revenue with their minor league offspring. With supporters throughout the country responsible for baseball franchises at the grass roots level and opponents headed by baseball commissioner Ford Frick taking sides, the case garnered national interest. As the suit advanced through the courts it was finally heard at the Supreme Court, but was dismissed. By the time the decision was handed down the Portsmouth team and the rest of the once proud and prosperous Piedmont League had dissolved. By 1962, major league baseball adopted the Player Development Plan and guaranteed that at least 100 minor league clubs would survive. The big leagues agreed to pay a portion of the salaries of minor league players, thus providing the extra income and incentives to ensure that the lower leagues would survive. Brother Lawrence, the Portsmouth gentleman banker, civic leader, and baseball prophet had been right all along—simply well ahead of his

time in regard to his concerns and foresight for the future of minor league baseball. From 1953 until 1955 the Piedmont League experienced unprecedented changes within the circuit as franchises struggled at the gate and with the bottom line. Many of the prime teams of the now defunct Inter-State league took up residence in the Piedmont. The Hagerstown Braves and the York White Roses arrived in time for the 1953 season, while the Colonial Heights-Petersburg Generals joined the league in 1954 and eventually morphed into the Sunbury Red Legs the following season. Vacancies were created for the new members when the Roanoke Red Sox disbanded in July 1953 and Richmond escaped to the International League in 1954. Portsmouth's cross-river rival, the Norfolk Tars, continued to field a team until mid-season 1955, when the franchise folded.

Frank D. Lawrence opened the 1953 season with new faces, new organizational ties, and a new name for the club: The Portsmouth Merrimacs. The moniker paid homage to the CSS Virginia (originally the Merrimac), the ironclad vessel that challenged the union ship USS Monitor in the historic battle on the waters of Hampton Roads during the War Between the States. Lawrence severed his longtime working relationship with the Chicago Cubs and established informal ties with a new team, the Cleveland Indians. The American League organization provided Merrimacs with a new manager, Bob Ankrum.

Besides Ankrum, there were other new faces on the team and for the first time in the history of Portsmouth baseball some of the faces were black. Lawrence and the 'Macs were the first team in the Piedmont to integrate their roster with African-American players and by the time the season rolled into the summer months several had secured positions in the starting line-up. The two most significant standouts on the team were Brooks Lawrence and Charles "Mule" Peete. Pitcher Lawrence showed exceptional skill on the mound while posting a strong 18-13 record while Peete began to establish himself as a key player in the league. The 'Macs, with the help of these standouts, earned a winning record of 72-63 for a fourth place finish. The ever-present and steady Kenny Guettler led the league in home runs for the third straight year and was among the league leaders in RBIs. Despite a successful season and the team's advancement to the postseason, the Portsmouth franchise was in trouble financially. With strict limits regarding the amount that could be spent on the operation of the team for salaries and the like, the Portsmouth franchise soon found its debts growing and fewer revenue-paying fans coming out to the ballpark.

In 1954, the 'Macs found themselves in the managerial hands of Al Monchak, who failed to impress owner Lawrence as the team faltered early in the season. Without much fanfare, Monchak was fired and replaced with the venerable Pepper Martin, a former St. Louis Cardinal. Martin had previously served as manager for the Miami Beach Flamingos, but lost his job midseason when the league disbanded. Despite the change, the course of the team failed to improve and the 'Macs again finished with a marginal record of 71-69, losing in the finals of the Shaughnessey playoffs to the Newport News Dodgers in a close seven game series.

As the 1955 season began, fans continued to avoid the ballpark and Lawrence struggled to break even on most nights. Promotions, slashed ticket prices, and other innovative methods to bolster attendance all proved fruitless. Across the Elizabeth River, the Norfolk Tars were in turmoil and by the middle of July the franchise locked the gates at historic Myers Field and disbanded. The 'Macs picked up several of Norfolk's key players and under the guidance of Kenny Guettler managed another fourth place finish. The slugging player-manager again took the league title in homeruns (41) and RBIs (113), but his power was not enough to make the 'Macs winners.

On the cold, rain splattered evening of September 22, 1955, the Merrimacs took the field for the last time and were eliminated in the fifth and final game of the Piedmont League playoffs by the Lancaster Red Roses. Only 353 faithful spectators sat within the confines of the ballpark to witness the passing of an era in Portsmouth baseball history. Fans suffered through five lonely seasons without baseball before the crack of the bat again resonated in the city.

**ANKRUM AND OWEN, 1953.**
For the 1953 Piedmont
League season both the
Norfolk Tars and the
Portsmouth Merrimacs
named new managers to
guide their respective teams.
Pictured here at Myers Field
in Norfolk is 'Mac skipper
Bob Ankrum (left) and his
counterpart with the Tars,
Mickey Owen. Ankrum was
hired by Frank D. Lawrence
through the Cleveland
Indians organization and
served in a dual role as both
skipper and second sacker
during his one season with
Portsmouth. (From the
collection of Ducky Davis and
Bobby McKinney.)

**MERRIMACS PROGRAM, 1953.**
This program was purchased
by a fan of the Portsmouth
Merrimacs for a home game at
the ballpark during the 1953
season. The 10¢ program listed
Frank D. Lawrence as president
of the club and Bob Ankrum as
manager. Local advertisements,
pictures of players and staff, and
an insert listing the rosters of
the two Piedmont League teams
were included. This particular
program featured the Norfolk
Tars as the evening competition.
(From the collection of
Mike Haywood.)

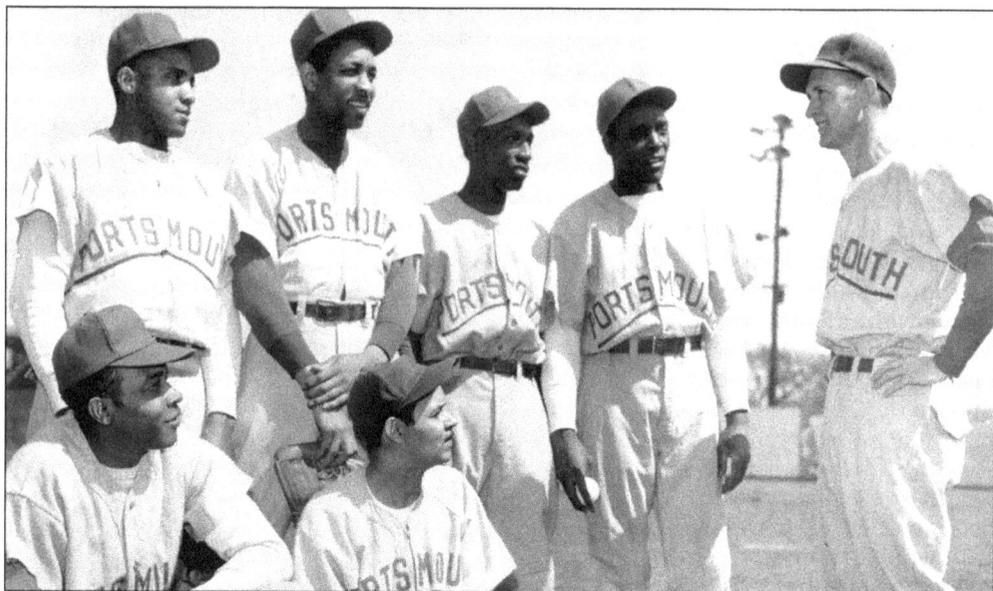

**MANAGER BOB ANKRUM WELCOMES NEW CANDIDATES, 1953.** Manager Bob Ankrum gives instructions to seven of the ten black players on hand for the Merrimacs' first day of spring training. The hopefuls, part of a preseason squad of 22 players, were sent through the paces of a two-hour workout on a chilly spring day. After the final cut, only three blacks remained on the 'Macs roster and suited up for opening day of the 1953 Piedmont League season. It was the first time since the league was formed in 1920 that blacks were allowed on the rosters. (From the collection of Ducky Davis and Bobby McKinney.)

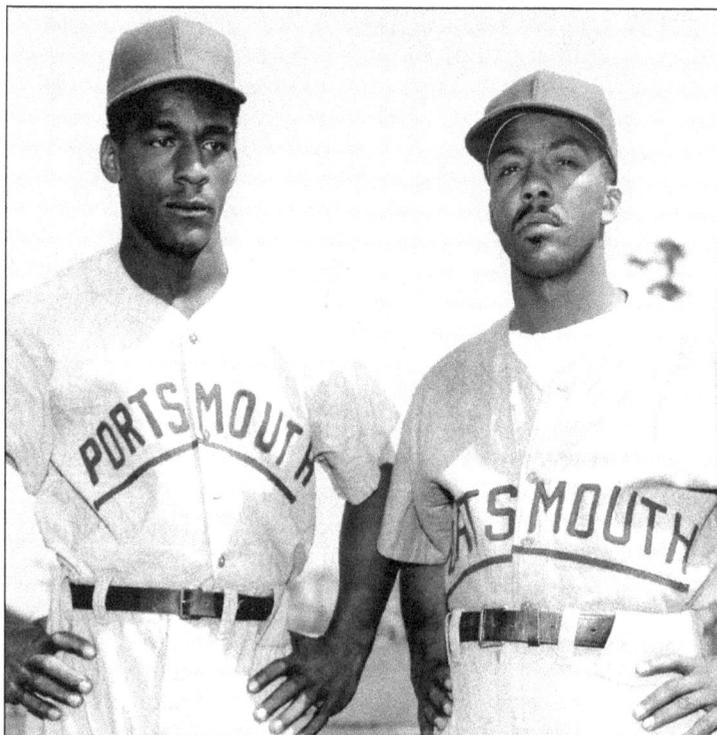

**'MAC HOPEFULS.** Burl Barge (left) and Tom Burt were among the ten African-American candidates invited to spring training in 1953. Both Burl, an outfielder from Norfolk, and Burt, an infielder from Portsmouth, were hoping to become members of the squad as the Merrimacs became the first team in the Piedmont to integrate their roster. Neither of the two hopefuls were offered contracts. (From the collection of Ducky Davis and Bobby McKinney.)

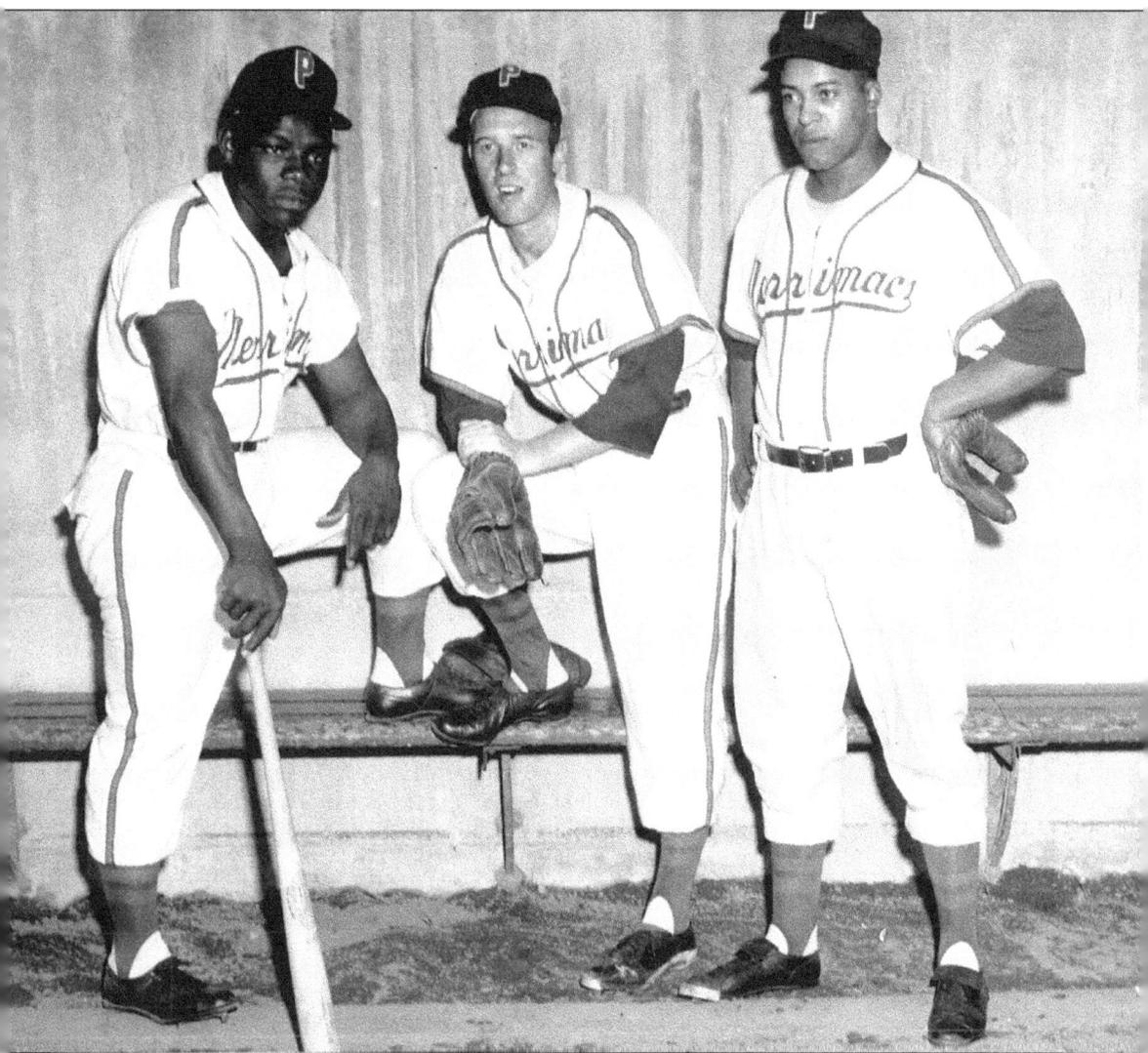

A NEIGHBORLY WELCOME TO PORTSMOUTH, 1953. Veteran outfielder Eddie Neighbors (center) was one of the first players to welcome the contingent of new African-Americans to the Merrimacs for the 1953 season. Pictured here in the dugout of Portsmouth Stadium are Charles "Mule" Peete (left) and pitcher Brooks Lawrence (right). For Peete, his inaugural year in the newly integrated Piedmont League proved to be a learning experience as he averaged .275 and hit only 4 homeruns during the season. The following year he mastered league pitching and improved his average to .311 and slugged 17 homers. Brooks "Bull" Lawrence proved his worth immediately with the 'Macs as he posted an 18-13 record with an equally impressive ERA of only 2.37. Owner Frank D. Lawrence had no difficulty selling his big right-hander to St. Louis where he paid immediate dividends to the Cardinals in 1954 with a 15-6 record. Brooks Lawrence's high water mark in baseball came in 1956 when he tallied 19 wins with the Cincinnati Redlegs. "Mule" Peete's potential was never tapped as the young outfielder and his entire family were killed in a plane crash in 1956 on the way to Venezuela to play winter ball. (From the collection of Ducky Davis and Bobby McKinney.)

105

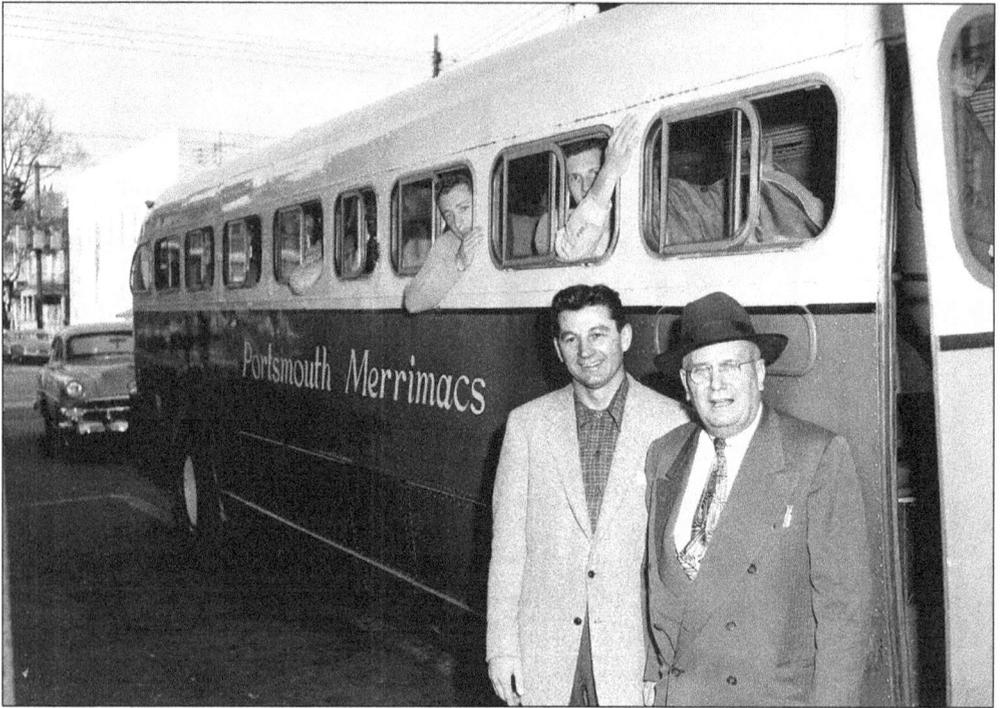

**ALL ABOARD FOR SPRING TRAINING, 1954.** Portsmouth Merrimacs manager Al Monchak and owner Frank D. Lawrence (above) pose for one last picture before boarding the bus taking the team to sunny Florida for preseason training in preparation for the 1954 season. The aging team bus made it as far as Florence, South Carolina, before it broke down. The team, shown killing time in downtown Portsmouth before boarding (below), finally made it to their destination, Avon Park, Florida, a day late and on a new bus. (PPL.)

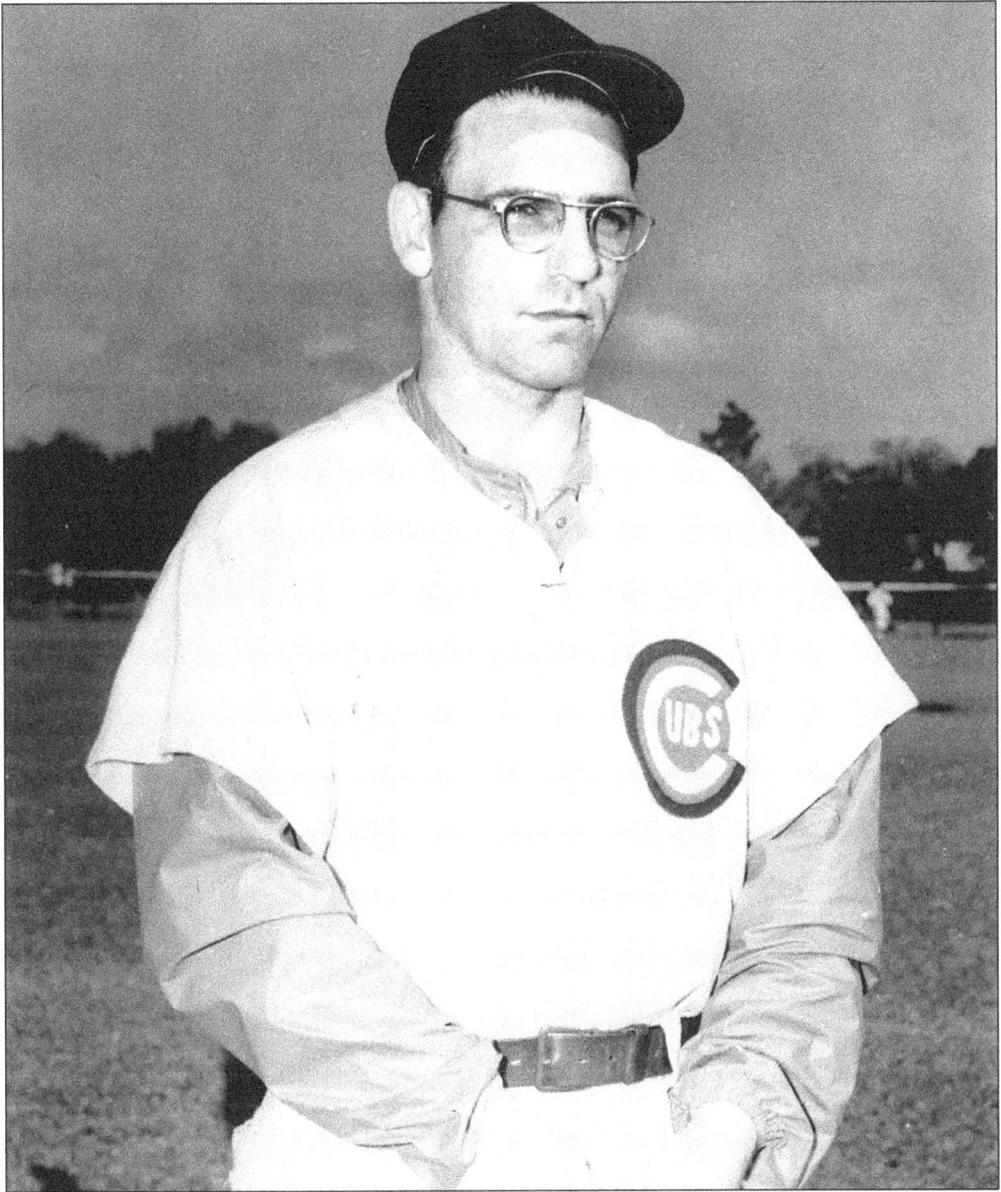

**New Specs for Portsmouth Slugger Kenny Guettler, 1954.** Because of failing eyesight, Kenny Guettler resorted to wearing glasses for the 1954 campaign. Pictured at Avon Park, Florida, during the first days of spring training, Guettler models his new look for the photographer. The slugging outfielder was a formidable fixture with Portsmouth from 1950 until the league folded in 1955. His best year in the Piedmont League came in 1952 when he rejoined the team in late May after an unsuccessful attempt to garner a major league contract. Despite missing almost two months of the season, Guettler won the league's Most Valuable Player award and the Triple Crown as the offensive leader in homers (28), RBIs (104), and batting average (.334). His average slumped in 1953, but with the help of the newly prescribed specs, Guettler increased his batting average almost 30 points in 1954 to a respectable .291. (CSTG.)

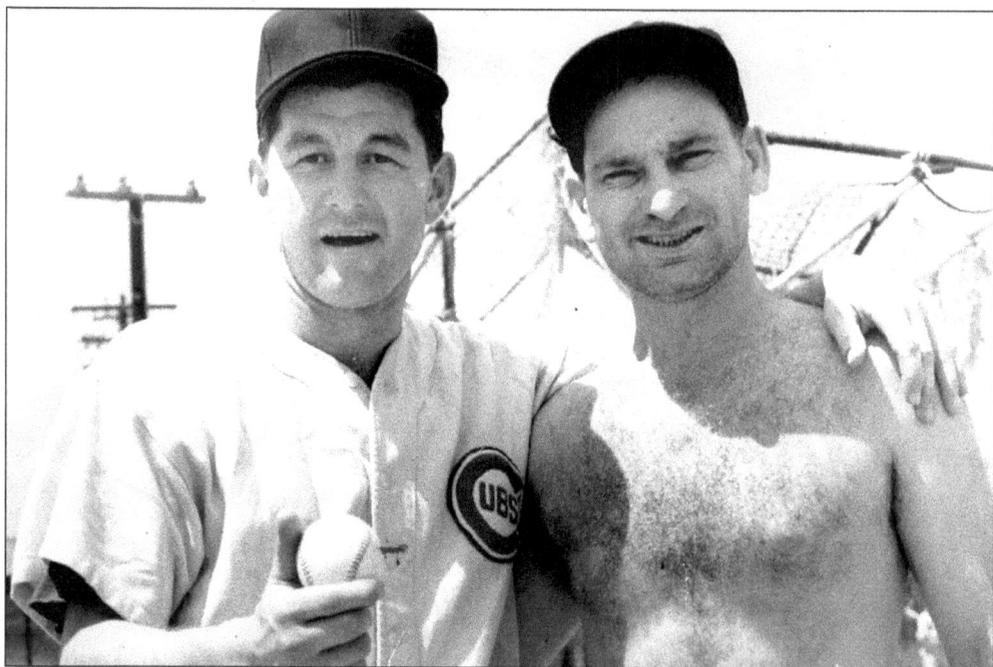

**FLORIDA FRIENDS, 1954.** When the 'Macs settled into spring training at Avon Park, news of the team's progress was reported to Portsmouth fans by *Virginian-Pilot* sports reporter Abe Goldblatt (right). A respected fixture in the Hampton Roads area, Abe is appropriately dressed for the humid Florida weather, while manager Al Monchak (left) wears an old Portsmouth Cubs flannel. Al served as a part-time shortstop with the Portsmouth Cubs in 1940 and had a short stint that year with the Philadelphia Athletics. (CSTG.)

**HURLER JIM BARNHARDT, 1954.** Right-handed pitcher Jim Barnhardt first earned a place on the Portsmouth roster in 1951 and dominated the Piedmont League with 19 wins and a league leading ERA of only 2.53. In 1952, he returned as the ace of the staff and posted an impressive 15-8 record with 6 shutouts, 145 strikeouts, and a 2.19 ERA. The following season Barnhardt was sold to the Reading Indians and proved to be a valuable asset to the Tribe as they captured the Eastern League pennant in 1953 and posted a 12-6 record. The lanky right-hander was purchased by Portsmouth from Indianapolis during the spring of 1954 and toiled on the mound for the Merrimacs, posting a 15-12 record while striking out 152 batters over the season. In 1955, his final year with the 'Macs, Big Jim struggled and found himself with a losing record of 8 and 11. (VP.)

**MERRIMAC INFIELDERS TALK IT OVER.** Things looked bright for this trio of Portsmouth Merrimac prospects in the spring of 1954. From left to right are Quincy Barbee, Bill Spirko, and Johnny Russo. Barbee, a 37-year-old first baseman, hit .370 for the Pampa Oilers of the West Texas-New Mexico League in 1952 and was considered a shoo-in to earn a spot on the 1953 opening day line-up for the 'Macs. Despite the hype, Barbee only appeared in 24 games and batted .264 before he was released. Bill Spirko came and went rather quickly with the 'Macs in 1954, but Johnny Russo found himself penciled into the Portsmouth lineup on a regular basis in 1954 and again in 1955 as their shortstop and second baseman. (VP)

**PEPPER MARTIN.** On July 30, 1954, Frank D. Lawrence suddenly announced that manager Al Monchak had been fired and replaced by former major leaguer Pepper Martin. Martin, known for his speed on the base paths as a one-time member of the "Gashouse Gang" with the St. Louis Cardinals, was serving as manager of the Miami Beach Flamingos of the Florida International League when the circuit disbanded on July 27th. Lawrence, always one to take advantage of an opportunity to find a big name to oversee the club, gave Monchak his walking papers and handed the team over to Martin. (VP.)

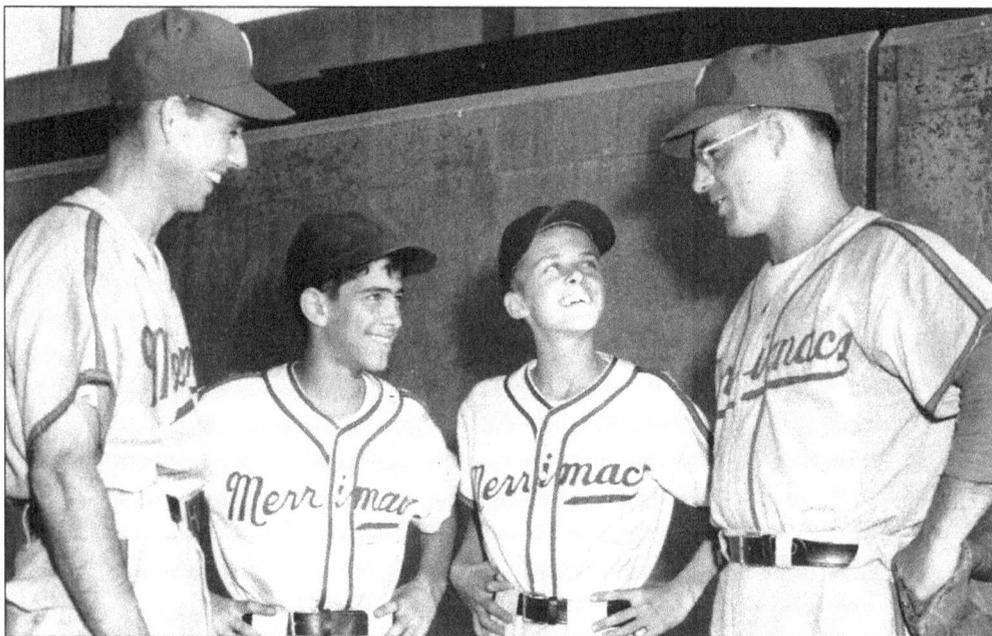

LISTENING TO EXPERIENCE, 1954. Merrimac outfielders Eddie Neighbors (left) and Kenny Guettler (right) share a special moment with two Portsmouth batboys before a scheduled Piedmont League game in 1954. Standing alongside center fielder Neighbors is his son, while fellow batboy "Bucky" Dodson is seen flashing a beaming smile to the slugging Guettler. (From the family archives of Roland Dodson.)

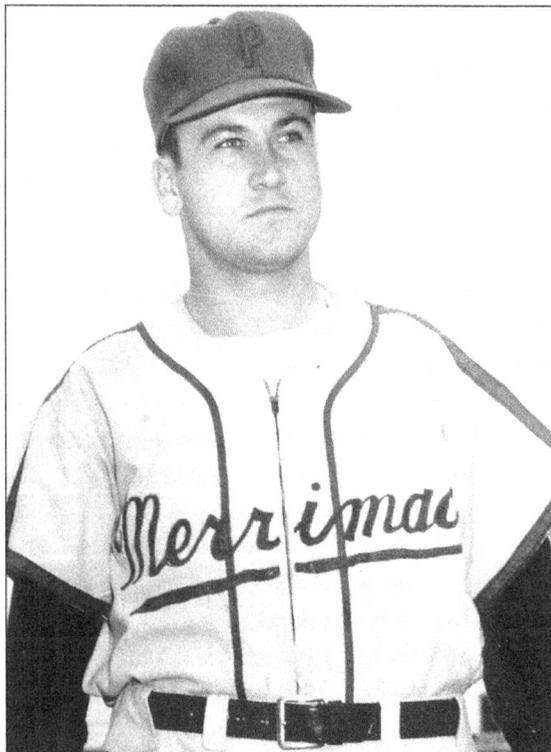

PORTSMOUTH'S OWN, 1955. In 1951, a young Sonny Richardson graduated from Portsmouth's Woodrow Wilson High School, where he had been the ace of the President's baseball team. The following year, Richardson was signed by Frank D. Lawrence to play for his Cubs as the right-hander pid dividends as he compiled a solid 8-3 record in his first professional season. After a two-year stint in the Army during the Korean War, Richardson returned to Portsmouth and became a member of the Merrimacs for their final season in the Piedmont before the league disbanded. The Portsmouth native finished his career with his hometown team by posting a 3-1 record. (CSTG.)

SLUGGER KENNY GUETTLER CONNECTS. Portsmouth slugger Kenny Guettler shows his powerful form in this interesting photograph taken high above the field from the pressbox overlooking home plate. The soft-spoken outfielder developed into one of the most feared hitters in Piedmont League history during his time with the Portsmouth Cubs and Merrimacs from 1950 until the league's demise in 1955. During this six-season span Guettler captured the home run title four times, the RBI title three times, and won the Triple Crown in 1952. After his final year in Portsmouth, Guettler was purchased by the Shreveport Sports and in his first Texas League season he became one of only 11 men in all of professional baseball at the time to hit 60 or more home runs in a single season. In that landmark 1956 campaign he hit 62 home runs, knocked in 143 RBIs, and batted .293 for a team that finished deep in the second division. Despite a phenomenal 15-year minor league career, slugger Kenny Guettler never played a single game of major league baseball. (National Baseball Hall of Fame.)

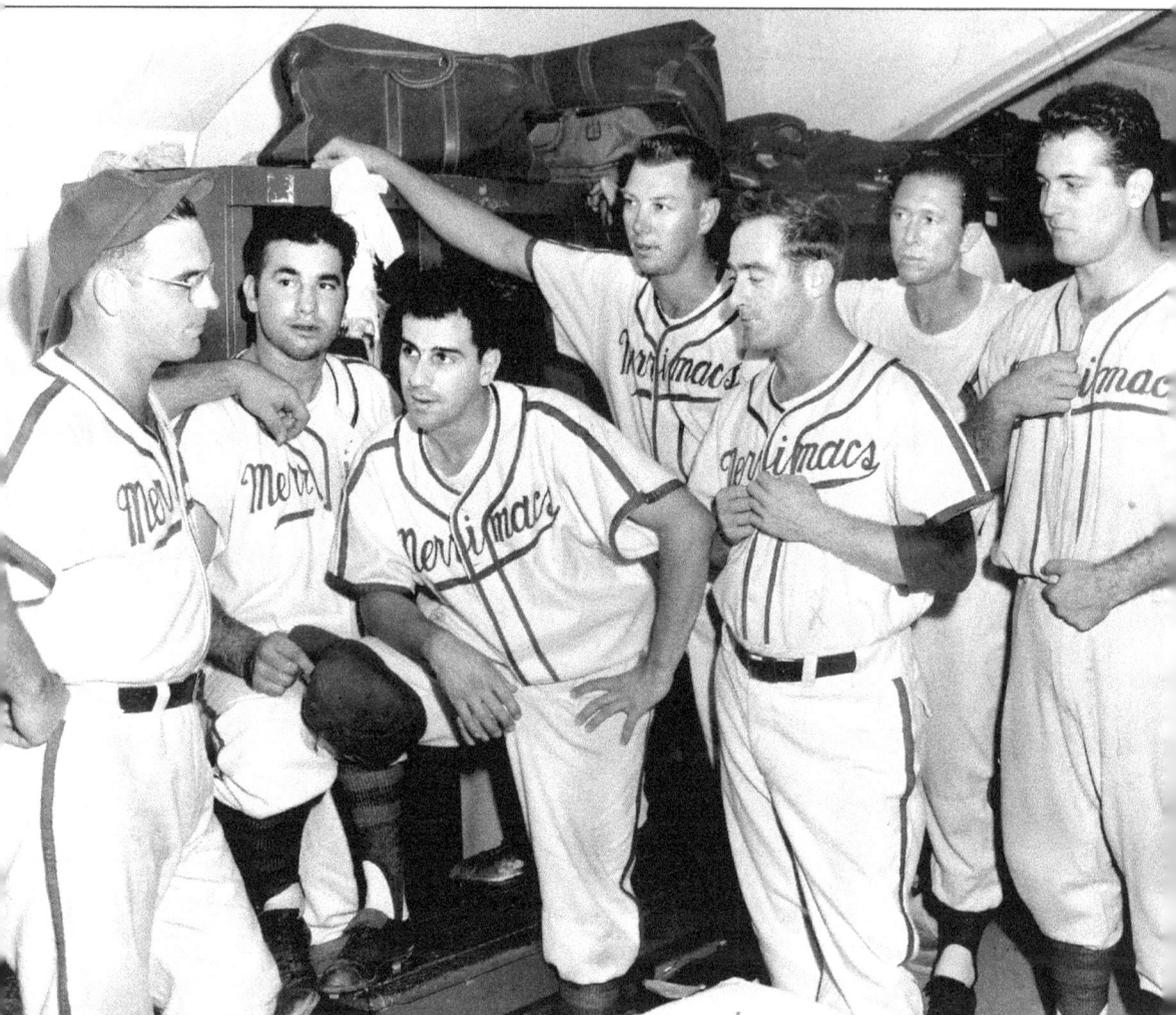

**NEW KIDS IN TOWN, 1955.** On the evening of July 13, 1955, the Norfolk Tars played their final game in the Piedmont League, folding up their operation due to financial losses and fan indifference. Portsmouth owner Frank D. Lawrence put out the word that he would be interested in picking the cream of the Norfolk crop for his Merrimacs and offered contracts to a number of unemployed Tars for his club. Pictured in the Portsmouth locker room, only two days after the demise of the Norfolk team, is Merrimacs manager Kenny Guettler (far left) welcoming the ex-Tars to their new home. Guettler rests his arm on catcher John "Yogi" Malangone while second baseman Tom Venditelli listens intently to his new skipper. The rest of the new contingent of 'Macs included first baseman Al Weygandt and pitchers Spec Padgett, Jerry Buchanan, and Fred Zirella. The influx of new players into the roster put a charge into the 'Macs as they rallied over the final months of the season and secured a spot in the playoffs. In just over two months, the fans of Portsmouth baseball soon discovered that the city was without the National Pastime. (From the collection of Ducky Davis and Bobby McKinney.)

# PORTSMOUTH BASEBALL NOTES
## 1953–1955

Interesting facts about the players in Portsmouth's baseball history

◆ In what may have been Pepper Martin's last professional at bat, the "Wild Hoss of the Osage" and former member of the St. Louis Cardinals' "Gashouse Gang" hit a 350-foot double off the right field wall at Myers Field in Norfolk. Martin, the 47-year-old manager of the Merrimacs, inserted himself as a pinch hitter late in the last regular season game of the 1954 season. To top off his last appearance on the diamond, Martin showed he still had a bit of his legendary speed—he stole third base.

◆ In 1953, the Portsmouth Merrimacs were the first of the Piedmont League teams to sign an African-American player to their roster. Over the course of the season several players made names for themselves including pitcher Brooks Lawrence and Charles "Mule" Peete. One black player that arrived at Portsmouth stadium with a resume almost unparalleled in all of baseball was Walter "Buck" Leonard. The North Carolinian began his career with the semi-pro Portsmouth Revels in 1933 before becoming one of the all time greats of Negro League baseball. In the waning weeks of the 1953 season, Frank D. Lawrence signed what the local papers called "an ageless Negro wonder" to a contract and manager Bob Ankrum inserted him at first base with little expected of the 47-year old legend. Much to everyone's astonishment, Leonard continued his brisk hitting against Piedmont League pitching and finished his brief 10-game stay with the 'Macs batting .333, tied for the league lead with Gerry Lynch of the Norfolk Tars. From the field he played his position flawlessly, with no errors recorded. The ten games he appeared in with the Merrimacs proved to be "Buck" Leonard's only opportunity to play integrated professional baseball.

◆ On July 13, 1955, the Norfolk Tars played their final game in the Piedmont League. Several of the Norfolk players including Tom Venditelli, John Malangone, Al Weygandt, and Jerry Buchanan were signed by the 'Macs. When the Tars folded, the local papers began to list the Portsmouth team as the NorPort Merrimacs in the standings.

◆ John "Yogi" Malangone, the squat catcher-first baseman for the Merrimacs, possessed what may be called a flamboyant personality. During the final months of the 1955 Piedmont League season, he physically ran sports reporter John Crittenden out of the Portsmouth locker room at least a dozen times for criticisms of his performance printed in the local paper. Malangone was the team comedian and always had the players loose and laughing. On more than one occasion he was found in the locker room shower after the game wearing a rubber Frankenstein mask.

◆ To the dismay of many local fans, Merrimac owner Frank D. Lawrence abruptly terminated radio broadcasts from the stadium and on the road for the 1955 season. At the time Lawrence was deeply involved in a suit he filed against major league baseball for their encroachment into his territory via the airwaves with radio and television broadcasts of major league games. He felt that to air games to the public would undermine his cause.

◆ Portsmouth outfielder Kenny Guettler experienced a number of disabilities that may have dashed the hopes and ambitions of most professional athletes. As a child growing up in Bay City, Michigan, the young Guettler was involved in an accident while playing hockey that left his right arm several inches shorter than his left. To make matters more challenging, Guettler was visually impaired and had trouble seeing a pitch more than thirty feet from home plate. The Portsmouth slugger overcame both limitations and put together a career that was one of the finest in the history of minor league baseball.

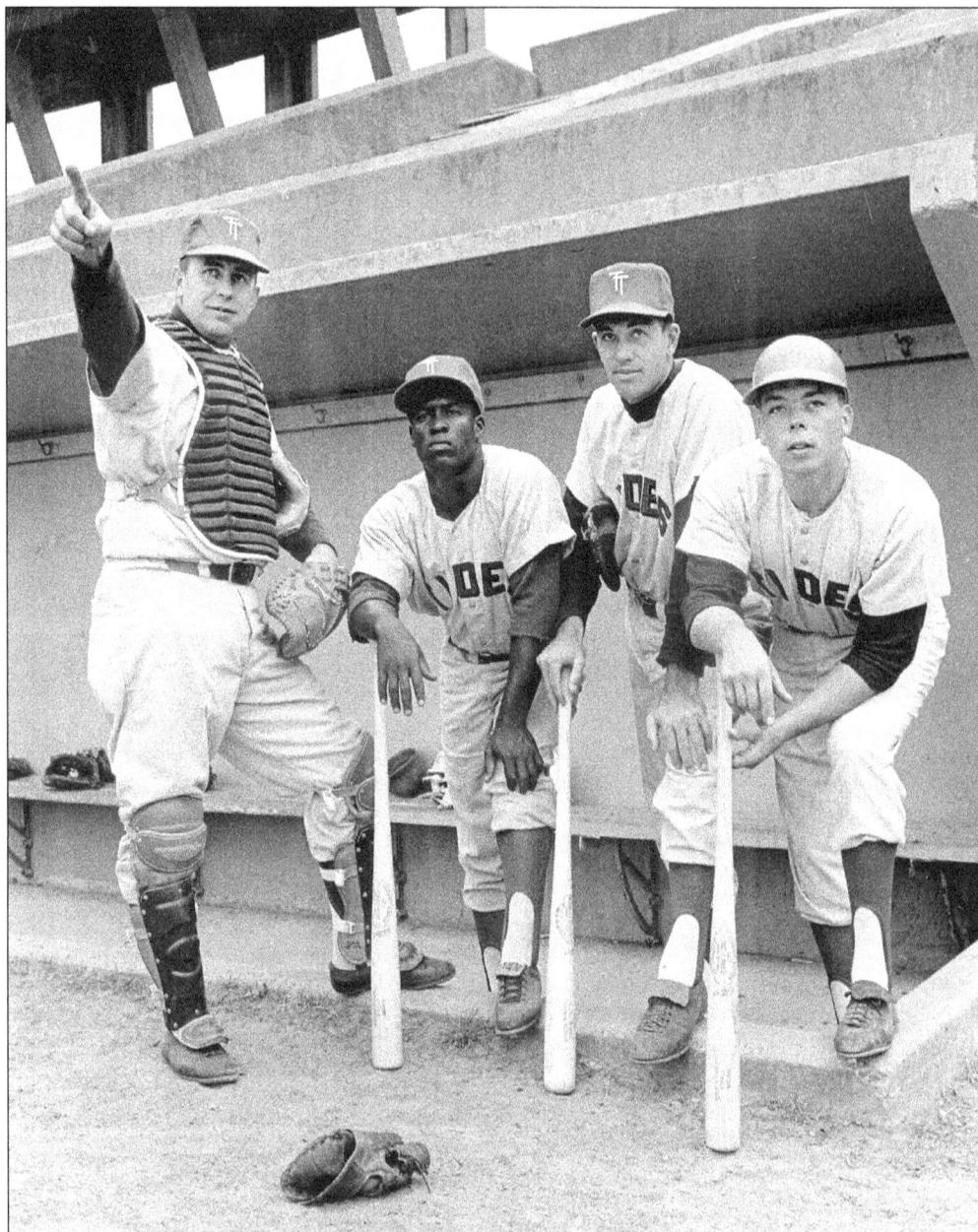

**POINTING TO THE FUTURE, 1963.** Attired in his catching gear, player-manager Allen Jones seems to be predicting the fate for this trio of players in the dugout of Portsmouth Stadium in the spring of 1963. To the right of Jones is second baseman Dave Kelly, outfielder Max Johnson, and a young-looking Jimmy Winn. By mid season both Kelly and Winn fulfilled their manager's prophecy and were given their outright release, leaving only veteran Max Johnson on the roster as the season came to an end. Kelly struggled at the plate and completed his short-lived career with the Tides, with an anemic .205 batting average. Winn never had the chance to establish himself with the club and appeared in only five games before turning in his uniform. (VP.)

# NINE

# The Tides Roll In, The Tides Roll Out 1961– 1969

Few of the faithful, waterlogged fans that sat in the stands of Portsmouth Stadium on the evening of September 22, 1955, could have imagined that they were witnessing the last professional ball game in the city for many years. Shortly after the final games of the postseason were completed, the Piedmont League formally disbanded with no hope of resurrection for the upcoming 1956 season. Declining attendance and limited funds in the league and team coffers contributed to the downfall of the historic organization. With Portsmouth Stadium relegated as a stage for high school football contests, a professional baseball game failed to materialize until local promoters enticed the Class A South Atlantic League to hold their annual All-Star game in the city during the 1960 season. The game stimulated interest in the community and the stadium was once again filled with a respectable number of fans. Following a study by the Sally League, a franchise was granted to William McDonald of Miami, Florida, for the start of the 1961 season and the Tidewater Tides were born.

For their inaugural season in the league, the Tides operated as an independent franchise and were not associated with any major league team for financial support or player development. Granny Hamner, a former "Whiz Kid" with the Philadelphia Phillies in 1956 and 1957, was named as the first manager for the Tides. Hamner, who had formally retired from pitching on the mound, soon found himself hurling for the Tides in emergency situations. The veteran must have impressed someone within the Kansas City organization because he dusted off his major league equipment and appeared in three games during the 1962 season with the Athletics. Hamner's Tides finished the year in sixth place, well behind the pennant winning Asheville Tourists while drawing 87,158 fans to the ballpark. Despite the losing record, the Tides had one of the better hitting teams in the league, led by slugging first baseman Sal Betancourt who collected 152 hits, 21 home runs, and batted a nifty .297 average from the plate.

With Hamner serving time up the big leagues for the 1962 season, Tides management selected Chase Riddle for their second season in the Sally. Under Riddle the club slumped badly and won only 55 games and finished 37.5 games behind the Lynchburg White Sox. Some of the excitement and allure of baseball returning to Portsmouth had eroded in the community and fewer than 49,000 fans clicked the turnstiles of the stadium. While the Tides were one of the weakest offensive teams in the league, Martin Beltran proved to be the big bat for Tidewater as he amassed 150 hits, 20 home runs, and a .309 average. Along with Beltran, the versatile Ron Cox (.307; 23 homeruns) and veteran Sal Betancourt (15 homers; .275 average) were big contributors in most offensive categories for the Tides. From the mound, Tides pitchers were the laughing stock of the league as they posted a less than impressive team

ERA of 5.16, while giving up 156 home runs to opposing batters. Of all the hurlers on the Tides, only southpaw Marv Mecklenburg was fortunate enough to muster a somewhat respectable record of 14-9.

Before the 1963 season could commence, the South Atlantic League made it clear they did not wish to continue their association with the Virginia teams due to the amount of travel involved for their more southern-based members. As anxious trepidation raced through the city that Portsmouth could once again be without baseball, the franchise was rescued by the efforts of general manager Dave Rosenfield. The Tides' GM convinced a group of local investors to purchase the franchise from McDonald and the team found a new home in the Class A Carolina League. The group, Tidewater Professional Sports, hired Allen Jones, a former catcher with the Cleveland Indians, to serve as player-manager for the Tides. For their third straight year the team failed to post a winning record, however fan support improved as more than 63,000 came out to enjoy the games at the ballpark.

The 1964 and 1965 seasons found Jones returning to the helm as the Tides established a new working relationship with the American League Chicago White Sox. The 1964 season was a banner year for the team as they placed second in the league and finished with a winning record (75-63) for the first time in the history of the new franchise. With a successful team on the field, fans turned out in record numbers as 83,255 filled the seats at the newly rechristened "Frank D. Lawrence Stadium."

From 1964 until 1965, there was no one better in the league than Tides outfielder Ed Stroud. The fleet-footed African-American won the 1964 Carolina League Most Valuable Player Award as he led the circuit in runs scored, hits, and stolen bases. The following year, Stroud led the Carolina in batting average and was selected to his second consecutive All-Star team. The Tides appeared in the league's postseason for the first time in 1964, but were eliminated in the first round. The following year they again gained a spot in the playoffs and proved to be nearly untouchable as they eliminated the Peninsula Grays and swept the Durham Bulls in the finals, capturing the league's postseason trophy.

The Tides management began a working agreement with the Philadelphia Phillies in 1966 and continued in the National League club's farm system through the 1968 season. Following their championship campaign in 1965, the Tides dropped to the cellar of the Carolina League in 1966, posting only a 58-81 record as the crowds dwindled to less than 43,000. In 1967, with Bob Wellman named skipper, the Tides rediscovered their winning ways and earned a spot in the postseason playoffs due mostly to the big bats of Ron Allen and Larry Hisle. The Tides again advanced to the final series, but the Durham Bulls had extracted their revenge and captured the trophy during a short three game series. With Wellman returning to manage the Tides in 1968, the team finished only 3.5 games behind the Raleigh-Durham Mets, but was sideswiped by the Wilson Tobs in the playoffs.

In the early days of 1969, Richard Davis, president of Tidewater Professional Sports, obtained permission from the Phillies to talk with the general manager of the New York Mets. Davis convinced the Mets GM to transfer their Jacksonville franchise to Portsmouth and persuaded the organization to assist with the financing of a new stadium. With the agreement finalized, the Tides became members of the AAA International League and the top-notch minor league franchise in the Mets' farm system. The announcement that the team would leave the Carolina League for a higher classification was met with enthusiasm by local fans, however euphoria was soon replaced by disappointment when it was confirmed that the new stadium would not be built in Portsmouth but in its neighboring city, Norfolk. The Triple A Tides, in their final year of residence in Portsmouth, went from fifth place in a tightly bunched race to first place in the last two weeks of the season. Under the able direction of Clyde McCullough, the Tides captured the league pennant with a 76-59 record.

On September 5, 1969, the Tides played their final game at Frank D. Lawrence Stadium in the city of Portsmouth. The historic run of baseball ended on a losing note as the Tides came out on the short end of the postseason playoff game 8-2 against the Columbus Jets. More than 2,000 fans witnessed the final game and with it the closing chapter of baseball in Portsmouth, Virginia.

TIDEWATER TIDES BASEBALL SONG, 1961. Once it was formally announced that Portsmouth would have a franchise in the South Atlantic League for the 1961 season it was only a matter of time before an official song was adopted to represent the new Tidewater Tides. Local musician and Tides organist Herbert Stewart composed a rousing and spirited tune that was published by his school of music located on London Street in downtown Portsmouth. Below is a sample of the lyrics found in the sheet music: "Batter up! The Tides are ready, Come on, PLAY BALL! We're the best team in the Sally, Come on, PLAY BALL! Get some pop and peanuts, Get a scorecard too. Have some fun let's live it up, that's the thing to do. Bleachers and the grandstand, All join in the fun; We'll stay 'til morning just to win this one. We have pow'r and pitching, give that ball a ride! Knock 'em, sock 'em, rock 'em, shock 'em, Tidewater Tides!" (CSTG.)

"PLAY BALL, TIDES!"
Tidewater Tides Baseball Song

Words and Music
by
HERBERT G. STEWART
ASCAP

Tides: Member of South Atlantic League
Portsmouth, Va.

Published by
STEWART SCHOOL OF MUSIC
423 London Street
Portsmouth, Virginia

LOOKING OVER THE PROSPECTS, 1962. Within the locker room of Portsmouth Stadium, newly appointed manager Chase Riddle scans the names of players he must select to decrease the roster for his final cut before the opening game of the 1962 season. Riddle guided the Tides to a disappointing seventh place finish (55-85) in the Class A South Atlantic League as the Tides struggled against the likes of the Knoxville Smokies, Greenville Spinners, and Macon Peaches. (VP.)

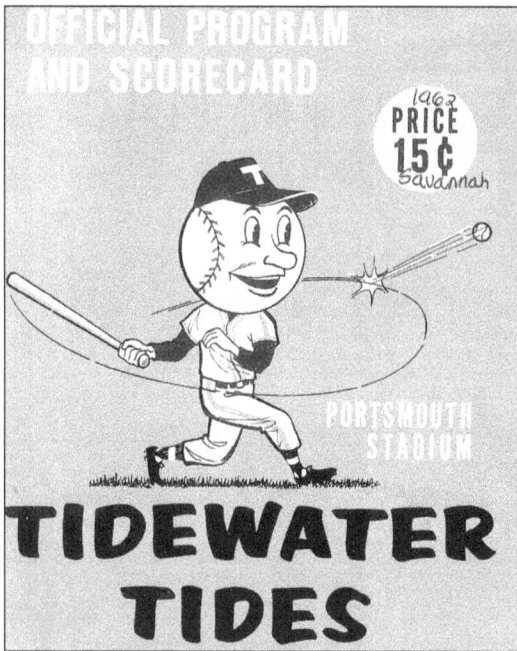

OFFICIAL PROGRAM AND SCORECARD

1962
PRICE
15¢
Savannah

PORTSMOUTH STADIUM

TIDEWATER TIDES

TIDEWATER TIDES HOME PROGRAM, 1962. This 15¢ program was purchased during the summer of 1962 at Portsmouth Stadium for a home game between the Tides and the Savannah White Sox. Interestingly, the White Sox moved their operation late in the season to Lynchburg, Virginia, due to "racial conflicts" in Savannah. While the White Sox took the pennant of the Sally League with a 92-47 record, their move surely affected the rhythm of the season, which was evident during the playoffs when they were swept in the opening round by the Macon Peaches. (CSTG.)

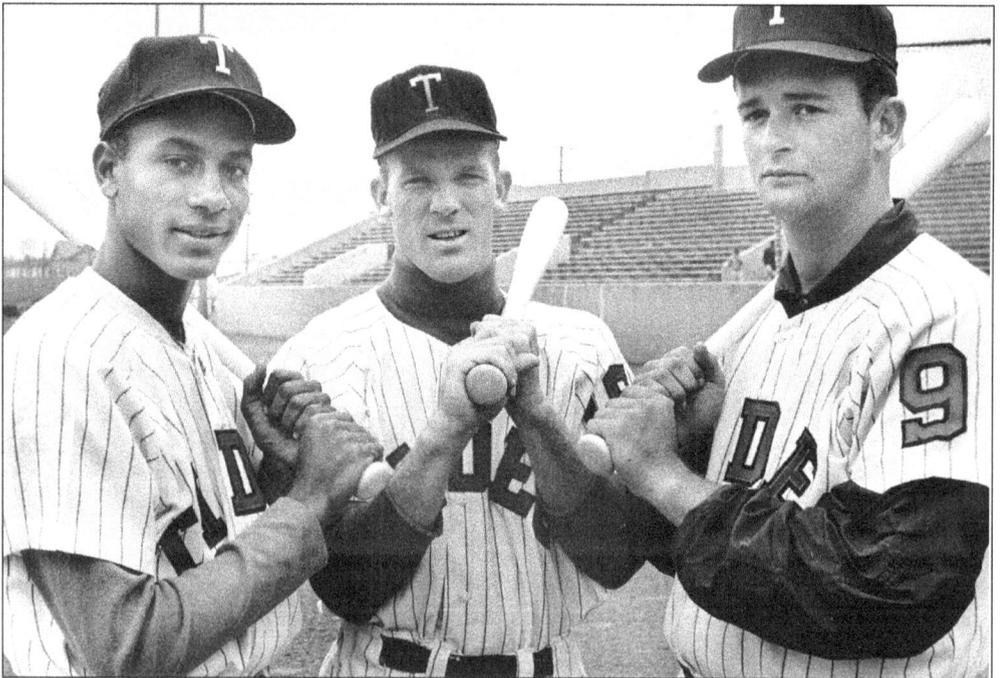

RIDDLE'S RAIDERS, 1962. Tides manager Chase Riddle possessed a trio of potent bats to pencil into his lineup for opening day of the 1962 South Atlantic League season. Pictured from left to right are Martin Beltran, Dennis Waite, and Ronnie Cox. Waite served as the lead off hitter for the Tides and slugged 19 home runs, while Beltran was an offensive dynamo, batting .309 with 20 homers for the season. Ronnie Cox, the team MVP, played a number of positions on the Tides roster and batted .307 from the plate while collecting 23 home runs during the campaign. (VP.)

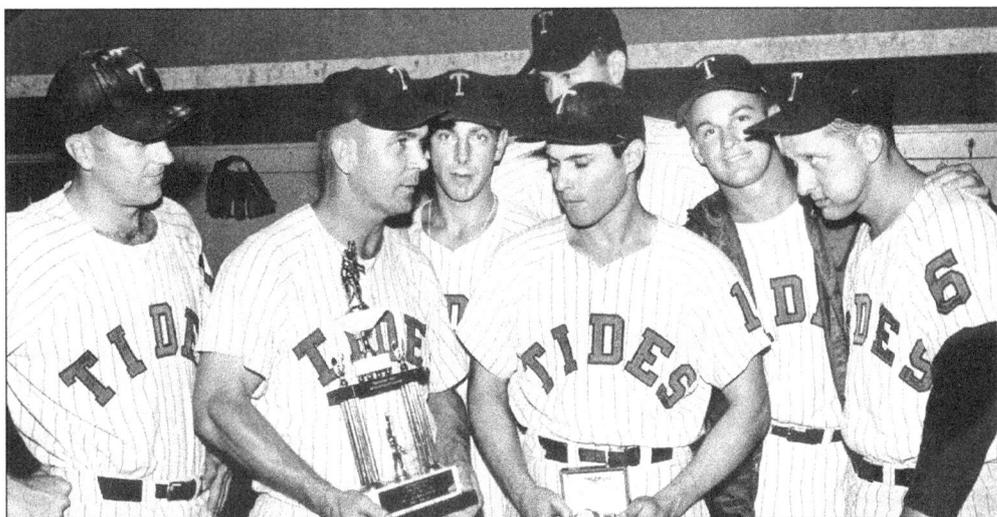

SAL BETANCOURT, MOST POPULAR TIDE FOR 1962. With his players looking on, Manager Chase Riddle (second from left) is pictured with shortstop Salvador Betancourt (third from right, foreground) in the dugout of the Portsmouth Stadium before the final game of the season. Betancourt is holding a wristwatch that was presented to him by the team for being voted the Most Popular Player by the Portsmouth fans. The versatile infielder batted .275 while slugging 15 home runs along with 65 RBIs over the 1962 season. Betancourt looks admiringly at the trophy held by manager Riddle for the Most Valuable Player on the Tides won by Ronnie Cox. Cox was called up to the Atlanta Crackers of the International League late in the season so the trophy was held at the ballpark until the MVP could return at the end of the campaign to retrieve his prize. (VP.)

DAVE ROSENFIELD, TIDES GM. Pictured here at his desk within Portsmouth Stadium, Dave Rosenfield was the guiding force in saving baseball in the Tidewater area in the early 1960s. He first served as general manager for the Tides in 1962 and continues in the same position with the Norfolk Tides. Rosenfield's long and storied career with local baseball is filled with numerous honors, including winning the International League "Executive Of The Year" award four times. (VP.)

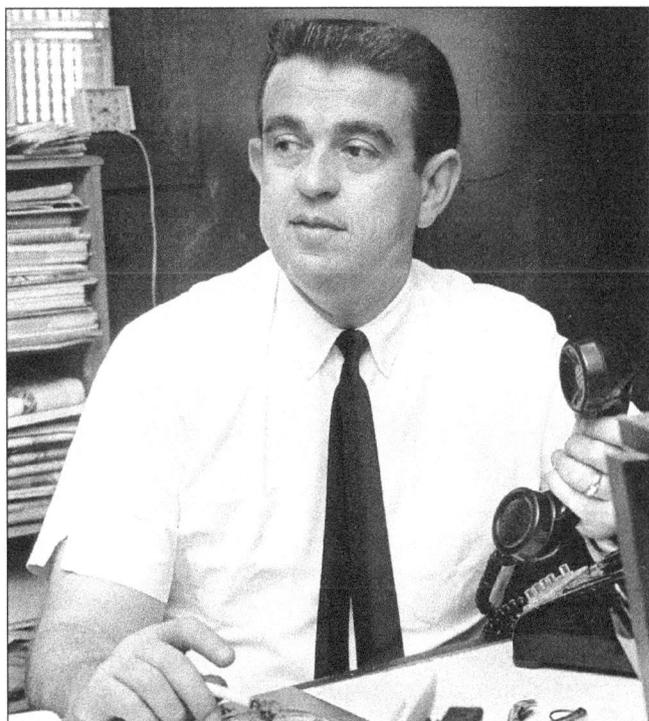

119

**TIDES SPEEDSTER ED STROUD.** During the 1964 Carolina League season there was no one better than Tidewater outfielder Ed Stroud. Nicknamed "The Creeper" for his deceptive move off first base, Stroud was selected MVP of the league while leading a number of offensive categories including runs scored (108), hits (167), and stolen bases (72). The following season he captured the league batting title, hitting .341 from the plate. For his accomplishments he was appointed to the Carolina League All-Star team in 1964 and 1965. As the 1966 season began Stroud found himself with the Chicago White Sox and eventually developed into an everyday player with the Washington Senators from 1968 until 1970. (VP.)

**RUDY MAY AND GARY MYKKANEN, 1964.** Pitcher Rudy May (left) proved to be one of the most dominating hurlers in the Carolina League in 1964 as he posted a 13-6 record while striking out 187 batters and accumulating a low ERA of 2.55. As a 20-year-old, May was called up to the California Angels, but failed to stick with the club and did not return to the major league until four years later. Once acclimated to the big leagues, May found success with the Yankees and later with the Orioles, where he won 18 games during the 1977 season. The Tides pitcher is shown handing a game ball to his favorite catcher during the 1964 season, Gary Mykkanen. (VP.)

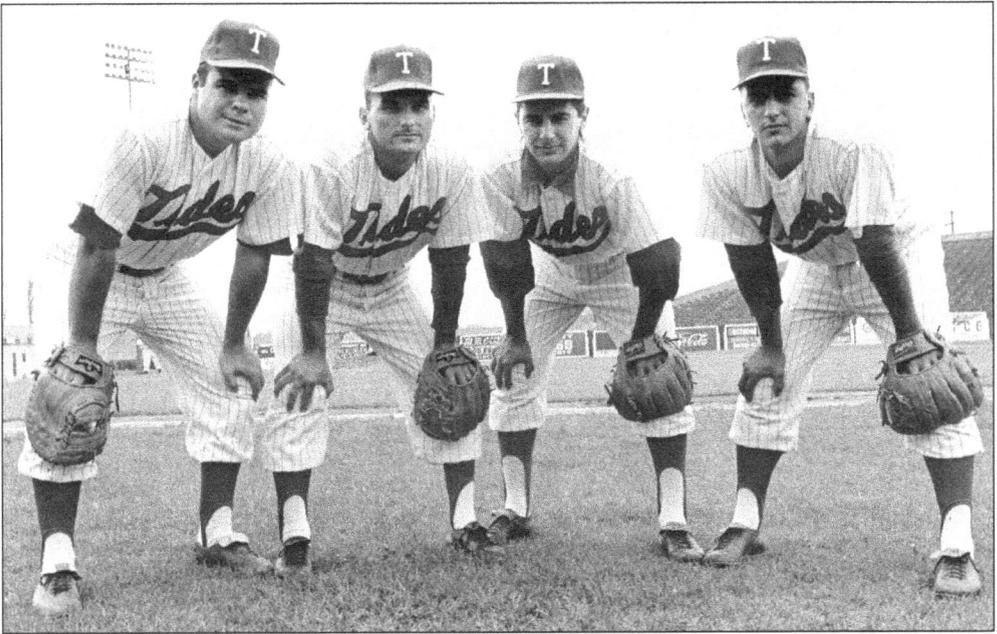

**ANCHORING THE INFIELD, 1966.** The starting infield for the 1966 Tidewater Tides huddle around the camera for a preseason photograph at Frank D. Lawrence Stadium. From left to right are first baseman Gene Stone, second sacker Gene Weston, shortstop Frank Rubino, and third baseman Bill Tomasseli. (VP.)

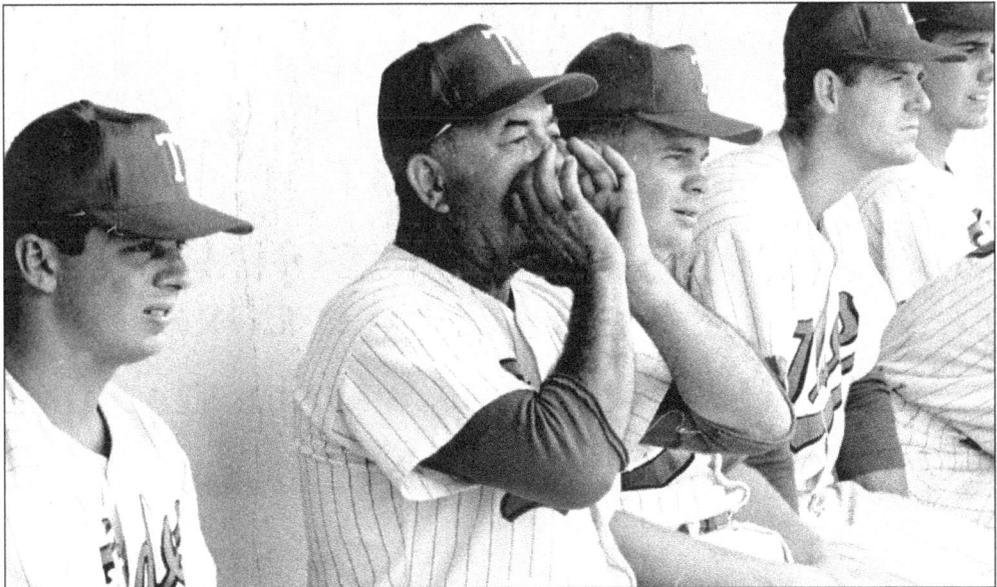

**DUGOUT DIRECTIVES, 1966.** With the Tides languishing in the cellar, the team jettisoned manager Bobby Morgan and replaced him with Lou Kahn (second from right). The change failed to ignite the Tides as they finished the 1966 Carolina League season dead last with a dismal 58-81 record. The new skipper is shown shouting words of encouragement to his batter at the plate. (VP.)

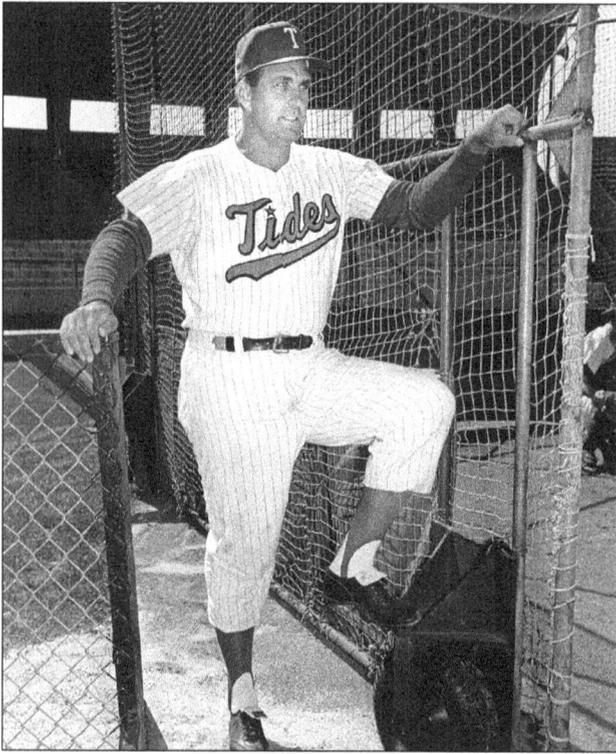

**TIDES SKIPPER BOB WELLMAN.** Taking a classic managerial pose at the batting cage is Tidewater skipper Bob Wellman. Handed a last place club from the 1966 campaign, Wellman put together a good year in 1967, guiding the Tides to a 70-68 record during the regular season. The team jelled in the postseason and advanced all the way to the Carolina League playoff finals before being knocked out by the Durham Bulls. In 1968, Wellman was retained and led the Tides to a second place finish but the team fell apart in the playoffs, losing in the first round. (VP.)

COURTESY PASS

*NOT TRANSFERABLE*

PLEASE PRESENT AT BOX OFFICE

**1967 SEASON**

**TIDEWATER COMMUNITY BASEBALL CORP.**

**FRANK D. LAWRENCE STADIUM**

Name Mr. & Mrs. W. E. Haywood

N⁰ — 72

**TIDES SEASON PASS.** This pass was presented to the parents of batboy Mike Haywood for the 1967 season. With the Tides continuing a working relationship with Philadelphia of the National League, the young Haywood was often seen attired in Phillies flannel as he performed his daily duties for the team. Not surprisingly, the former batboy remains a diehard Phillies fan to this day. (From the collection of Mike Haywood.)

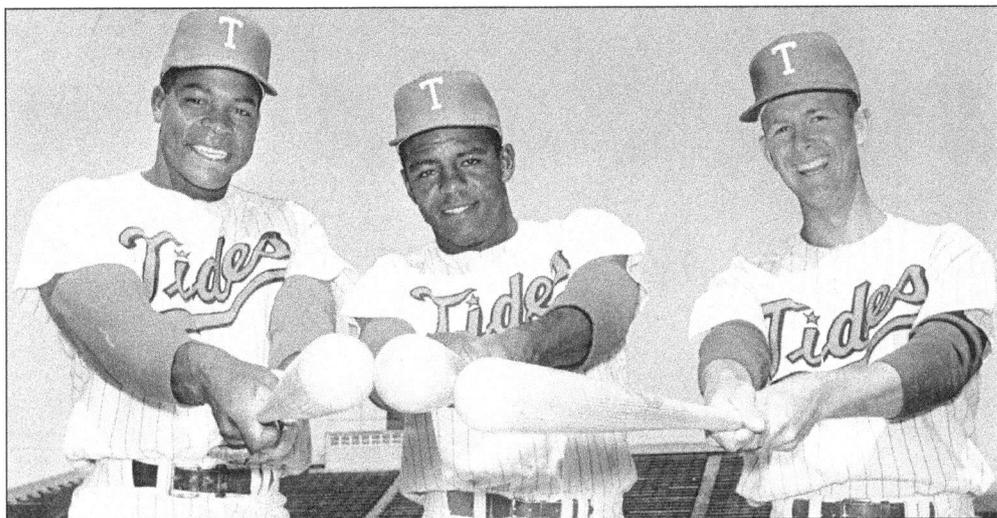

**TIDEWATER'S BIG STICKS, 1967.** Pictured above are (from left to right) Ron Allen, Larry Hisle, and Stirling Coward. Allen, the baby brother of major leaguer Richie Allen, served as the starting first baseman for the Tides in 1967. He led the Carolina League in RBIs (100), and contributed 24 homeruns while batting a cool .288 at the plate. Larry Hisle socked 23 homers and batted .302 for the season with both Tides earning All-Star honors. Ron Allen suited up with the St. Louis Cardinals in 1972, while Hisle settled into the major leagues for a 14-year career with a variety of teams including the Phillies, Twins, and Brewers. He led the American League in RBIs with 119 in 1977. (VP.)

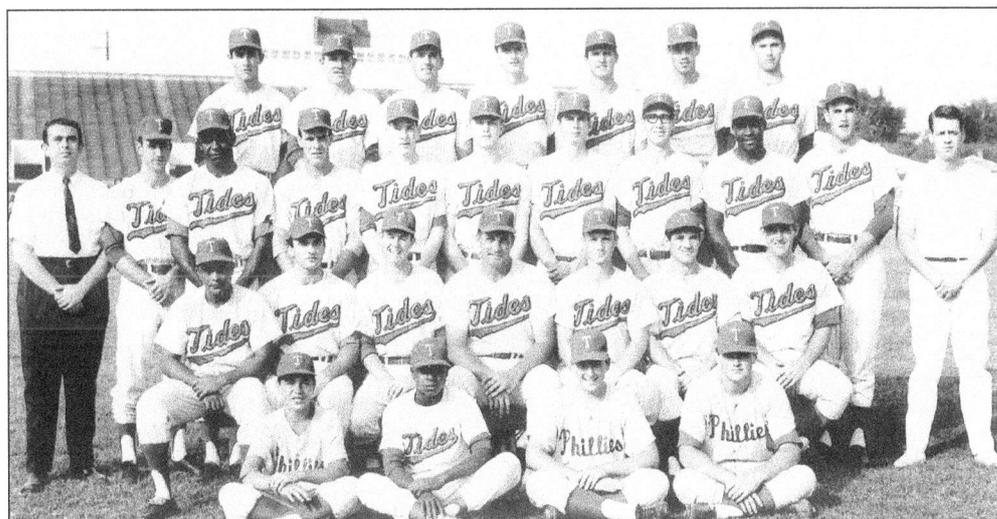

**THE 1967 TIDEWATER TIDES.** The 1967 Tidewater Tides squad is shown assembled on the grass of Frank D. Lawrence Stadium. The following are pictured from left to right: (first row) batboys Robert Wright, Robert Louis Cross, Mike Haywood, and Carl Vaughn; (second row) Vic Torres, Bill Carnegie, Stirling Coward, Manager Bob Wellman, Denny Doyle, Mike Compton, and Gene Harbeson; (third row) General Manager Dave Rosenfield, Don Hammitt, Larry Hisle, Terry Harmon, Buford "Billy" Champion, Mike Wegener, Dave Bennett, Gil Pinard, Ron Allen, Len Clendenin, and trainer George Adams; (fourth row) Lowell Palmer, John Hawkins, Tommy Keyes, Jackie Brown, Scott Reid, Chris Heintz, and Jack Nutter. (From the collection of Mike Haywood.)

**INTERNATIONAL LEAGUE CHAMPS, 1969.** The opening day starting line-up for the Tidewater Tides pose for the camera on the diamond of Frank D. Lawrence Stadium. The Tides captured the 1969 International League pennant with a 76-59 record under the guidance of Clyde McCullough. Pictured from left to right are Steve Renko, pitcher; Lloyd Flodin, catcher; Bobby Heise, shortstop; John Tracy, second baseman; Roy Foster, right fielder; Billy Sorrell, left fielder; Mike Jorgensen, first baseman; Bobby Pfeil, third baseman; and Bernie Smith, center fielder. (VP.)

**TIDES HURLER JIM BIBBY, 1969.** Standing six feet, five inches, it is not surprising to learn that Jim Bibby was a basketball star in college. In limited action with the Tides in 1969, the big right-hander won 4 and lost 4 with an ERA of 3.48. His big league career spanned 12 seasons, from 1972 to 1984, with the St. Louis Cardinals, Texas Rangers, Cleveland Indians, and Pittsburgh Pirates. In 1980, with the Bucs, he led the circuit in winning percentage with a 19-6 record and was selected to the National League All-Star team. Over his major league career Jim Bibby posted a 111-101 record with 1,079 strikeouts. (VP.)

**DANNY "THE BEAR" FRISELLA.** Danny Frisella made his major league debut with the Mets in 1967, but was used sparingly as a starting pitcher with little success. His unreliable control with New York soon found him relegated back to the minors. In 1969, Frisella appeared in 15 games and posted an impressive 11-2 record with a 2.76 ERA with the Tides. The "Bear," as he was nicknamed because of his thick thatch of body hair, returned to the Mets, but only logged four innings of work in relief and was battered with an inflated 7.71 ERA. He eventually became a regular on the New York roster until he was traded to the Atlanta Braves in the off season. Frisella's last year in the major leagues came in 1976 with two teams, the St. Louis Cardinals and the Milwaukee Brewers. On New Year's Day 1977, at the age of thirty, Danny Frisella was killed in a dunebuggy accident in Phoenix, Arizona. (VP.)

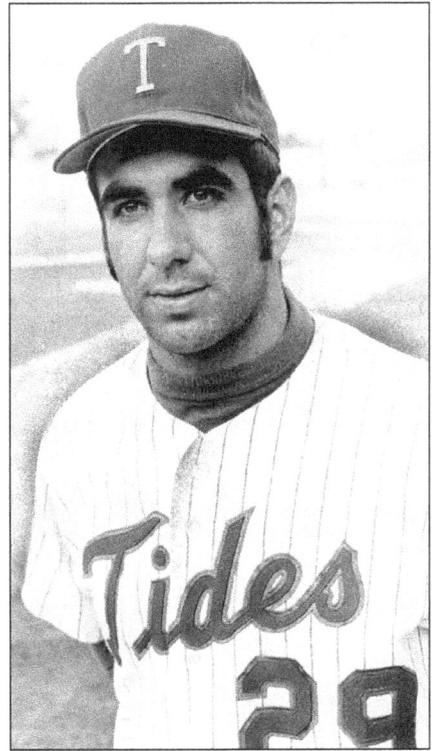

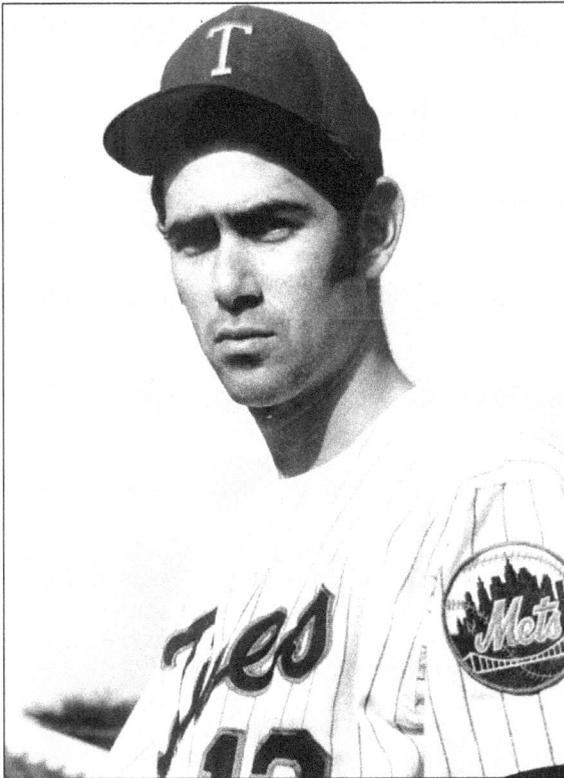

**ART SHAMSKY, 1969.** Originally signed to a contract by the Cincinnati Reds, Arthur Lewis Shamsky was a regular fixture in the outfield with the New York Mets beginning in 1968. He proved his worth during the 1969 miracle season for the Mets by hitting .300 from the plate, followed by an impressive performance in the National League Championship Series as he stroked 7 hits in 13 at bats for a .538 batting average. While Shamsky's potent bat drove the Mets to the postseason, it fell silent during the Fall Classic as he went hitless in the 1969 World Series. In this rare 1969 photo, Shamsky only appeared in eight games during a short rehab assignment in Portsmouth. (VP.)

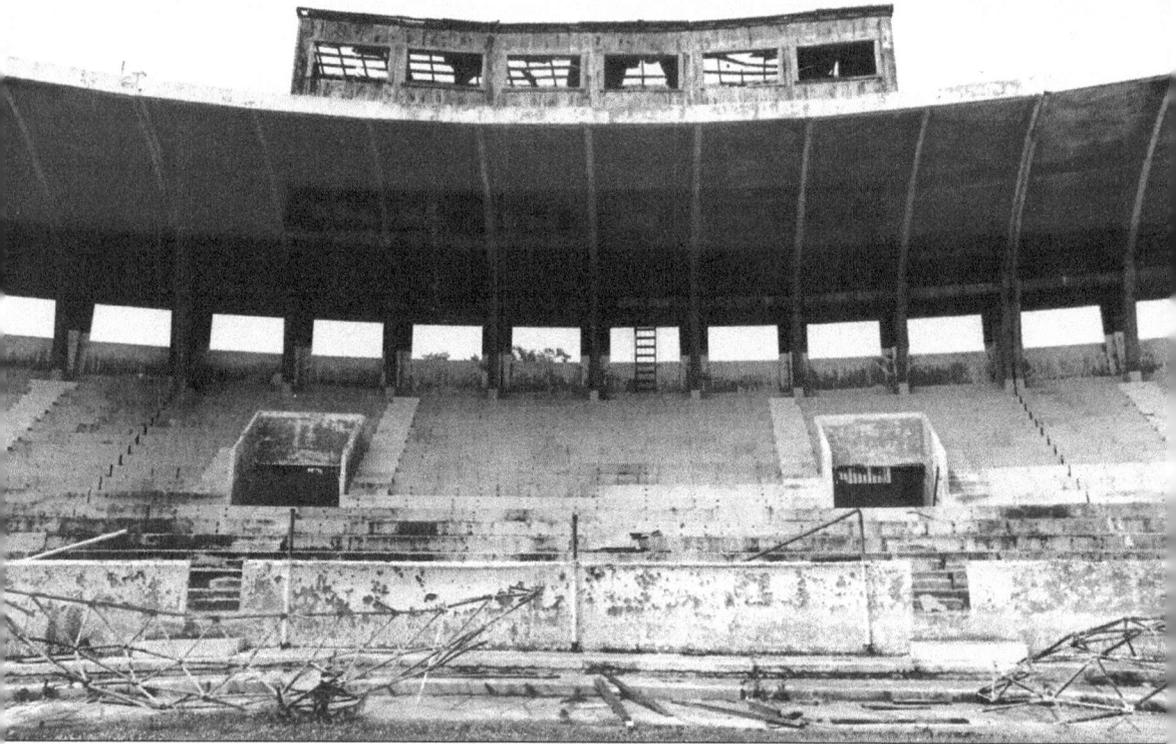

**A Stadium Filled With the Ghosts of Portsmouth's Baseball Past.** Started in 1939 as a WPA project, Portsmouth Stadium opened to rave reviews for its state-of-the-art design and fan-friendly seating. Beginning with its first historic game on Easter Sunday, April 13, 1941, the solid concrete walls and freestanding covered grandstand served as witness to a wealth of baseball lore for many years. From the ceremonial homecoming of Hack Wilson, Eddie Stanky, and Pie Traynor in 1941, to the rebirth of baseball in Portsmouth in 1961 with the Tidewater Tides; from the numerous visits by the greats of the Negro Leagues to the effective and dominating play of the great Navy teams during the war years; from the celebrations of players and fans as the Cubs won Piedmont League pennants to its day of rechristening as "Frank D. Lawrence Stadium" in 1964, the ballpark served as a sturdy canvas for the colorful and masterful painting of baseball in Portsmouth. As the Tidewater Tides left for Norfolk to begin play in 1970, the use of the stadium shifted to stage high school contests on the gridiron with an occasional rock concert and motorcycle race thrown in for good measure. By 1990, as evidenced in the photograph above, the stadium was stripped of its seats and allowed to fall into disrepair. During the summer of 1992 an eerie sound filled the old stadium. Instead of the crack of the bat and the cheers of the crowd, the few workers on the field heard only the deep howl and crash of the wrecking ball against the fortress-like façade of the ballpark. The swing of the crane had sadly replaced the swing of the bat and the ghosts of Portsmouth's baseball past were scattered into a stiff wind blowing off Scott's Creek. The site where the historic ballpark once stood is now the location for Portsmouth's I.C. Norcom High School and athletic field. (PPL.)

126

# PORTSMOUTH BASEBALL NOTES
## 1961–1969

Interesting facts about the players in Portsmouth's baseball history

♦ In 1961, the name for the new baseball team in Portsmouth was selected in a contest conducted by the *Virginian-Pilot* with members of the sports department serving as judges. The choice by a wide margin was "Mariners," the favored moniker of longtime sports editor emeritus, W.N. Cox. Despite the consensus by fans and judges, Robert Mason, editor of the paper, overrode the decision and selected "Tidewater Tides" because of the catchy sound and alliteration of the name.

♦ At the final home game of a disappointing 1962 season, the Tides entertained the Macon Peaches in a doubleheader at Portsmouth Stadium. While Ronnie Cox and Sal Betancourt received awards for Most Valuable and Most Popular Tidewater Tide respectively in a special ceremony between the twin bill, a special award was presented to Martin Beltran by the Macon pitching staff. In the doubleheader, Beltran gathered six consecutive hits, thereby earning the "BMTMP Award" (The Biggest Menace To Macon Pitching) from his frustrated opponents. The night also proved to be special when one looks at the numbers: 6 hours of baseball, 18 innings, 16 runs, 37 hits, 71 baseballs used, 3 speeches, and 36 musical numbers by the John Thomas Hokum Boys Jazz Band.

♦ As the 1963 season came to a close, Portsmouth fans flocked to the stadium for a mundane three game series against the Wilson Tobs to see one of the biggest stars of the day. On the roster for the Tobs was Los Angeles Angels hurler Bo Belinsky, known for his penchant in dating Playboy bunnies and beautiful young Hollywood actresses. Despite the fact that Belinsky had served in the majors, his pitching skills were not enough to draw big crowds to the ballpark and few locals really cared to see him on the mound. However, when word got out in the media that he was bringing his current girlfriend on the road trip to Portsmouth and she would be attending each game, fan interest perked up. To no one's surprise, the seats surrounding Belinsky's girlfriend sold out rather quickly. Over the three game series a steady stream of curious boys and infatuated men made every effort to catch a glimpse of actress Mamie Van Doren as she watched Belinsky and the Tobs challenge the Tides.

♦ Tides outfielder Ed Stroud established more Tidewater offensive records than any other player from 1961 to 1969. In 1964, he set the record for most hits (167), runs (108), and stolen bases (72). The following season he set the standard for batting averages with a high mark of .341.

♦ On Saturday, May 16, 1964, between games of a doubleheader between the Tidewater Tides and the Greensboro Yankees, Mayor R. Irvine Smith officially rededicated historic Portsmouth Stadium as "Frank D. Lawrence Stadium." With the 73-year-old Lawrence wiping away tears, a large bronze plaque was unveiled in front of a small, but appreciative crowd.

♦ The last pro game ever played in Portsmouth came on September 5, 1969, and with two outs in the bottom of the ninth inning, Tidewater Tides first baseman Mike Jorgensen hit the final home run out of historic Frank D. Lawrence Stadium. A few moments later, at exactly 10:08 p.m., the last out was recorded and the final chapter in the history of baseball in Portsmouth, Virginia, came to an end.

## ABOUT THE AUTHORS

Clay Shampoe and Tom Garrett consider themselves archaeologists on a quest to unearth, research, and report local sports history from the Hampton Roads area of Southeastern Virginia. Their mutual journey in the creation of this book goes back many years. It is a culmination of shared interests that began with the gathering of local memorabilia and a desire to learn as much as possible regarding the history of baseball in Portsmouth.

Clay is a speech pathologist on staff at Children's Hospital of The King's Daughters in Norfolk. Tom is a retired Special Education principal who served in the Portsmouth Public Schools for three decades. Their working relationship is only exceeded by the deep friendship and respect they share for one another. They are co-authors of *Baseball in Norfolk, Virginia* published by Arcadia Publishing. Future books that will explore the baseball history of the Norfolk Tides, the rise and fall of the Virginia Squires, and Tidewater's football history are in the planning stages. Tom (left) and Clay (right) are pictured during a research visit to the National Baseball Hall of Fame in Cooperstown. (Photo by Jim Shampoe.)

## BIBLIOGRAPHY

Chrisman, D.F. *The History of the Piedmont League*. Bend, Oregon: Maverick Publications, 1986.

Chrisman, D.F. *The History of the Virginia League*. Bend, Oregon: Maverick Publications, 1988.

Clark, Dick and Larry Lester. *The Negro Leagues Book*. Cleveland: The Society for American Baseball Research, 1994.

Filichia, Peter. *Professional Baseball Franchises*. New York: Facts on File, Inc., 1993.

Heaphy, Leslie A. *The Negro Leagues, 1869–1960*. Jefferson, North Carolina, and London: McFarland & Company, Inc., 2003.

Johnson, Lloyd and Miles Wolff, Editors. *The Encyclopedia of Minor League Baseball*. 2nd Edition. Durham: Baseball America, Inc., 1997.

Light, Jonathan Frazier. *The Cultural Encyclopedia of Baseball*. Jefferson, North Carolina, and London: McFarland & Company, Inc., Publishers, 2000.

Riley, James A. *The Biographical Encyclopedia of the Negro Baseball Leagues*. New York: Carroll & Graf Publishers, Inc., 1994.

Visit us at
arcadiapublishing.com

www.ingramcontent.com/pod-product-compliance
Lightning Source LLC
Chambersburg PA
CBHW080557110426
42813CB00006B/1326